SUPERREALIST
PAINTING & SCULPTURE

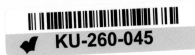

SUPERREALIST PAINTING & SCULPTURE

CHRISTINE LINDEY

Orbis Publishing · London

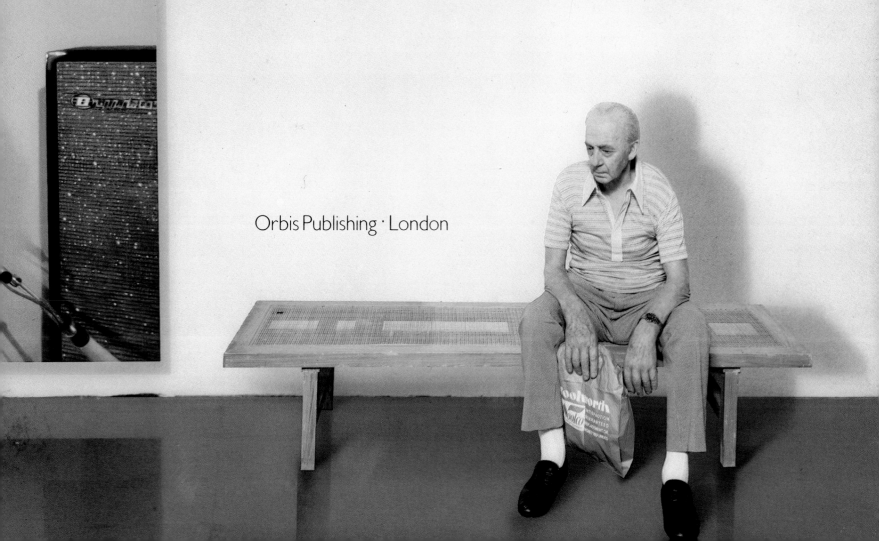

For Ray, Marie and Jean-Claude

I would like to thank my family, friends and students without whose support I really would *not* have written this book, and especially Carol Mann for her wholehearted encouragement throughout. To Raymond Lindey, more than thank you!
I am grateful to John Roberts whose idea the book was, to Christopher Wright for initially encouraging me to undertake it and to my editors, Stephen Adamson, Tristram Holland and Prue Chennells for their patience and understanding. I am indebted to Jonathan Reed for his energetic picture research and to Paul Welti for transforming images and words into a truly creative whole. The librarians at Croydon School of Art, the Tate Gallery, the Victoria and Albert Museum and the Westminster City Library were all extremely helpful, while Dorothy Branwell and Margaret Hoskyns-Abrahall at Watford School of Art gave help which certainly went beyond the call of duty: thank you.
Finally I should like to extend my warmest regards to all the artists featured in this book. C.L.

Illustrations on previous page:
Franz Gertsch *Patti Smith II,* 1978, acrylic on unprimed canvas, 111 × 165″ (280 × 420cm)
Duane Hanson *Man on a Bench*, 1977–8, cast vinyl, polychromed in oils, life-size

© 1980 by Christine Lindey
First published in Great Britain by Orbis Publishing Limited, London 1980

Printed in Italy by New Interlitho, Milan

ISBN 0 85613 074 5

CONTENTS

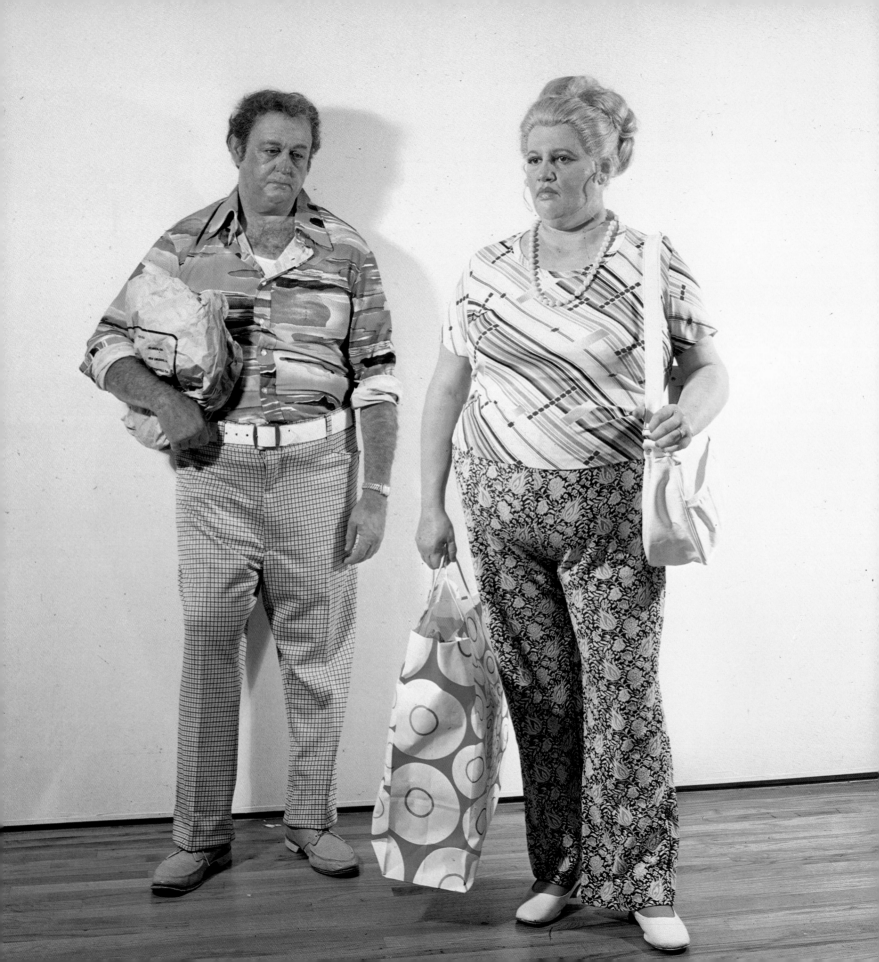

INTRODUCTION

The simple fact that this book deals with art mostly produced within the past ten years is surprising in itself, partly because the illustrations are so life-like that we could easily be forgiven for mistaking them for photographs, but also because we do not expect to find such precise realism in contemporary art in the first place. Ever since the Impressionists questioned art's concern with mimicry, modern artists have dealt with every aspect of reality except the simulation of visible appearances. Illusionism untempered by fantasy has been the *bête noire* of serious and innovatory art for over a hundred years, yet in the 1970s a large number of artists, art school trained and fully aware of recent developments in the Fine Arts, are once again deliberately choosing to depict the visible world, and doing so in a more objectively realist fashion than at any other point in the history of Western art.

Many have welcomed their works. Delighted to find realism alive and well, they argue that here at last is an art which can be understood by the uninformed layman; paintings and sculptures of recognizable subjects which can be approached without first wading through pages of theories or explanations. But the cool realism of the style has also earned it

Duane Hanson
Couple with Shopping Bags, 1976, cast vinyl, polychromed in oils, life-size

the distinction of being vitriolically attacked by many critics. It has been dismissed for being cold and inhuman, retrogressive, or merely naive, by an art press which nowadays usually bends over backwards to accept novelty in any form.

The Superrealists have no manifesto with which to counteract accusations and no single geographical centre in which to discuss and exchange ideas. Its artists are scattered throughout the USA and although primarily an American movement, there are also important practitioners of the style in Europe. Their techniques and subjects vary, they hold diverse and sometimes contradictory artistic outlooks, and see themselves as individuals rather than as members of a group. Yet the works do share certain basic characteristics which warrant their being discussed as part of a movement, albeit a loosely-knit one. Both painters and sculptors portray their subjects with such verisimilitude that their works appear unnaturally real: Super-real. Indeed, this has given the style its name. Others have called it Hyperrealism, Sharp-Focus Realism, New Realism, Radical Realism, Post-Modernist Illusionism, and Post-Pop Illusionism. Most of these names have shortcomings: they have been used to identify previous styles, or lead to confusion with present styles, or are short-sighted or clumsy. The generally accepted term for the paintings and sculpture together is now *Superrealism*, while the sculptures alone, made from life casts, are called verist, and

the paintings, based on photographs, are usually called photo-realist.

The plethora of names by which it has been known reflect the nebulous status of the movement in its early days. Linda Nochlin's exhibition 'Realism Now', held at Vassar College, New York State, as early as 1968, pioneered serious attempts at defining the then emerging works of Malcolm Morley, Richard Estes, and Robert Bechtle. A passionate defender of realism in art, she focused on their use of precise and literal realism, placing them alongside non-photo-realists such as Philip Pearlstein. She identified their impersonal attitude to subject matter, and discussed their work as a welcome alternative to abstraction. Ivan Karp, the New York dealer largely responsible for spotting and promoting the new trend, further identified its commitment to urban subject matter and, more importantly, to immaculate focus. In 1972, the Dokumenta 5 exhibition, held at Kassell, Germany, first brought Superrealism world-wide attention and questioned its status as the antithesis of abstraction by including it alongside other contemporary movements such as Land and Performance art; a particularly pertinent context, since these movements equally deal with tangible reality and frequently make use of photography to record their ephemeral works.

In contrast, the photo-realists depict photographs of reality. In itself, painting from photographs is hardly new. The

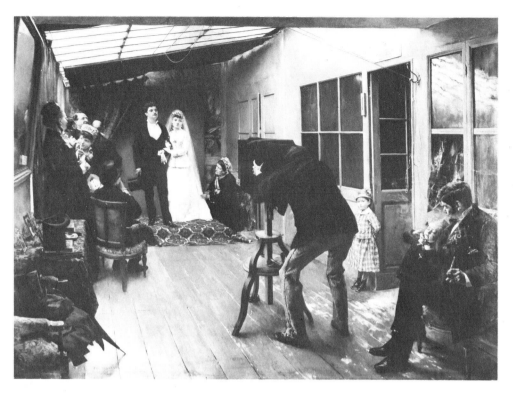

photograph has been the uneasy bedfellow of art since its invention in 1839, and there has been continuous interaction between the two since then. Nineteenth-century artists such as Dagnan-Bouveret often relied on photographic information, but they idealized or romanticized it in some way using the photograph as raw material to be reorganized into 'subject paintings' redolent of anecdote or narrative. Innovatory painters from Manet to Bacon have taken a more creative approach, using the photograph as a point of departure for some of their paintings, and many contemporary non-Superrealists continue to work in this way, while the Pop painters have 'quoted' photographic imagery in a tongue-in-cheek manner.

The Superrealists, however, confront photography with a directness hitherto unseen, thereby raising important questions about contemporary visual communications. Paintings are nowadays largely experienced vicariously. The 'paintings' in this book, for instance, are neither paintings nor photographs; they are photo-mechanical prints, of photographs, of paintings. We experience the vast majority of works of art in this way, so that we are often shocked at how different a familiar work looks when we first see the original. The knowledge that their works will be seen as printed images has prompted many contemporary artists to confront this issue. Some have sought alternative ways of working – either by accepting the photo-mechanical process as a medium, or by stressing the importance of primary experience by creating new art forms such as Performance or Land art, both of which eschew reproduction. By working directly and meticulously from photographs the Superrealist painters also produce works which seemingly defy reproduction, since by reproducing them we return them to the original source. The only way to come to an accurate understanding of the work is therefore to

Dagnan-Bouveret (left)
A Wedding at the Photographer's, 1878–9, oil on canvas, 33 × 47″ (835 × 120cm) Artists have used photography as a source of information since its invention but, unlike earlier artists, the Superrealists do not transform their source material, so that when reproduced in books their paintings look like the photographs they have been taken from – as on pages 70 and 71 of this book (right).

Richard Es
Central Savin
oil on canva
36″ × 48″

see the original. The wheel has turned full circle.

Another reason for painting from photographs is to widen our awareness of the ways in which photo-vision *transforms* reality. We frequently accept the photographic image as real. At no time in history has mankind produced so large a number of such detailed images of reality: cinema and television screens, posters, magazines, newspapers, even soap packets, carry pictures of every conceivable aspect of the universe – we fall in love with film stars we have never seen, buy goods from illustrated catalogues, and order food from pictorial menus. As Richard Estes puts it, 'We accept the photograph as real.'[1] Compare a work by Superrealist Ron Kleemann with one by Alex Colville, a traditional realist: Kleeman (*Private Sanitation*, 1976) deliberately accepts the 'artless' composition of the close-up from which he paints. He records the ensuing distortions of scale, the fuzziness of out-of-focus areas, the shallow depth of field and above all the inherent flatness of his pictorial source. It is a painting of a photograph as much as a painting of a truck. In *Truck Stop*, 1966, painted from life, Colville defines his forms with line, organizing his subject into a carefully structured composition and using one-viewpoint perspective to create a traditional illusion of three-dimensional space within the picture frame. Both paintings portray trucks with accurate and detailed realism, but Colville's belongs to a pictorial tradition which dates back to the Renaissance whereas Kleeman's is dependent on photographic

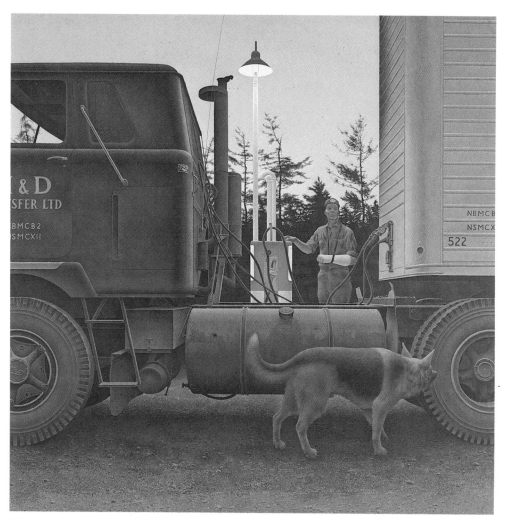

Alex Colville (above) *Truck Stop*, 1966, acrylic polymer emulsion, 36 × 36″ (91 × 91cm)

Ron Kleeman (right) *Private Sanitation*, 1976, acrylic on canvas, 44 × 66″ (119 × 168cm)

The true subject of Kleeman's painting is the photographic image, with its strange distortions of scale and fuzzy, out-of-focus areas, wheras Colville's work remains within the traditional domain of the realist, where composition, light and colour are manipulated to present the artist's personal view of the subject.

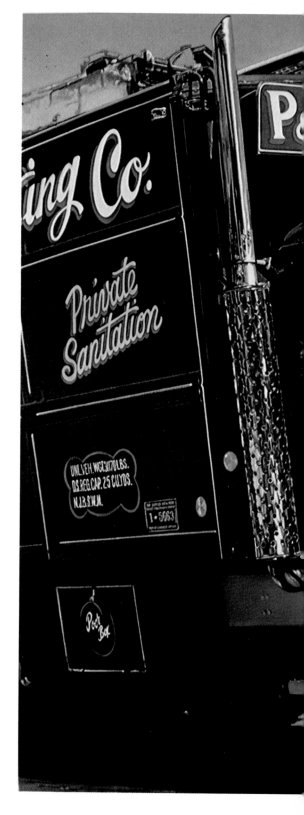

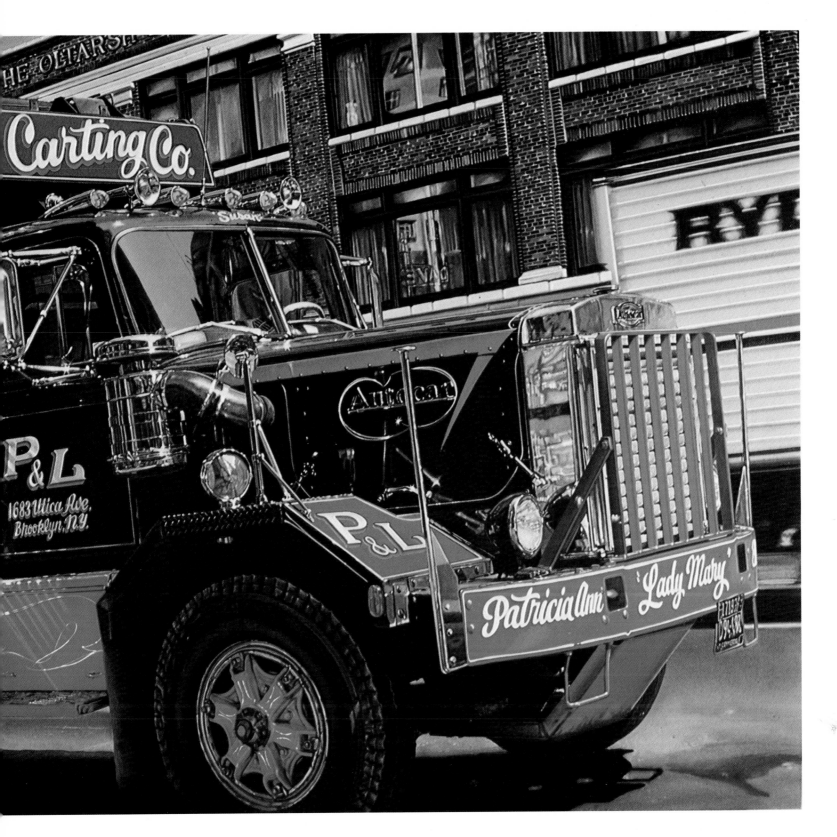

convention. Their formal means are dissimilar because their artistic credos differ. Colville's painting shows 'nature seen through a temperament': the artist has found an eerie mystery in the mundane; he has manipulated composition, light and colour to present us with his personal interpretation of the subject. This approach, first identified by Zola in the work of the Impressionists, continues to condition the aesthetic expectation of most people: it survives in Colville's work and underlies most twentieth-century realism. In contrast, a classic Superrealist canvas such as Kleeman's seeks to avoid such subjectivity.

While Superrealist paintings open our eyes to the visual characteristics of mass imagery, many of the painters work from photographs mainly because they act as a 'distancing device', coming between the artist and tangible reality. They are freed from responding directly to their subjects and provided with an existing visual format from which to paint reality. In this sense they accept the photographic image as equating reality. But by painting this 'reality' as it *looks* rather than as it *feels* to them, they take an essentially modern attitude which differs from previous uses of both the photograph and realism. A similar no-comment stance can be found in Minimal art, contemporary music, literature and film, and permeates current attitudes in general, which tend to avoid imposing particular world views on others.

Richard McLean (left)
Wishing Well Bridge,
1972, oil on canvas,
60 × 63" (152 × 160cm)

This lack of subjectivity allows the artists to concentrate on their craft and, paradoxically, their works become 'suffused with an intensity in relation to the act of painting itself, and an intensity in relation to the act of seeing directly, unhampered by preconceived notions about the image' (Linda Chase).[2] Many photo-realists view the craftsmanship involved as both a pleasure and a challenge. The artists are free to study and paint every detail of their subjects as depicted by the photograph, to enjoy shapes as shapes, and colours as colours. They have access to any aspect of reality, transfixed, and can linger over their subject at will. The photograph provides them with detailed illusions of the solid, three-dimensional world, already transferred onto a flat, two-dimensional surface. They need not concern themselves with the perennial problem of describing space and volume on a flat surface, but can concentrate on the outward skin – the surface quality of vinyl or the reflections in a polished surface – without becoming involved in a Cézannesque analysis of form.

This brings us to the final major reason for the artists' use of the photograph and to a further important aspect of Superrealism. Many of its practitioners turned to realism in rebellion against recent artistic attitudes, yet were anxious to avoid lapsing into out-dated formal languages. Pictorial conventions such as the snapshot, the glossy magazine image, and the poscard provided the painter with relatively unexplored compositions. The camera's manner of recording the world could be investigated: its cropping of the subject; its shallow spatial organization; its tonal – as opposed to linear – description of form; its inability to focus at will; all provided new ways of seeing which differ from human vision. It provided painters with a visual language relevant to their own times but fresh to realist art, so freeing them from the

shadow of previous forms of realism. As John Salt explained, 'The photograph wipes out art history for you.'[3]

Although the Superrealists are united in their commitment to the portrayal of concrete reality and their avoidance of the imaginary, the contrived and the fantastic, their subject matter varies enormously. It is often pointed out that they focus on aspects of reality which are not normally considered beautiful, that they belong to the 'warts and all' tradition seen in sixteenth-century Flemish painting and often synonymous with the harsh realities of life, as in Courbet or even Caravaggio. Yet the majority of Superrealists do not choose their subjects with this in mind. They may depict Californian suburbs, highway diners, or the streets of New York city, but many do so simply because these are their own everyday surroundings rather than for their symbolic properties; in this sense they belong, rather, to a tradition initiated by the Impressionists and Cézanne, and followed by many twentieth-century artists. Their subjects are, however, frequently suggestive of the American way of life made familiar by film and television, and as such they are likely to provoke strong reactions which may range from romantic dreams of the 'good life' to criticisms of its blandness and uniformity. The artists are of course aware of these implications but avoid stressing any particular viewpoint. They see this as a positive factor: Robert Bechtle, for example, finds it fascinating that he 'can paint something which is very specific – a particular car or a particular person at an identifiable location – that is just as open to various interpretations as an abstract painting.'[4]

The artists' use of precise realism has blinded many to the fact that Superrealism is not merely a simplistic return to realism, but is on the contrary undertaken with sophisticated awareness of contemporary art. Some have even

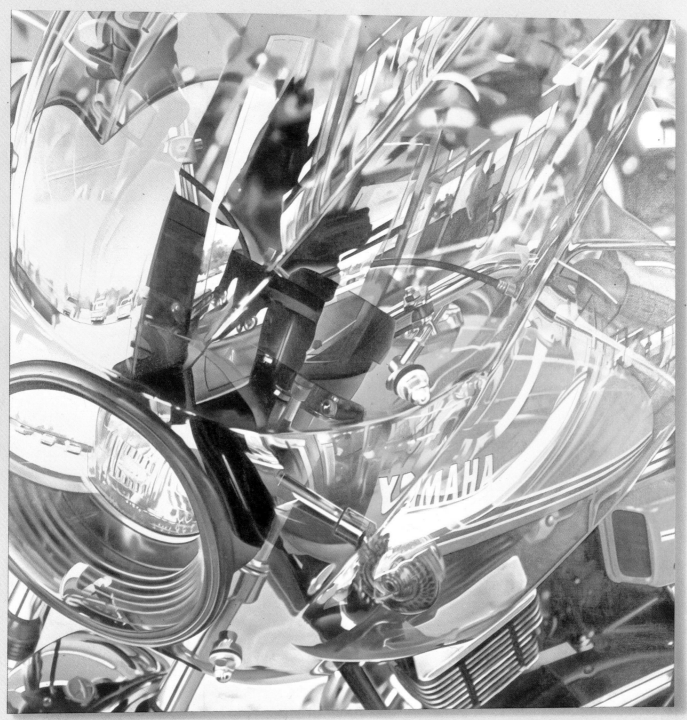

David Parrish (above) *Yamaha*, 1978, oil on canvas, 78 × 77″ (198 × 195cm)

Ben Schonzeit (right) *Cauliflowers*, 1975, acrylic on canvas, 84 × 84″ (213 × 213cm)

Both paintings are derived from cropped photographs but whereas Parrish exploits the near-abstract shapes found in his sources, Schonzeit explores the visual effects of the photographic close-up itself.

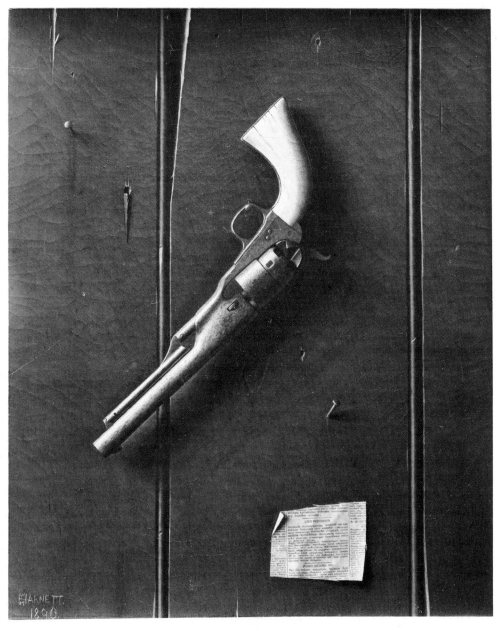

William Harnett (above)
The Faithful Colt,
1890, oil on canvas,
18½ × 22½″ (47 × 57·2cm)

Idelle Weber (right)
Navels 5 for 69,
1972, oil on canvas,
48 × 50″ (122 × 127cm)

Both artists depict
their subjects in great
detail but whereas
Weber is not
deliberately trying to
make us believe that
the objects she paints
really exist on the
canvas, Harnett's
work is unashamedly
trompe l'oeil.

compared it with *trompe l'oeil* yet,
although they copy, the photo-realists do
not set out to create illusions, either of
reality or of the photograph. Comparison
between William Harnett's classic *trompe
l'oeil* painting *The Faithful Colt*, 1890, and
the Superrealist work *Navels 5 for 69*,
1972, by Idelle Weber, reveals the
differences. Weber gives us a highly
detailed representation of her subject but
does not aim to deceive us into believing
the painted objects to be real ones, as does
Harnett.

There has in fact been a continuous
tradition of realism in the twentieth
century. Figuration itself never died,
despite many claims to the contrary, as the
works of modern giants like Picasso,
Matisse and Bacon testify, and it is very
much alive in the works of many
contemporary artists. Precise realism in
the twentieth century can be seen in the
works of the Russian Social Realists and in
that of some traditional Western artists
such as Tretchikoff, Wyeth and Annigoni.
During the inter-war years progressive
artists such as the Neue Sachlichkeit
painters and the American Social Realists
used precise realism as a language for
social comment, while Magritte and other
Surrealists used it as a means of
portraying their states of mind. But all
these works are intended to be judged
according to the manner in which they
transform tangible reality to convey
meaning.

Superrealism clearly differs from these,
yet the distinctions are far more nebulous
in the case of contemporary uses of
precise realism. We have already seen how
the work of an artist like Colville differs
from Superrealism, yet it has been
included in exhibitions and publications
on the subject. Others, like Pearlstein and
David Hepher, do share the Superrealists'
coolness with regard to subject matter,
but are as opposed to the use of the
photograph as Colville is. Even artists who
work closely from photographs are not

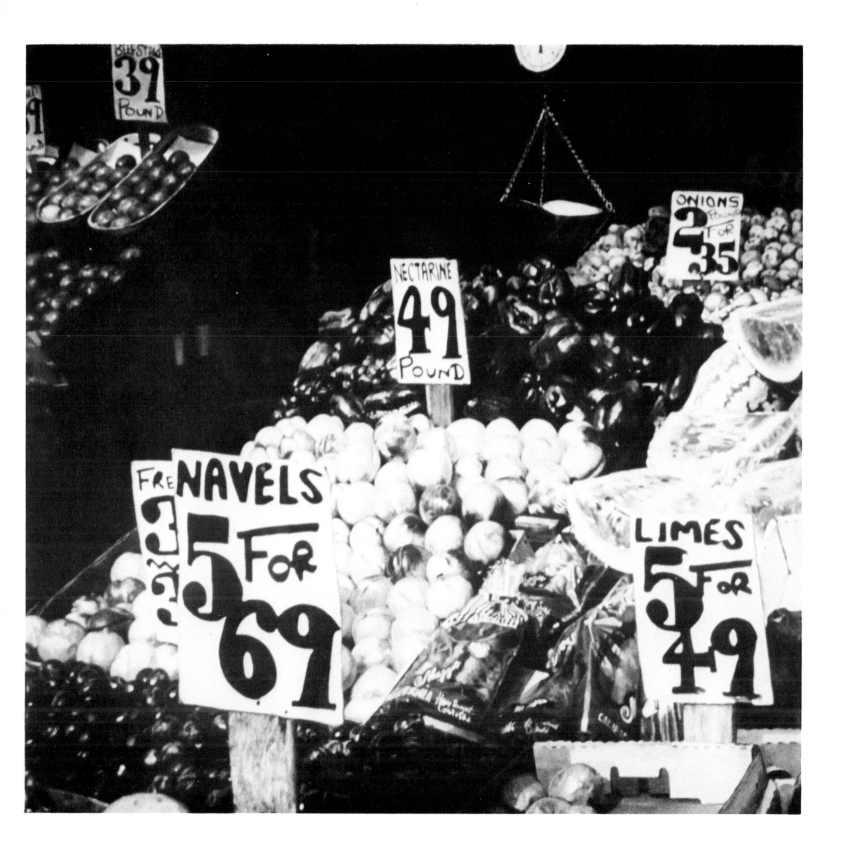

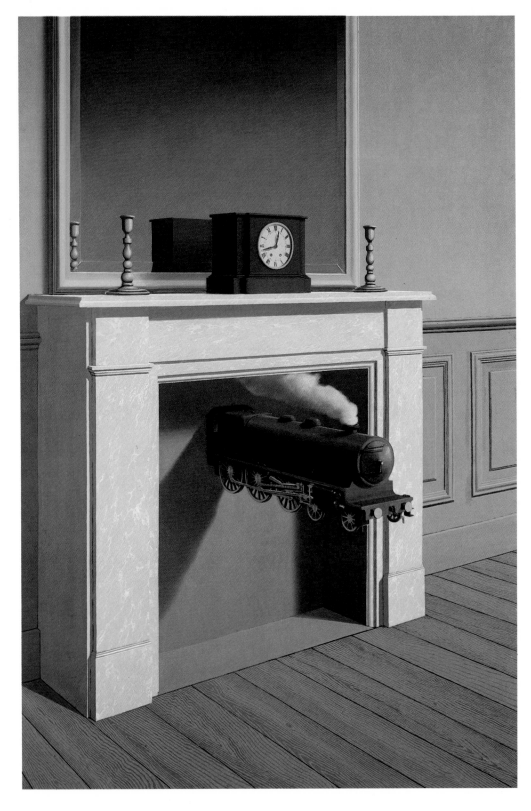

René Magritte (left)
Time Transfixed,
1939, oil on canvas,
$57\frac{1}{2} \times 38\frac{3}{8}''$ ($146 \times 98\cdot4$cm)

Stephen Posen (right),
Untitled, 1974,
oil and acrylic on
canvas, $85 \times 68''$
(216×172cm)

Precise realism has
been used in many
ways by twentieth-
century artists
without being
Superreal. Magritte
used it to convey the
Surreal, while the
subject of
contemporary artist
Posen's painting is
artificially contrived
and he uses a mixture
of realist languages,
of which the photo-
derived is only one.

necessarily Superrealist. Stephen Posen's paintings are investigations into the nature of colour and pictorial space which show an allegiance to Cézanne and Matisse rather than to photo-realism. Also their subject matter, which is partly non-figurative, is chosen to explore differing levels of reality and illusion, rather than to depict the tangible world. Nevertheless, some artists, such as Brendan Neiland and Michael Leonard, do appear to exist on the borderline between precise realism and Superrealism, while conforming to some of the latter's basic tenets. In the final analysis, however, the decision as to who is a Superrealist must to some extent be a personal one.

Responses to the movement are equally open to interpretation. For many people, disillusionment sets in when they discover that the skilful realism which originally seduced them is achieved 'merely' by copying. Yet copying has a long and venerable history in Western art; it was considered normal artistic procedure until the Renaissance and survived well into the twentieth century as a teaching method, while many highly regarded works such as Van Gogh's paintings after Millet have been created in this way. But the latter are admired for the way in which they *depart* from their source, so that the Superrealists' concern with copying (or rendering, as they prefer to call it) challenges commonly held aesthetic criteria such as the stress on originality and spontaneity, and the tendency to equate copying with cheating. However, as Tom Blackwell points out, things change when they are copied: 'The act of translating visual information in the photograph into a

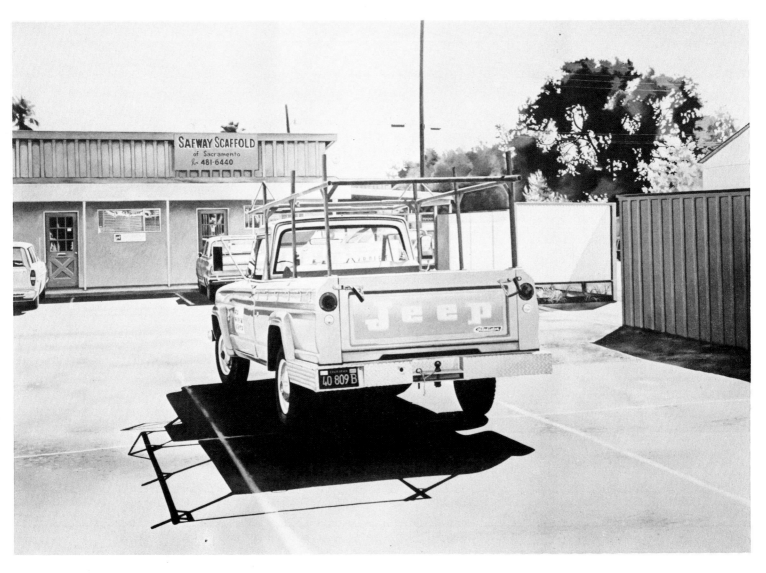

painting changes it very profoundly . . . all the information is filtered through a human sensibility.'[5] The process becomes a statement in itself, and much of the impact of Superrealist works rests on the changes which occur.

Seen in the original, the visual experience is quite unlike that of looking at a photograph. The paintings are often large, so that the subject is difficult to see in its entirety unless one is far from the painting, and when seen close-to one is primarily aware of the actual surface of the canvas and the quality of the marks made on it. This physicality and presence of the paintings is quite unlike the thin and expendable quality of the photo-sources, so that the works only truly 'look like photographs' when returned to this medium in a reproduction.

Another common criticism of Superrealism is that the artists' refusal to communicate personal responses precludes interpretation. In an age which accepts that reality is neither finite nor immutable, that one person's fantasy is another person's reality, they set out to show the visible world as it truly is, unqualified by comment. In most cases the sullen silence which the Superrealists maintain with regard to their subjects is intended as a means of allowing the spectator to respond in his or her way, rather than as an indication of the artists'

indifference to the world they portray. Paradoxically, modern-day attitudes to art tend to stress the importance of understanding the artist's point of view rather than examining public response, and in terms of criticism this has meant that writers on the subject, including myself, have shied away from passing on their own responses to the works or to the subjects portrayed, in an effort to remain true to the artists' expressed views.

It has been convincingly argued that the absurdity and impassivity of Superrealist art is part of its essentially modern stance, relating as it does to the late Existentialism of Samuel Beckett or to the factual approach of the French New Novel and its counterparts in the Cinema Verité of the 1960s. One could add, too, that an attempt to make social comment via non-symbolic illusionism must contain an element of naïvety, given the sophisticated forms of communication available to the contemporary artist. Indeed, the implications of the movement are full of irony and paradox. The photo-realists were driven to seek new pastures partly because of artistic indigestion caused by the unprecedented abundance of photographic reproduction which gave artists ready access to the art and styles of all periods – Malraux's 'museum without walls' had become the Big Brother of art,

causing as many problems as it solved. Paradoxically the photo-realists use the very technology which caused their oppression in the first place as a central element in their work. Yet by producing slow and painstaking 'copies' of photographic images, they appear to invalidate the very characteristics for which photography is generally valued.

Nevertheless, there remains an element of absurdity, verging on nihilism, in Superrealism. The painters produce hand-made copies of the machine-made; in calligraphic terms this would be tantamount to a writer carefully copying out the typeface of a printed page. In this sense the verist sculptors are even more open to accusations of insane purposelessness, since they actively set out to deceive the senses; indeed, the effect of their works rests partly on this element of shock. Its impassive realism has led many people to feel that Superrealism is undoubtedly clever, but they wonder if such uninterpretative simulations of reality can really be taken seriously as art. Yet this question, like many others raised by the movement, must ultimately be answered by each individual, since there is no proviso within the works themselves to prevent us from responding to the social implications, nor indeed to the beauty and poetry which we may find in them.

Ralph Goings (left)
Jeep, 1969, oil on
canvas, $43\frac{7}{8} \times 61\frac{7}{8}''$
(111·2 × 157cm)

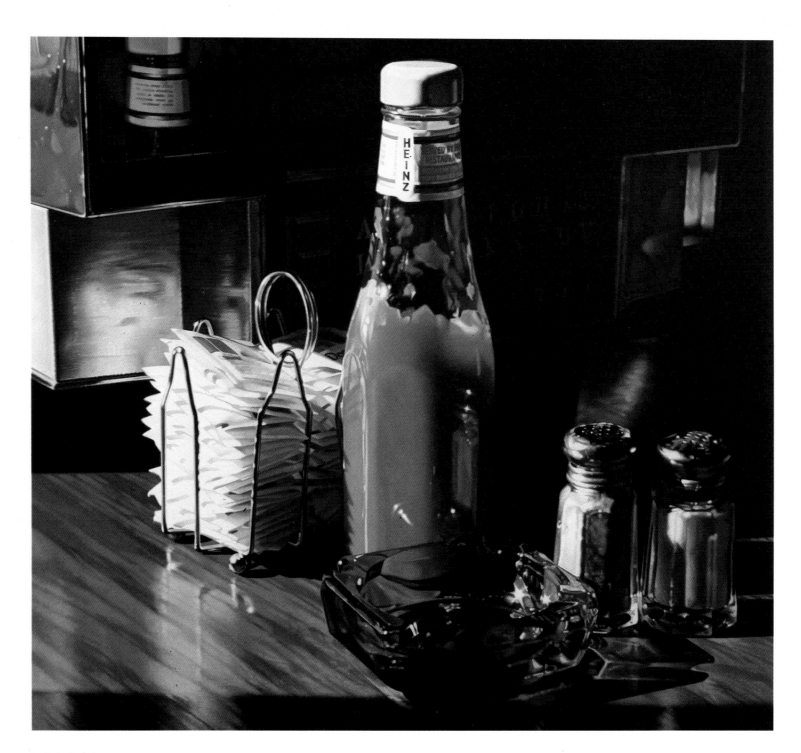

Ralph Goings
Still Life with Sugars, 1978, oil on canvas, 28 × 30″ (71 × 76cm)

ROOTS

Because of its illusionism, Superrealism has sometimes been seen as a return to pre-modernist attitudes: the re-emergence of the Western realist tradition after its temporary immersion under modernism during the twentieth century. Certainly many Superrealists have great admiration for past realists such as Vermeer and Ingres, but the artistic debt which they owe these old masters is almost non-existent. Superrealism is very much a product of the 1960s and a close look at the ideas and works of its artists show that its artistic roots are to be found in post-1945 art.

This is partly a question of subject matter: clearly Vermeer could not have painted a fast-food diner, but the differences also exist on a far deeper level. They involve the artists' ways of relating to reality and their understanding of the role of art; attitudes formed by modern concepts which have little in common with pre-twentieth-century art. This is why works with relatively dateless subject matter, such as the nudes of de Andrea or of Hilo Chen, still have a contemporary look.

Superrealism is not a cohesive movement, and the influences on individual artists obviously differ – as does the degree to which each artist has been affected by a particular movement. However, the ideas and early works of the group as a whole do follow a fairly clear pattern; and the artistic ideas which emerge as having been generally the most influential are Abstract Expressionism,

Pop, New Realism and Minimal art. It may seem surprising that, of these four, two are essentially abstract or non-figurative; but artistic influence goes beyond mere outward form and the impact of Abstract Expressionist and Minimalist attitudes can be seen to have shaped Superrealism even though visually the works are totally different.

Abstract Expressionism

The importance of Abstract Expressionism for the Superrealists lies primarily in the strength of their reaction against it. In many ways their work is a deliberate attempt to make art which is totally different, not only in the way it looks but in the way it is conceived and made. The Abstract Expressionists either lashed out at the canvas in a blind fury in an effort to exorcise their inner demons or painted colour fields intended to act as objects of meditation, invitations to the spectator's inner being. For some, the very act of painting was seen as the essential reality, so that the spectator was left with a record of the confrontation between painter and canvas. The critics, with Clement Greenberg at their helm, explained to a baffled audience what these pictures 'meant', how they were to be looked at, what was to be gained from them. We, the spectators, were taught to make certain demands from painting which we had never made before. In return we gained new experiences; tangible reality became only one of many realities, the fluidity of reality was made

evident, and we were encouraged to see art as a means of delving into our subconscious.

On a wider scale, similar ideas were shaping post-war attitudes. The emphasis on self-development and introspection of Abstract Expressionism was paralleled in the attitudes of the Beat generation. These survived into the 1960s when 'doing your own thing' became the catch-phrase which neatly summed it up. The major tenet of Abstract Expressionism was derived from 1920s Surrealism, namely that art could be a means of discovering – and so liberating – one's subconscious drives. Again, this was not limited to Fine Art: a look at a few American television situation comedies or films of the 1950s shows that no American was unaware of his own subconscious. You may not have been rich enough to have an analyst, but you had to be very dumb not to know about Freud and Co.

Abstract Expressionism revolutionized the art world, especially in America. The edicts of Greenberg became law. They shaped ideas on the nature and purpose of art for a whole generation of students in the 1950s and early 1960s, and formed the underlying fabric of aesthetic expectations: so that Abstract Expressionism became the recognized academic style, the basis upon which art was taught and judged. Art students spent much of their time developing colour sense, a feeling for surface, and above all what was generally referred to as 'handwriting', their own personal way of

applying paint to canvas. The kind of marks made were seen as the key to the artist's individual psyche. But for many students, including most future Superrealists, this was like acting out a charade; the work was done without real understanding of the issues involved, and an awareness of the mystical levels of reality or of subconscious drives. The feeling, the 'angst', which was the prerequisite for great Abstract Expressionist art, was missing.

It is easy to imagine how exciting it must have been for artists trained in this way to begin to feel their way towards the idea that art need not always be a matter of self-expression, of liberating repressed urges; that to be an artist does not necessarily mean to be possessed of an uncontrollable desire to express one's innermost being. For many, the simplest way to explore alternatives was to turn to realism. Because painterly realism was too close to the oppressor, meticulous realism was the answer: slow patient work instead of impulsive, dramatic action; neatness as opposed to sloppiness; tangible, visible reality in preference to the fluid, unspecific realities of the subconscious mind.

Part of this reaction stemmed from a desire to investigate taboo areas – a characteristic of modern art in general. By the 1950s realism had become the leper of the art world: Greenberg's aesthetics had exiled it as unworthy of serious critical attention. At best it was considered the province of anachronistic day-dreamers and of old-fashioned art professors, at worst the work of mere opportunists pandering to the lowest common denominator of public taste. The idea that serious, meaningful art could be highly realist seemed ludicrous. Yet for many future Superrealists Greenbergian aesthetics needed to be questioned. Why could artists not paint the world they saw around them? Why could they not work in a highly controlled manner? Why should intuitive mark-making be the only

serious form of painting? For the older Superrealists, some of whom had begun their careers as Abstract Expressionists, this questioning meant re-evaluating the very basis of their own work. For the younger artists, it was a matter of rejecting what they had learned at art school as a step towards evolving a mature style.

The impact of Abstract Expressionism has also left some positive marks on the Superrealists. They all tend to stress the individuality of their work; many still talk about 'handwriting'; and the large scale and emphasis on surface of many of their paintings is a bequest which Abstract Expressionism handed on to American painting in general. For the more intellectual among the Superrealists, the involvement with process can also be seen as a legacy. The notion that the activity of the creative act is as important as the final product underlies the works of Chuck Close and Malcolm Morley, as well as Don Eddy's recent work; while formal influences can be traced in the free brushwork which unexpectedly reveals itself when one looks closely at an original painting by Charles Bell, or John Salt. The expressionist current can also be felt to underly the works of a few Superrealists in the sense that they still view painting as a gut reaction to the world as they experience it. The angst of the Beat generation has not yet been completely eroded: it can be seen in the concern with morality displayed by Audrey Flack and Duane Hanson.

In essence, Abstract Expressionism's underlying pre-occupations conditioned the Superrealist's attitudes to their work, rather than affecting its outward appearance. A great many of them make frequent references to Abstract Expressionism when discussing their work. To a large extent it was the background from which they sought to escape, yet it has left more marks on them then they would like to admit.

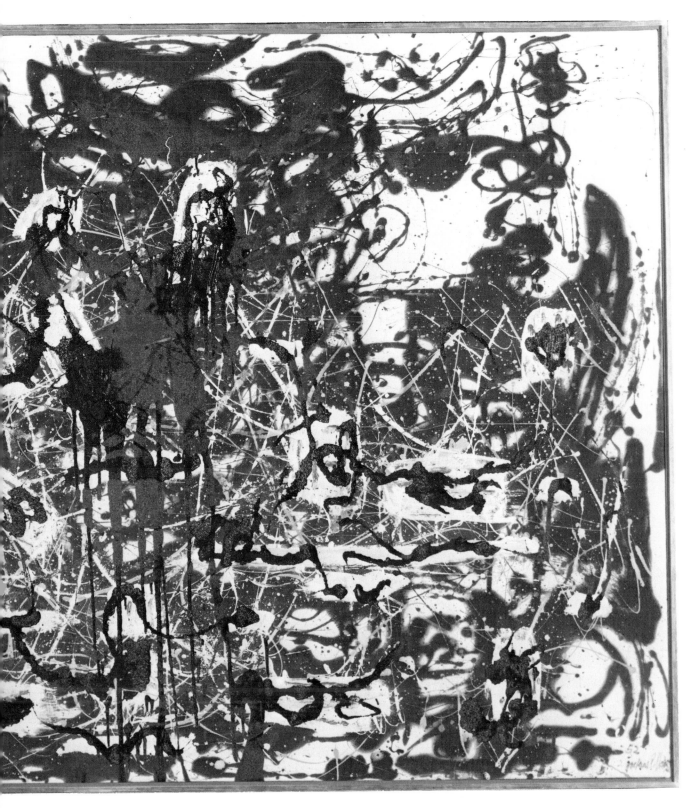

Jackson Pollock
Untitled (Yellow Island), 1952, oil on canvas, $56\frac{1}{2} \times 73''$ (144 × 185cm) Superrealism developed partly as a direct reaction against Abstract Expressionist paintings such as those of Pollock.

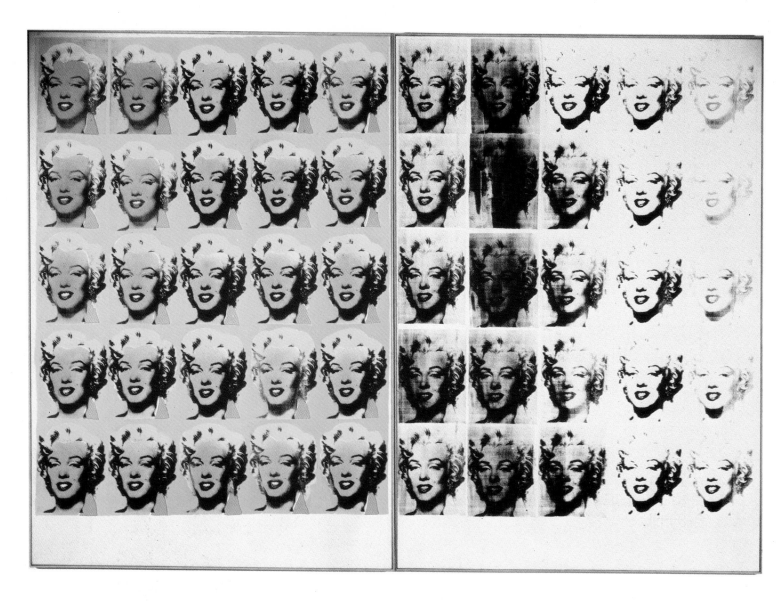

Andy Warhol (above)
Marilyn Monroe Diptych,
1962, oil on canvas,
(2 panels) 82 × 114″
(239 × 290cm)

Chuck Close (right)
Richard, 1969,
acrylic on canvas,
108 × 84″
(274 × 213cm)
(Reproduced here in
black and white, it is
actually one of
Close's black and
white paintings.)

The Pop artists'
approach towards
ready-made imagery
paved the way for the
Superrealists' use of
photographs as visual
sources. But whereas
Pop artists such as
Warhol usually
painted the
glamorous or famous,
the Superrealists
focus on the
anonymous or
unknown.

Pop art

If Abstract Expressionism was the father figure which Superrealism metaphorically killed, its mother was Pop art. It was the first movement to question the premises of Abstract Expressionism. Significantly, few Superrealists criticize Pop art, and none do so with the vehemence which they reserve for, say, action painting. They do, however, point out the differences between Pop art and their own work. Their common ground is such that some writers have seen Superrealism as a mere offshoot of Pop. Edward Lucie-Smith, for instance, referred to Malcolm Morley as 'second-generation Pop'.[1] Although the two movements undoubtedly share many attitudes, the differences between them are as illuminating as the similarities. But without Pop it is very unlikely that Superrealism would have evolved, and of all the movements which influenced it, Pop is the one to which it owes the most. For some artists it provided a climate which encouraged them to turn to realism, for others it was a phase in their own work from which they evolved their later style.

Pop art opened up the possibility of using figurative imagery in a manner which avoided the dying and bankrupt academicism of the provincial art class. The critical approval it received gave courage to painters such as Robert Bechtle who were feeling their way towards a viable return to realism in the early 1960s, but who have never painted Pop canvases. More importantly, Pop initiated the use of figuration in a dispassionate manner: painting the subject as it is, deadpan; and banished the idea that figurative painting must be the result of a confrontation between painter and subject, with the canvas as the stage for the drama. Cézanne's *petites sensations* became irrelevant – in fact they were consciously avoided.

The disregard with which Pop artists viewed modern art traditions established

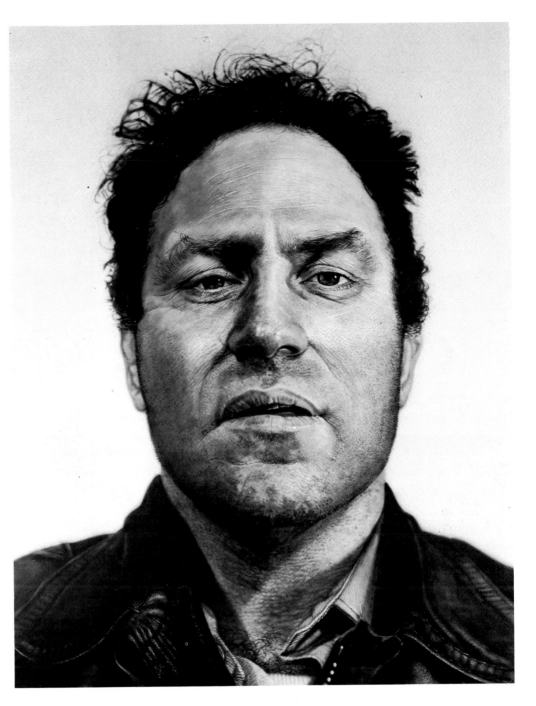

James Rosenquist
President Elect, 1960–61, oil on masonite, (3 panels), 84 × 144" (213 × 365cm) Unlike the Superrealists, Pop artists such as Rosenquist frequently juxtaposed disparate source imagery in one painting.

another important precedent for the Superrealists, since many of them turned towards painting from photographs precisely in order to escape the yoke of art-historical references. For the younger Superrealists the mood of the times could be found in Pop – it was an example to be followed. For the more mature artists it heralded a change in attitude which they were experiencing personally.

Possibly the greatest contribution which Pop made to Superrealism was its use of ready-made imagery, which pointed the way towards using photographs as a visual source. Taking a half-loving, half-mocking look at the biggest and best world created by the advertising moguls, Pop artists such as Jasper Johns and Andy Warhol incorporated this imagery into paintings. They were not simply returning to figuration in order to paint pictures about contemporary life, they were commenting on the stereotyped 'reality' perpetuated by the consumer society's attendant ad-men. Warhol, for example, did not paint still-lives of soup-cans; his subject matter was the Campbell's soup-can label.

Pop artists often adopted the techniques of the commercial artists, as well as their subject matter, in order to make their point. In his exploration of the comic strip, Roy Lichtenstein used Ben Day tints and manually reproduced the dots which are to be found in cheap colour printing. Other Pop artists adopted the use of the airbrush, which had been used by commercial artists since the 1930s as a means of reproducing and enhancing photo-derived images – for example to exaggerate the curves of Betty Grable's legs. Some found the opaque projector useful, again a device borrowed from the graphics studio. James Rosenquist earnestly reproduced the colour of black and white photography on canvas, so anticipating Chuck Close's black and white paintings.

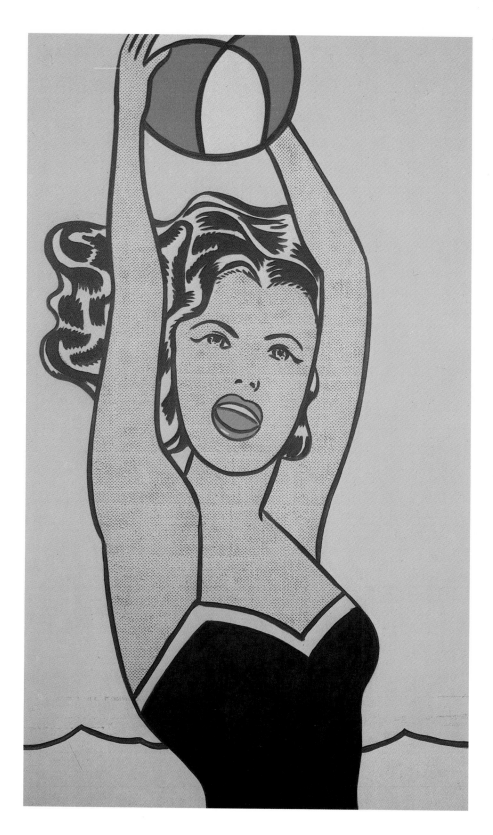

Roy Lichtenstein
(left) *Girl with Ball*,
1961, oil on canvas,
$60\frac{1}{2} \times 36\frac{1}{2}''$ (152 × 93cm)
(above) Newscutting
from which *Girl with Ball* was derived

However, comparisons between Pop art and Superrealism show that while Pop may have *appeared* to reproduce ready-made imagery, the way in which it did so was extremely contrived. Mass-media imagery was manipulated into a new aesthetic whole. The degree to which Pop artists transformed their source imagery is becoming increasingly apparent with the passing of time, now that the initial shock of seeing figuration and vulgar subject matter is gone. For example, Roy Lichtenstein's *Girl with Ball*, 1961, looks like an accurate transcript of a newspaper ad – the conventions of the original drawing are well observed – but compared to its source, the formal niceties of line and tonal contrast which occur in the painting are revealed to be the artist's: they are not present in the original news image. Often Pop painters isolated their

Robert Bechtle
(above) *Santa Barbara Motel*,
1977, oil on canvas,
48 × 69″ (122 × 175cm)
(left) Working slide
for *Santa Barbara
Motel*.

Comparison of the
way Lichtenstein and
Bechtle handle their
source imagery
reveals one of the
essential differences
between Pop and
Superrealism.

31

David Kessler
Jim, Weyman, Peter; end of roll vacation slide, from the 'Ruined Slide' painting series, 1976–7, airbrushed acrylic on canvas, 60 × 84" (152 × 213cm)
In his works on the 'Ruined Slide' theme, Kessler deals with the distortions created by photographic mistakes.

subject by placing it against a uniform background, where it floats *as* an image; the flatness of the picture plane continues to reign supreme, still true to Greenberg's aesthetics. Other Pop artists tapped the techniques of collage for its compositional freedom, juxtaposing disparate images and altering scales in order to make their point. Superrealists do neither of these things. They faithfully render the entire photograph in the interest of making an utterly convincing realistic image.

By far the most glaring difference between the two movements, however, is in subject-matter. Gone are the glamorous, in their place are the real: Marilyn and Elvis make way for Mum with kids in tow, an uncooked chicken replaces a sizzling hamburger. Pop artists painted famous people, or beautiful stereotypes found in the advertising world; the Superrealists paint the unknown, the anonymous, friends of the artist who look like everyman. Similarly, Pop depicted objects as glamorized consumer products. Isolated from their surroundings, seen as in a manufacturer's brochure, they are distant and unattainable, to be desired rather than possessed. Objects in Superrealist works may look shiny and new but they belong to the realm of the possible because they are shown in a context. A Bechtle car is in someone's driveway – we know it must belong to someone, so we can sense its reality. The Superrealist artists took heart from Pop's return to figuration but chose to paint the real world, not the world according to the ad-man.

Furthermore, the Superrealists depict their subjects with greater precision than Pop artists. Pop may have appeared objective when compared to the highly subjective approach of the Abstract Expressionists, but when compared to a classic Superrealist work the handling of form and paint in Pop works often looks emotive and 'messy'. This is especially

true of those works which contain an expressionist current, such as the tableaux of Edward Keinholz or the early plaster sculptures of Claes Oldenburg. (Pop was far from a homogeneous movement and artists as diverse as Keinholz and Warhol are included under its umbrella.) Although the majority of Superrealists willingly acknowledge their debt to Pop, they do criticize it on these grounds.

The Conceptual/Minimal aspects of Pop art are also more predominant now that the battle for figuration is no longer taking place. When Warhol produced his portraits of the famous, the implications of his works went beyond the mere fact that they were representational. The image was not his own, it was ready-made. Taking a leaf out of Duchamp's book he stressed that the creative act does not necessarily depend on manual skill. To emphasize this point he did not even carry out the work himself, but instructed assistants in his 'factory' to do it. The choice of colours, medium and subject were his, but the actual making of the image was not seen as the important part of the creative act. Neither were the techniques used for the making of the painting those of the traditional painter: he adopted the modern photo-mechanical techniques used by commercial printers. Thus his portraits of Marilyn Monroe are not traditional realist portraits – they are not Warhol's personal response to Marilyn, but paintings of official glamour shots of the star as seen by millions in movie magazines. The appeal is clearly as exciting for its conceptual overtones as it is for its purely visual content. These were the aspects of Pop art which opened the door to Minimal/Conceptual art and, by the same token, to those Superrealists who work from ready-made imagery and for whom process is all-important. And because they share the same roots Minimal art and Superrealism are also connected.

Minimal art

Though the visual links are non-existent, pure Superrealism has a great deal in common with Minimal art; so much so that in the Saatchi collection in London, which consists mainly of Minimal and Superrealist works, there is no clash even though the works hang side by side. Stepping over a shiny aluminium floor-piece by Carl André to take a close look at the silvery surface of a giant head by Chuck Close does not jar one's aesthetic senses. An Agnes Martin grid painting, discreet to the point of self-effacement, is not overpowered by a crudely coloured

ocean-liner painting by Malcolm Morley. It is difficult to account for this harmony since cold reason would lead us to suppose that the two kinds of art are total opposites. One is severely abstract, often geometric, the other is representational and highly detailed. But, in a sense, they are opposing poles of the same attitude: the central concept which unites them is a commitment to 'coolness'.

Both Minimal and Superrealist art are products of the same era – the 1960s – when the key word was coolness. The emotional outpourings of the Beat generation were replaced by a guarded,

self-contained and irreverent style. The word 'cool' was slang for all that was approved; it was cool to like the cheekiness of the Beatles or the anti-art bias of the Dadaists, it was uncool to like hot jazz or to show your emotions. Pop art had heralded the change in the Fine Arts, but it still had one foot in the emotional 1950s: with Minimalism and Superrealism coolness achieved its full expression.

The Superrealists seek to be non-emotive in their attitude to subject matter; they achieve this by working from reality at one remove. The Minimalists seek to eschew emotional

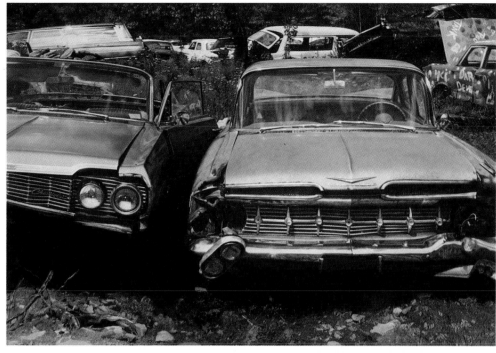

(Left) A view of the Saatchi collection, London, in which **Malcolm Morley's** Superrealist painting, *S.S. Rotterdam*, 1966, liquitex on canvas, 60 × 84″ (152 × 213cm), hangs beside **Agnes Martin's** Minimalist work *Drift of Summer*, 1965, pencil on canvas, 72 × 72″ (184 × 184cm). Surprisingly there is no visual quarrel between these two works because of the no-comment stance that they both take.

Don Judd (above) *Untitled*, 1967, galvanized iron, green lacquer on front and sides, 6 units out of 10, each 9 × 40 × 31″ (23 × 102 × 79cm)

John Salt (right) *Two Chevies in Wreck Yard*, 1976, oil on canvas, 38 × 57″ (97 × 145cm)

references as well, but do so by using geometric abstraction of such simplicity that it cannot remind us of anything but itself. Unlike earlier abstract art it makes no appeal to the spiritual or the subconscious. The Minimalist artist Frank Stella made this point when he said, 'My

painting is based on the fact that only what is seen there is there . . . All I want anyone to get out of my paintings and all I ever get out of them is the fact that you can see the whole idea without any confusion. What you see is what you see.'[2] This attitude is remarkably close to the photo-realists' desire to paint reality as it *is* rather than as the artist interprets it.

Minimalists achieved impassivity by using clear-cut, unambiguous forms and colours. Evidence of brushwork is ruthlessly repressed; this is art as the antithesis to the romantic notion of wild inspiration. The same approach is found in Superrealism – neat, careful and highly conscious work. Both result in paintings which neither impose the artist's sensibility on the spectator nor specify the response.

The Superrealists set out to depict the world around them without comment. For example, John Salt's car cemeteries are not intended as social or moral comments on the waste caused by built-in obsolescence – he paints them simply

because they exist. The Minimal artists have a similar aim in choosing shapes for their extreme simplicity. Both reflect the desire to produce works which do not depend on the relationship between their parts but exist as a whole, independent of outside references and modernist aesthetic considerations. The Superrealists' desire to avoid references to any earlier art was met by working from photographs; the Minimalists by evolving an abstract aesthetic which opposed that of previous Western abstraction. The work of Richard Artschwager illustrates the compatibility of the two movements. Well known for his abstract Minimalist sculpture, he also paints deadpan reproductions of unseductive newsprint images, and sees no conflict between the two. Since these paintings deal with information theory rather than with problems of *seeing* as such, they form part of his Conceptual/Minimal outlook, yet were an important influence on Malcolm Morley, a Superrealist.

Richard Artschwager
(left)
Apartment House, 1964, liquitex on celotex with formica frame, $70 \times 49\frac{1}{2} \times 6''$ ($179 \times 125\cdot7 \times 15\cdot2$cm) In his deadpan copy of news imagery, Artschwager comes very close to Superrealism, and yet he sees no conflict between this kind of work and his abstract Minimalist sculptures.

Both movements use traditional means, insofar as they are making permanent works on canvas or in three dimensions. Within the context of contemporary art this in itself serves to unite them, the realist/abstract polarity being replaced, to a certain extent, by the newer polarity of permanent/ephemeral work. But it is the firm resolve to paint non-interpretatively which most links the two movements.

It is important to bear in mind, however, that not all Superrealists are influenced by Minimalism, nor do they all share the commitment to 'coolness' which has been described. Artists such as Audrey Flack and Ralph Goings turned to realism because they were dissatisfied with abstraction *per se*; they are as hostile to Minimalism as to Abstract Expressionism. The succession of these two movements in the 1950s and 1960s — making it look as if abstraction was becoming the unchallenged dictator of the serious avant-garde — resulted in both movements being viewed with similar suspicion. For some Superrealists Minimalism was an enemy, a tyrant whose dictates must be opposed. For others, particularly the more intellectual, it served to establish the artistic mood which their work shared.

New Realism

Pop art was not the only realist revolt against Abstract Expressionism, though it was the most publicized one. Even before Pop emerged, artists such as Philip Pearlstein and Alex Colville had been painting realist pictures. Refusing to accept the ruling abstract aesthetic, they

Robert Bechtle
(above)
Watsonville Chairs,
1976, oil on canvas,
$48\frac{3}{4} \times 69\frac{3}{4}$"
(123·8 × 172·2cm)

Philip Pearlstein
(below)
*Two seated nudes on
yellow, blue and gray
drapes*, 1970, oil on
canvas, 72 × 60"
(184 × 152cm)

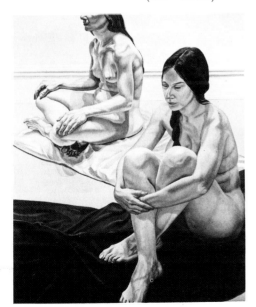

doggedly stuck to the idea that a painter's job is to depict tangible reality. Seemingly out of touch with, and little respected by, the avant-garde, they carried the banner of realism. For those Superrealists for whom Pop was either too slapdash or too concerned with glamour, these painters were important precursors.

Referred to loosely as New Realists, they have little in common apart from the fact that they *are* realists. Willard Midgette, himself a realist, summed up the position well: 'New Realism does not denote a group of painters linked by common attitudes (though sub-groups of this kind could easily be recognized if anyone were interested); it signifies an interval of attention by the art world. A 'New Realist' is simply one whose work was not widely known before the current interest in Realism.'[3] The relationship of these painters to the Superrealists is complex. While they influenced them, they also represent the kind of realism which the photo-realists are at pains to avoid. Superrealism itself was instrumental in revitalizing serious interest in realism, so helping the New Realists to achieve recognition. When photo-realist works began to emerge they were often confused with those of the New Realists, and exhibitions and books on the theme of 'New Realism' or 'Superrealism' indiscriminately included works from both groups. Essentially, what differentiates them is that the New Realists do not paint pictures of photographs.

The more traditional among the New Realists, painters such as John Koch and Alex Colville, work in a manner so exact and detailed that it recalls the accuracy of photographic imagery. In this sense their paintings were an example to Superrealists seeking a way out of abstraction, but neither of these two painters actually used photographs in their work, indeed they share the traditional academic outlook which strongly objects to the use of photographs. Comparison between their works and those of the photo-realists reveals the basic differences. They are carefully composed by the artist rather than being dependent on the randomness of information which is captured by the impartial camera lens. The way in which people and objects are depicted is dependent on human vision, with its ability to focus and re-focus at will. There is often a hint of narrative, or at least the creation of a definite mood in the paintings, as opposed to the deliberate impartiality of most Superrealist works.

Other New Realists such as Pearlstein, Alfred Leslie and Gabriel Ladermann paved the way for Superrealism by returning to unsentimental realism. Unlike the Pop artists, Pearlstein and Leslie avoided glamorous imagery and concentrated on 'reality' in the sense of being true to everyday life. During the 1950s and early 1960s they were courageous harbingers of precise realism

Howard Kanovitz (left)
The Painting Wall The Bucket Stool, 1968, polymer acrylic on canvas, 94 × 116 × 16" (240 × 295 × 41cm)

Lowell Nesbitt (right)
Boston Staircase '65, 1965, oil on canvas, 80 × 60" (204 × 152cm)
(Reproduced here in black and white)

Neither Kanovitz nor Nesbitt works in a truly Superrealist manner, yet their explorations of photographic illusionism helped to provide a framework for early Superrealism.

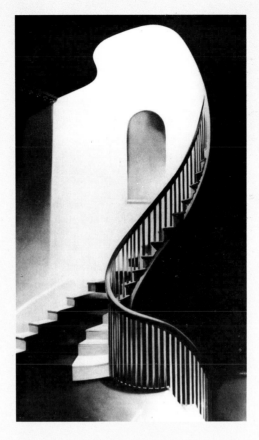

in an art world which would not hear of it. Though they too were concerned with the way the eye perceives things, their hostility to the use of photographs ultimately led to a rift with the Superrealists.

Of even greater importance were those realists who explored the use of photographs in paintings which are neither Pop nor Superrealist. Working at the same time as the pioneers of Superrealism, and in some cases prior to their first ventures, they shared enough common ground to be mutually influential. As early as 1963, Michelangelo Pistoletto was depicting illusionistic photo-derived figures on shiny stainless steel surfaces, while Howard Kanovitz began in the mid-1960s to explore various forms of illusionism, sometimes

combining *trompe l'oeil*, traditional realism and renderings from photographs in a single painting. Both aimed to comment on various forms of illusionism rather than on photographic vision as the Superrealists were to do. Other realists using photographs included Lowell Nesbitt, who worked in so sensuous and painterly a style that the final image was not reminiscent of the visual qualities of its source, and Alex Katz, who simplified and formalized the original photographic image to a degree which would not be permissible to a Superrealist. Harold Bruder's paintings retain some of the pictorial conventions of photography – arrested motion in the figures, and sharp tonal transitions as a means of defining form – but do not totally reflect the peculiarities of the photograph. His spatial and compositional organization is dependent on a Renaissance-derived approach which is essentially traditional. For these painters, the photograph was merely an element in their works rather than its *raison d'être*. (Audrey Flack recalls the mutual benefit which she and Bruder derived from each other's works in the early 1960s, though she also points out that he ceased to understand her when she began to paint pictures which faithfully rendered the entire photographic image.) Yet the willingness of some New Realists to explore certain aspects of photographic illusionism provided a framework within which the early Superrealists could articulate their own ideas. And the New Realists' concern with mundane reality created a viable alternative to the subject matter of Pop.

Before the late 1960s these painters could not be categorized within any artistic niche: they were seen as loners, at best on the fringes of Pop, at worst as quaint guardians of a dying academic tradition. When the work of the Superrealists emerged, that of the New

Realists was re-emphasized, and it began to look as if a swing towards realism was taking place: no longer a peripheral flutter of activity but a major field deserving serious critical attention. The outcome, in the shape of exhibitions and publications, was to herd the two groups together, regardless of their work's relationship to reality or to the photographic image. Though certainly useful in that it led to exposure for all the artists concerned, it tended to obscure the very real differences which exist between the two movements, as well as to conceal the debt which the Superrealists owe to these independent realists.

Other contemporary movements

Since the advent of Pop art, many artists have been coming to terms with 'reality' in different ways. Much of contemporary art is concerned with redefining art itself, in an effort to come to terms with the increasingly complex structures and technologies of an electronic age. Both the role of art and the form it takes have changed beyond recognition since the days when an artist's work consisted of either painting, drawing or sculpture. For example, Christo's *Running Fence*, 1976, deals with landscape, but rather than making art from this theme it modifies the landscape itself. A twenty-four and a half mile long nylon curtain was spread over the entire length of a valley, and a large part of the work consisted of the negotiations which the artist had with the various owners of the land across which his curtain stretched. Joseph Kosuth's *One and three chairs*, 1965, questioned reality by assembling a real chair, a photograph of the same chair, and a dictionary definition of the word 'chair'. Artists such as Victor Burgin have worked directly with modern photo-reproduction techniques to create mass-produced art in the form of cheaply available posters, while in the case of

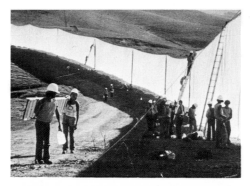

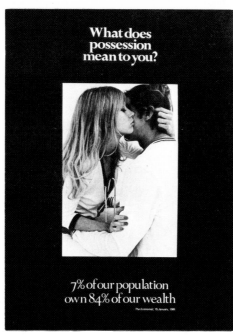

Christo (top)
Running Fence, 1976, diaphanous nylon fabric strung from 18ft (5·6m) steel poles across 24½ miles (39·5km) of California. It stayed up for 2 weeks.

Victor Burgin (centre)
Possession, 1976, poster, 46 × 33″ (119 × 84cm)

Joseph Kosuth (right)
One and three chairs, 1965, a wood folding chair, photograph of

chair and photographic enlargement of dictionary definition of chair

All three artists use photography as an element in their working process: Christo to record ephemeral land art, Burgin as a means of creating cheap mass-produced (poster) art, and Kosuth as an essential part of a complex conceptual art.

Performance art it is the artist him- or herself who becomes the work of art.

Surveys, diaries, films, video-tapes and posters are now all accepted as possible vehicles for artistic expression. For ephemeral works the documentation is usually photography. In their willingness to deal directly with tangible reality and in their use of photography the work of Conceptual, Land, and Performance artists shares common ground with Superrealism. But the similarities go no further: these artists seek a more direct way of dealing with reality, and view the mere *depiction* of reality in painting or sculpture as naïve or retrogressive. Unlike earlier forms of realism, therefore, the choice of becoming a Superrealist involves not only the desire to be true to the realities of life as he or she knows it, but also the deliberate decision to depict this reality in painting or sculpture.

It could be argued that the greatest influence on Superrealism is the changing face of reality itself. As Richard Estes put it, 'I couldn't do these pictures fifty years ago because none of this existed fifty years ago.'[4] Certainly Superrealism would not be what it is without the stainless steel and plate-glass shop façades, shiny motorbikes or fast-food diners which it depicts. But the artists' choice of such subjects, and their ways of dealing with them, have roots in other art movements.

Abstract Expressionism set the stage by providing a dogma against which the Superrealists reacted with controlled passion. Pop art gave them a language by legitimizing the use of photographs and other ready-made images as subject matter. The New Realists gave them moral courage by doggedly asserting that art could be realist without Pop's 'arty' or jokey overtones. The Minimalists created the cool climate in which Superrealism flourished and at the same time provided a contemporary abstraction against which the Superrealist could react.

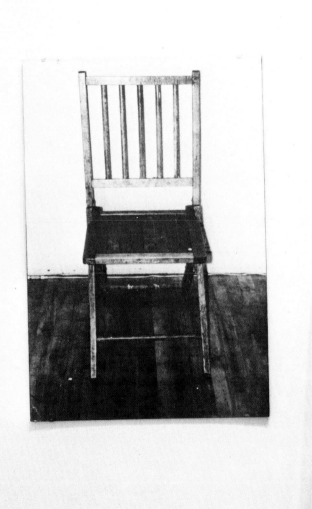

chair (châr), n. [OF. chaiere (F. chaire), < L. cathedra:
see cathedra.] A seat with a back, and often arms, usually
for one person; a seat of office or authority, or the office
itself; the person occupying the seat or office, esp. the chair-
man of a meeting; a sedan-chair; a chaise; a metal block
or clutch to support and secure a rail in a railroad.

PIONEERS

By 1965 Audrey Flack, Malcolm Morley and Robert Bechtle were working in a style which we now call Superrealist. Soon after, in 1967, Richard Estes began to paint his New York shop fronts while in the same year Chuck Close and John Salt commenced work on their first paintings of photographs. None of these pioneers consciously set out to create a new movement in art: each artist arrived at his or her manner of working independently of the others and for vastly differing reasons. Each had turned to the photograph to solve particular artistic problems but in so doing they unwittingly established the boundaries of the new style while their central concern with the world as seen through the lens, rather than the eye, unearthed an area so rich in artistic possibilities that by the end of the 1960s a host of other painters were investigating it, and Superrealism came into existence.

The early Superrealist work of Flack, Morley and Bechtle show their basic differences of approach. Flack turned to photographic realism because she felt that art should be readily accessible to the untrained eye; Morley was indifferent to the subject matter of his paintings – for him the photograph itself was the subject; while for Bechtle the photograph provided a way of being a realist while retaining emotional distance from his subject matter. Flack appeals to the heart, Morley to the mind, while Bechtle deliberately avoids programming any specific response into his work.

Malcolm Morley

The first to arrive at a truly mature Superrealist style, Morley was also the first to reject it. His career to date falls into three phases: he began as an abstract painter, developed to become a pioneer of Superrealism and then turned to his present highly personal form of semi-abstract representationalism. His seemingly abrupt about-turns in style stem from a central preoccupation –

Malcolm Morley
(left) *Central Park*, 1970, oil on canvas, 72 × 72″ (184 × 184cm)
(above) *Independence with Cote d'Azur*, 1965, acrylic on canvas, 40 × 50″ (102 × 127cm)

indeed his entire output so far consists of a dialogue about the nature of art and the making of images and paintings, and his Superreal works, painted between 1965 and 1970, were a phase in that dialogue. His is a sophisticated, art-world-orientated attitude, concerned above all with the perennial question, 'what is art?'

An expatriate Englishman now living in America, Morley studied art at Camberwell Art School in London during the first half of the 1950s. Rejecting the life-painting tradition of the school, and reserving judgement on Pop, which was emerging in London when he left in 1957, Morley's early works consisted of horizontal bands upon which he painted different kinds of marks. Influenced by Barnett Newman, the colour-field painter, these were paintings in which Morley questioned the validity of mark-making and which explored problems of pictorial surface. In common with other young Minimalists, his paintings aimed to establish the importance of the picture surface *as* surface and the paintings as objects, devoid of exterior associations.

In 1965, when Morley painted his first ocean liner in a sharp-focus realist style, what appeared to be a radical change in outlook was in fact a continuation of the Conceptual/Minimal preoccupations which had formed the basis of his abstract paintings. His aim was not to paint a picture of a ship, but to transfer the colours, shapes and textures which he found in a picture postcard onto canvas. He said at the time, 'I order the source photo by phone by describing the surface configuration such as "Send me up a four-colour print that has small multiple details in one part and a larger detail in another (like sky)".'[1] His main aim lay in making hand-painted copies of the machine-made, and to ensure that nothing would distract him from this basic concern, he evolved a highly structured method of translating the visual information from source image to canvas

Malcolm Morley (above) *Steamship*, 1966, oil on canvas, 28 × 40" (71 × 102cm)

(right) Detail of *Steamship* (Reproduced actual size)

which was close to Minimal art but which also recalls the ritual and magic of a private game. He squared up his canvas and source image, sometimes cutting up the latter into its constituent rectangles, and painted the subject upside down, with the canvas covered up apart from the particular rectangle on which he was working. All that mattered was the process of carefully matching shapes and colours, since he took pains to avoid knowing what these represented while he was painting them. He was in fact continuing to explore the different kinds of marks which can be made on canvas, yet paradoxically the resultant painting was a highly illusionistic, truly super-real image. Morley stressed the all-important role which he allocated to *process* by making his procedure known, and on one occasion by painting part of a work in public as a self-chosen alternative to talking about his work.

Unlike the Pop painters, Morley was not concerned with the symbolic

properties of his subject. 'I have no interest in subject matter as such, or satire, or social comment, or anything else lumped together with subject matter... There is only Abstract painting, I want works to be disguised as something else (photos) mainly for protection against 'art man-handlers".'[2] His aim was to comment on the nature of mechanically reproduced images *as* images rather than for their particular subject. *Independence with Côte d'Azure*, 1965, illustrates this point. It recalls not so much a ship at sea as a picture postcard of one. The white border with which Morley surrounds the central image acts as a flattening device, and we are led to read the whole painting as two-dimensional, so reflecting the flatness of

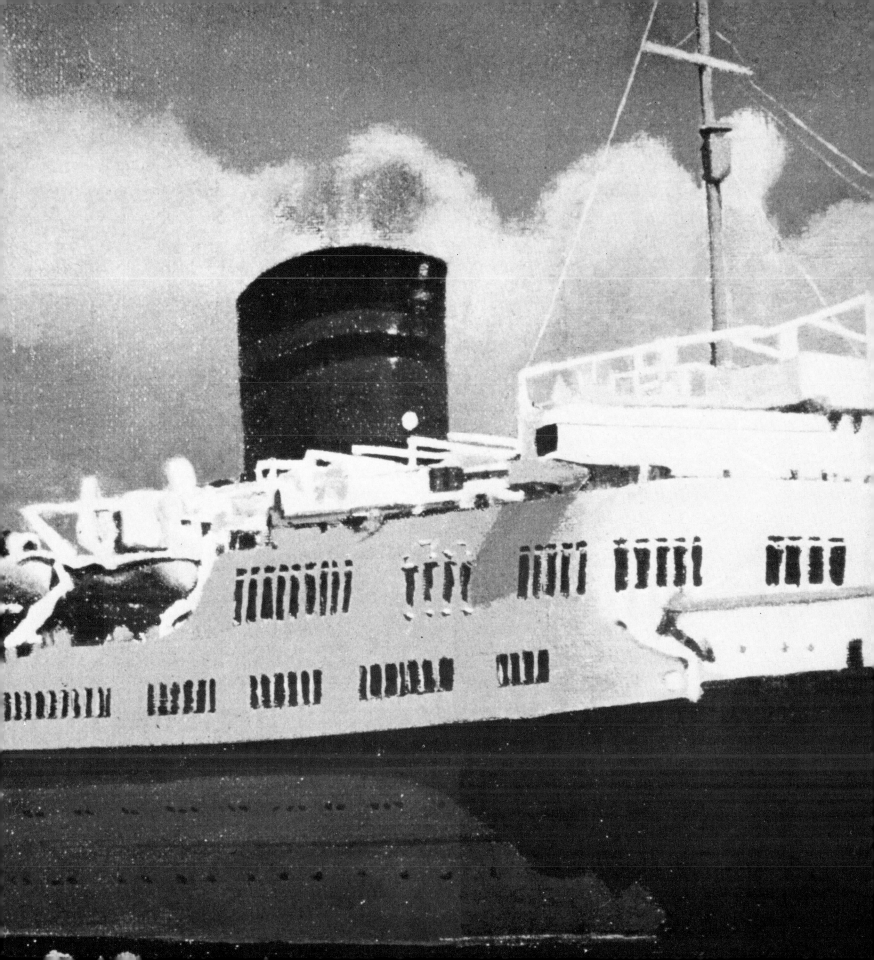

the source photograph, while the trite composition and crude colour so faithfully rendered are clearly derived from the pictorial convention of the postcard. Similarly, his paintings from reproductions of old masters, which depart from the size of both the reproduction and the original painting, emphasize the elasticity of scale which is the hallmark of colour reproduction: rather than heightening our awareness of Vermeer or Raphael, these paintings point to the gulf which exists between first-hand experience of paintings and that of looking at reproductions.

The true subjects of Morley's Superrealist paintings are the peculiarities of the technologically-produced image. The paintings investigate a variety of these images, not classifiable by subject, but by their particular technical origins: for example, the Kodachrome snapshot (*Central Park*, 1970). Other works were based on the ten-cent postcard, the colour reproduction, the retouched photograph to be found in travel brochures. His earnest rendering of these images on canvas explored the surface textures, colour distortion and pictorial conventions of such mundane images and by elevating them to the status of 'Art' he also raised questions about art itself and its place in a society already flooded with images of all kinds. As he explained, 'It was like making art that couldn't be reproduced because it goes back to the source it came from.'[3]

Morley's Superreal canvases are

south africa

Greyville Race Course – Durban, South Africa

Malcolm Morley
(left) *S.S. Rotterdam*, 1966, liquitex on canvas, 60 × 84″ (152 × 213cm)
(above) *Race Track*, 1970, acrylic on canvas, 68 × 86″ (173 × 218cm)
'I have no interest in subject matter as such, or satire, or social comment . . .'
(Malcolm Morley, 1969)

comments on the disparity between a painter's palette and the uniform colour and texture of mass-produced prints. When seen close to, the paintings are surprisingly tactile; the texture of the paint varies from area to area and the colour is far more complex than that of the source imagery. Morley's post-1970 works show an increasing pre-occupation with surface texture, to the point where the illusion of reality is no longer retained. But even these works were still painted from pre-existing imagery. The turning

point was *Race Track*, 1970, a meticulously rendered image upon which he painted a large expressionist cross, thus deliberately destroying the illusion which he had so carefully created. Since then the surface textures of his paintings have grown increasingly lively with thickly impastoed paint to the point where the source image becomes difficult to identify. His Superreal works had questioned the possibility of being a realist painter in an age of mass-produced images; his recent work indicates that, for him, the answer is 'no'.

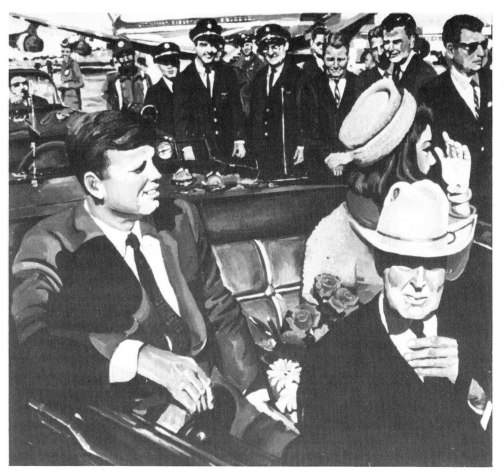

Audrey Flack
(above) *Kennedy Motorcade, November 22, 1963*, 1963–4, oil on canvas, 96 × 70″ (244 × 178cm) (right) Audrey Flack in front of her painting *Marilyn*.

Audrey Flack

Morley's distrust of illusionism meant that he had to kill it; for Flack the photo-derived canvases of the early 1960s were only a beginning. *Kennedy Motorcade, November 22, 1963*, 1963–4 was, like Morley's paintings, based on a pre-existing image. But for Flack the choice of subject was crucial. The Kennedy motorcade, five minutes before the President's assassination, was topical and emotive; her concern was to communicate its importance, and she retained the conventions of the news photograph because she felt that the veracity and immediacy of photo-reportage imagery would have more impact on modern sensibility than elaborate studio reconstructions. Yet she did not retain all the peculiarities of the source image: the brushwork was broad and sweeping, and she dispensed with the texture and 'fuzziness' of the original because it would detract from her main concern: the subject matter. She has continued using a realist style because she has faith in its validity as a means of making art accessible: 'Art is for people, I mean, if art isn't for people who is it for? And that is what is important about Superrealism.'[4] Her use of the photograph in the early 1960s was as an expedient, a means of obtaining information about her required subject. Her work then evolved to become a serious exploration of the complexities of photo-vision, while in her recent work she uses photo-realism as a language with which to convey statements rich in symbolic meaning. An exception among Superrealists, she has always stressed the importance of subject matter, and refutes the belief that Superrealism is a cool and impersonal style.

A native New Yorker, Flack trained as a painter at Cooper Union and Yale in the late 1940s and early 1950s. Torn between her instinctive desire to be a realist and the pull of the current avant-garde style, her move towards realism was gradual and fraught with difficulties. In the early 1950s she painted Abstract Expressionist canvases but also drew from the old masters – her twin heroes were Jackson Pollock and Bouguereau. Her early realist works were loose and expressionist; later she became closely aligned with New Realists such as Pearlstein and Bruder, some of whom were also experimenting with working from photographs. However, while they were not willing to let this be more than a point of departure, she became increasingly involved with accepting the distortions of photographic vision and allowing these to become part of her paintings. By 1964 she had produced *Kennedy Motorcade . . .* and other works unashamedly painted from photographs.

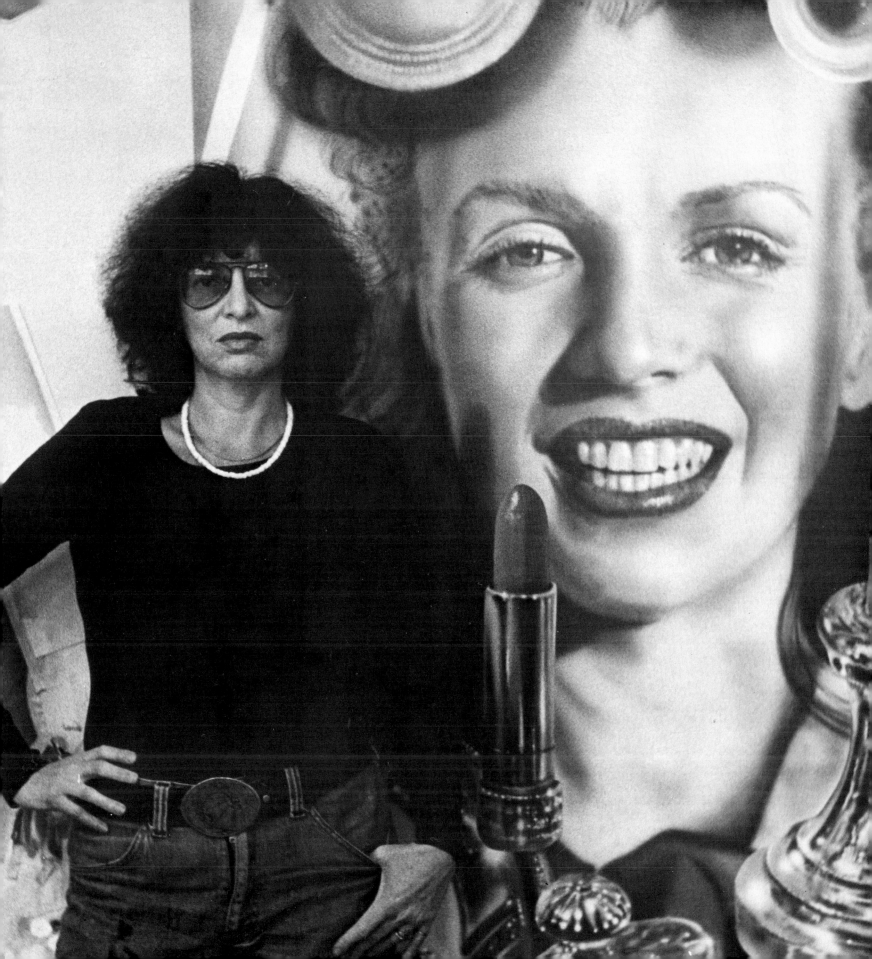

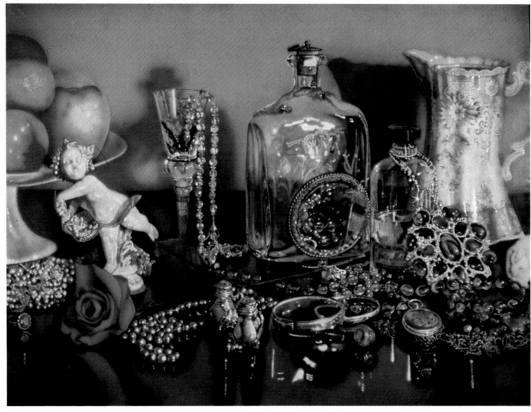

Audrey Flack
(above right) *Jolie Madame*, 1973, oil on canvas, 71 × 96″ (180 × 244cm)
(above) Working slide for *Jolie Madame*
(below) *Dolores*, 1971, oil and acrylic on canvas, 96 × 96″ (244 × 244cm)
(far right) *Marilyn*, 1977, oil and acrylic on canvas, 96 × 96″ (244 × 244cm)

Photography had a two-fold effect on Flack's work: she became increasingly aware of the formal qualities of photo-vision and also of the extent to which such vision influences modern perception. '(Photography is) . . . my whole life, I studied art history, it was always photographs, I never saw the paintings, they were in Europe . . . Look at TV and at magazines and reproductions, they're all influenced by photo-vision . . .'.[5] At the end of the 1960s she began a series of paintings which dealt directly with art, illusion and photography. In works such as *Dolores*, 1971, she explored the visual effects found in colour transparencies, the main vehicles of visual information about art. Dispensing with squaring up, the traditional means of transferring information from small to large, she adopted the techniques of photography itself, projecting slides onto the canvas in

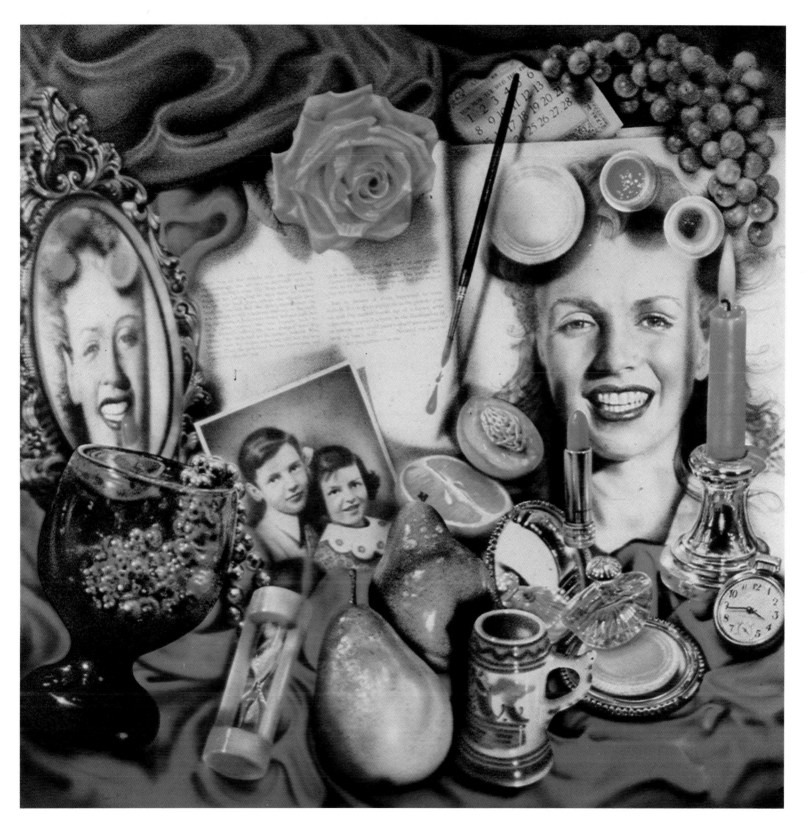

Audrey Flack
Leonardo's Lady,
1975, oil over
acrylic on canvas,
74 × 80″ (188 × 204cm)

order to remain close to the qualities of the original image. In 1971 she began to use a spray-gun for applying colour, thus eliminating the 'handwriting' of brush-marks. The resultant works, often on a large scale, embody the visual characteristics of colour transparencies. In *Dolores*, for instance, the colours reflect the lurid brightness of Kodachrome film when projected by a beam of yellow light onto a white screen. The fuzziness of out-of-focus areas, such as those on the outer edges of the madonna's headdress, is rendered so that seen close to these parts of the painting look like Abstract Expressionist explosions of colour. The outlines, where one shape meets another, are meetings of edges, not hard hand-drawn lines, reminding us that the camera has no pencil and can only register changes of tone and colour. This period, *c.*1969–72, was the time Flack's work came closest to Morley's; like him she was exploring the pictorial properties of mass-imagery, painting pictures of pictures, rather than using photographs as a mere source.

Working on these paintings had revealed to Flack the richness and variety of photo-vision. No longer satisfied with commenting on its effects on art or on existing imagery, she began to use her discoveries as a pictorial language with which to make personal statements. She became a modern still-life painter. In paintings such as *Jolie Madame*, 1973, she worked from her own photographs of the things she likes: jewellery and make-up, precious metals and ripe fruit, shiny reflective surfaces. These works deal with the human desire for luxury and adornment: 'Whether you're putting on mudcake or lipstick from Bloomingdale's, it's all part of a very human instinct and it's very important that it be seen . . .'[6] – but they also deal with visual perception. Having become an accomplished photographer herself, she delights in the rich possibilities offered by photo-vision,

playing on contrasts between sharp and soft focus, and exploring the ambiguities of space and scale which occur as the slide image is being transcribed onto canvas. In *Jolie Madame*, background objects like the fruit bowl appear to be thrown up onto the picture plane while others, such as the leaf and the decanter, seem to float in pictorial space. The lack of focal point together with the large scale of the work encourage an all-over reading of the canvas: the effect is profoundly different from traditional perspectival illusionism. As Flack says, 'My still-life painting opened up a whole new vision of seeing. I remember going to Europe and being very shocked at how dull the work looked compared to the reproductions [in art books] and I thought I never want that to happen to my work.'[7]

From 1976–8 Flack worked on three giant eight foot (244cm) square canvases, in which she united all her earlier preoccupations and developed the latent symbolism of her 1972–6 paintings. Collectively known as the *Vanitas* paintings to acknowledge the seventeenth-century still-life tradition which inspired them, she chose objects which symbolize universal concerns to convey moral messages. One work deals with war, another with fate and fortune, while *Marilyn*, 1977, focuses on human tragedy. Flack chose Marilyn Monroe because she feels that people identify with her, that her tragic life and her survival in public memory are symbolic: 'I think all three paintings are a protest. They are saying fight back . . .'[8] Flack uses universally understood symbols – a candle, a watch, an egg-timer stand for time, fruit and flowers suggest the ephemerality of living things. She does so because she seeks to make the subject matter as well as the style of her work accessible to all. Flack has turned photo-realism into a language with which she conveys meaning; her work is a brave effort to take art out of its ivory tower.

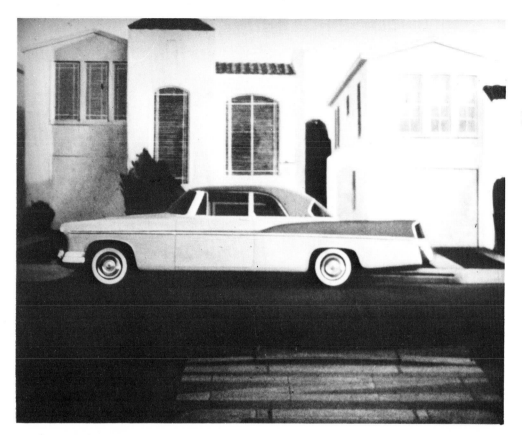

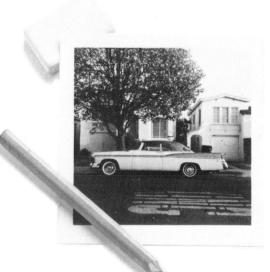

Robert Bechtle
(left) '56 *Chrysler*,
1965, oil on canvas,
36 × 40" (91 × 102cm)
(above) The working
Polaroid print for '56
Chrysler

Bechtle's early
Superrealist works
were not concerned
with the subtleties of
photographic effect –
if a detail bored him,
he omitted it.

Robert Bechtle

For Bechtle, photo-realism is a means of
ensuring that his paintings will remain
neutral. Of the three originators of the
style he is the most typically Superrealist,
both in his commitment to coolness and in
his subject matter which is centred
around suburban American life and chosen
deliberately for its lack of universal
association or meaning. Though his works
do not conform to previous realist norms
his approach to painting is traditional; he
does not set out to redefine the role of art.
His main concern is with setting himself
fresh aesthetic problems in order to
create original paintings.

A West Coast artist, Bechtle's art
school works in the 1950s were influenced
by Diebenkorn's brand of Abstract
Expressionism which stressed the
properties of paint as paint but did not

totally reject representation. Bechtle
reacted against this and turned to working
from the photograph, largely as a means of
finding painting problems which had few
precedents. It was a way of
approaching reality with fresh eyes, free
from the shadow of art history. '56
Chrysler, 1965, for example, with its sleek
car proudly parked outside neat suburban
villas, is a simple record of modern life, yet
depictions of people's homes has a
tradition in Western art which stretches
back to eighteenth-century country house
painting and beyond. By painting his
subject from an artless photograph
Bechtle freed himself from memories of
previous solutions to similar subjects and
by the same token discovered new formal
problems.

Since those early days Bechtle's artistic
development has undergone no dramatic

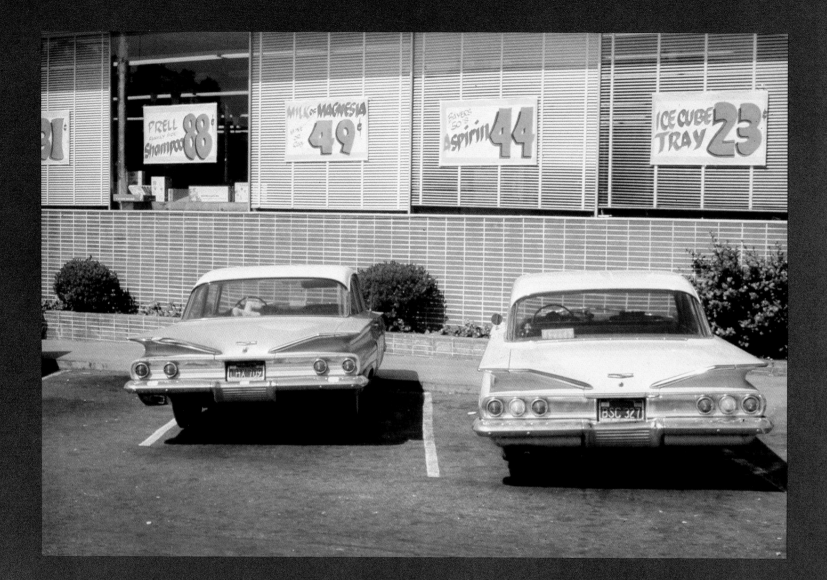

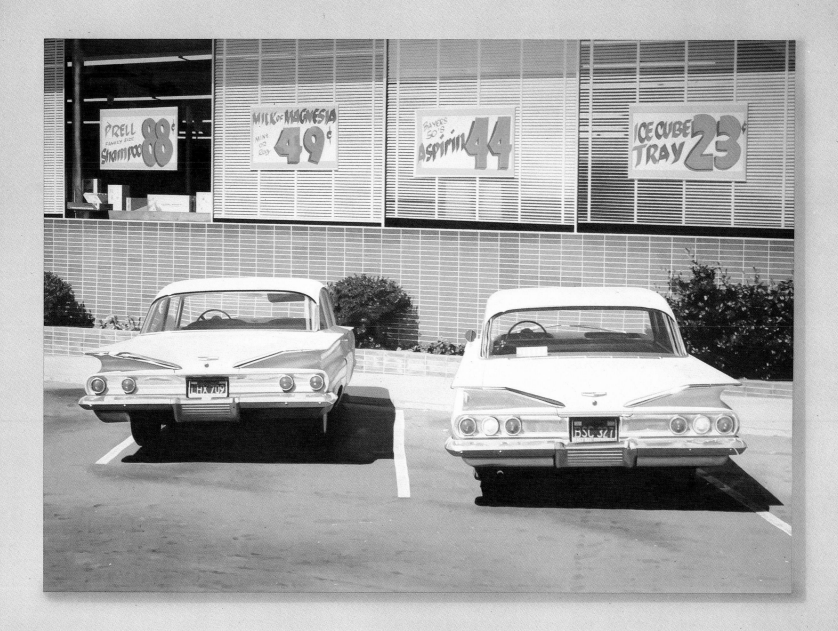

changes of direction, but those which have occurred have been engendered by his use of photographs. Like Flack, he has become increasingly sensitive to the characteristics of photo-vision: his works from c.1969 are more 'photographic' – textures are rendered with greater precision and composition becomes more dependent on the pictorial conventions of photography. His early works, c.1965–9,

were not concerned with the subtleties of photographic effect – if a detail bored him he omitted it – so that compared to a mature painting such as '60s Chevies, 1971, with its subtle changes of colour and tone, the earlier work appears crude and generalized. In more recent works Bechtle has shown his ability to extract visual richness from potentially uninteresting source photographs or

Robert Bechtle
(above) '60s Chevies, 1971, oil on canvas, 45 × 63" (114 × 160cm) (left) a projection of Bechtle's working slide for '60s Chevies

Bechtle's aim is to portray the world exactly as it is rather than as he interprets it. 'It's just a record of the thing'. (Robert Bechtle, 1972)

slides. For example, space flattened by the camera lens in *Agua Caliente Nova*, 1975, leads to a juxtaposition of rock, land and sky on the same plane, and the wide expanse of road, which has little intrinsic attraction as tarmac, becomes fascinating as a shape within the painting.

Yet Bechtle's aims since 1965 have been consistent: to portray the world as it is rather than as he interprets it. The photograph acts as an intermediary between subject and artist, and allows him to avoid the intuitive responses which painting from life would engender.

Although he takes his own photographs, Bechtle takes pains to keep these impartial too: 'When I'm photographing a car in front of a house I try to keep in mind what a real-estate photographer would do and try for that quality. It's just a record of the thing.'[9] He achieves neutrality by working from photographs which depict the subjects according to the way they would depict themselves; real-estate shots for views of houses, snapshots for paintings of family outings. He is fully aware of the issues raised by his subjects, but presents them impartially so as not to

colour the viewer's own response to them. 'I am certainly aware of the social implications of the subjects. I can identify with my subject matter in a sense – I like it and I hate it . . . It deals with a very middle-class life-style . . . Yet . . . I try to preserve a kind of neutrality which doesn't tell the viewer what to think about all this . . . It's up to the viewer to make his own response.'[10]

Bechtle's self-chosen coolness also enables him to become involved with the act of seeing *as* seeing, regardless of aesthetic or social preconceptions about his subject matter. For instance, during

the late 1960s and early 1970s synthetic materials such as Formica were looked upon as necessary evils – sensible, but not as beautiful, as natural ones such as wood. By refusing to make such value judgements, Bechtle was able to discover visual beauty in hitherto despised materials and objects: in the gleaming wipe-down surfaces of fast-food diners, or the formal organization of a seemingly characterless supermarket. Depictions of space, colour, shapes and textures are his concern. His unprejudiced eye enables him to extract exciting shapes and compositions from the humble family snap while freeing him to look at every aspect of his subject with equal intensity – whether it be a tree, a car, or the Californian sky. Concentrating his energy on the visual qualities of his subject, he reveals the unexpected beauty which is to be found in the mundane.

By using non-emotive subjects as depicted in uncontrived source photographs, and by keeping his draughtsmanship and brushwork as anonymous as possible, Bechtle wins an impartiality for his paintings which paradoxically throws us, the viewers, back on our own resources. We have no choice but to respond. Because the painter leaves us no clues as to how to interpret his subject matter we are forced to come to terms with our own views on its inherent meaning. Bechtle's paintings underline the essentially modern concept that we each have our own reality.

Flack, Bechtle and Morley are undoubtedly the original pioneers of Superrealist painting, yet while their early works in the style were still unknown to the outside world, three other painters were also moving in a similar direction. Richard Estes, John Salt and Chuck Close are included in this chapter because they emerged as mature Superrealists early enough to have been as great an influence on the movement as the original trio.

Close and Estes are often singled out among Superrealists because they stand for the two extremes of the style. To those who have little sympathy with realism, Close's work has the saving grace of being prompted by Minimal/Conceptual ideas, while Estes is praised by those who value the return to realism for its ability to wrest poetic beauty from everyday surroundings. The critic Gerritt Henry, for instance, felt that 'photo-realist greatness belongs primarily to painter Richard Estes . . . If Chuck Close with his sub-standard human faces is the negative example of the genre, then Estes . . . is the positive . . . Estes alone among the Superrealists records in his peopleless cityscapes an ''atmosphere'' that is really there.'[11] Conversely, Barbara Rose, historian of modern American art, rejected the whole photo-realist movement on the grounds that it was 'academic in the worst sense' but felt that Close was 'the best of the worst' because he at least had an 'equivocal relationship with modernism.'[12]

Robert Bechtle
(left) *Agua Caliente, Nova*, 1975, oil on canvas, 48 × 69″ (122 × 175cm) (above) *Berkeley Stucco*, 1977, oil on canvas, 48¾ × 69½″ (123·8 × 175·6cm)

'I am certainly aware of the social implications of the subjects . . . Yet . . . I try to preserve a kind of neutrality which doesn't tell the viewer what to think . . .' (Robert Bechtle. 1972)

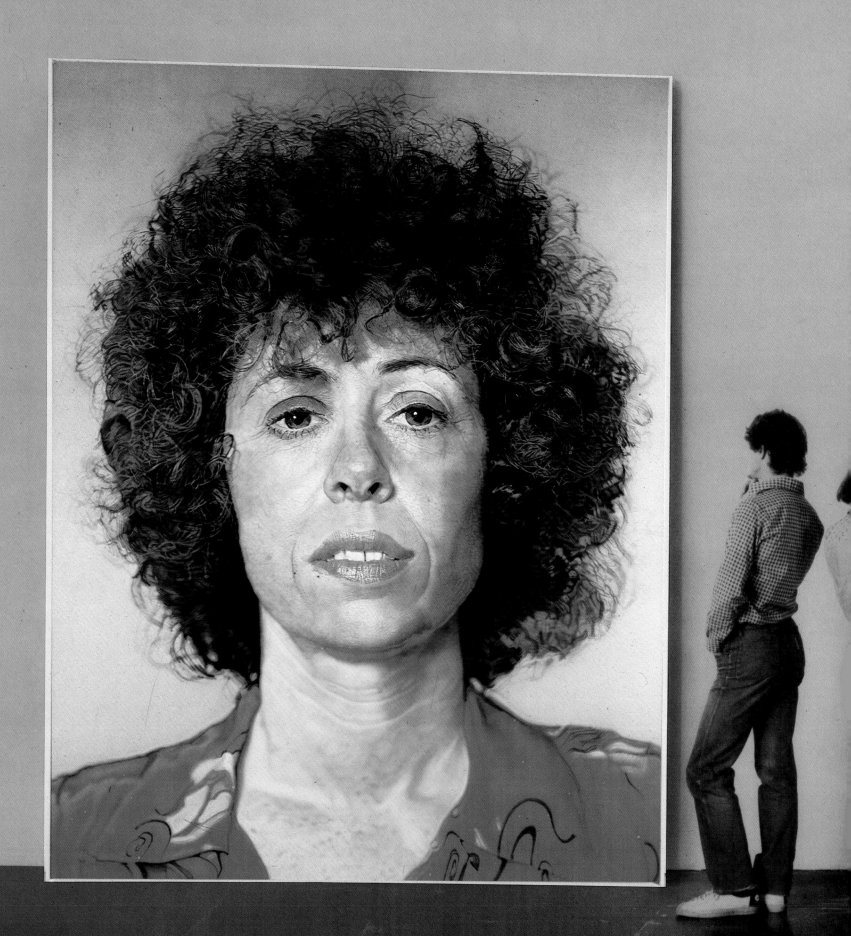

Chuck Close

(left) *Linda no. 6646*, 1975–6, acrylic on canvas, 108 × 84″ (274 × 213cm) Close's very large works are rarely seen as a whole; rather, viewers find themselves focusing on the changing textures or colours on the work's surface.

(below) *Nat, Horizontal, Vertical Diagonal*, 1973, watercolour on paper, 30 × 22½″ (76 × 57·2cm) Close's subject matter for both his large and small paintings is strictly limited to photographs of his friends.

Chuck Close

Close's relationship to modernism is indeed the key to an understanding of his work. He feels that he has little in common with other Superrealists because for him realism, rather than being an end in itself, is the by-product of an intellectually-based, systematic approach to painting which is closer to Minimalist concepts of 'thereness': recalling Frank Stella's dictum, 'what you see is what you see.'[13] Like the Minimalists, his decision to work in such a way was rooted in his reaction against art school days dominated by Abstract Expressionist dogma. To escape from the self-indulgence which the very freedom of Abstract Expressionism can engender, he devised a set of restrictions within which to work, rather as a composer might decide to keep an entire piece of music within the same key. The decision to work from photographs was just one of these, 'not because that's what I wanted my art to be about, but because no matter how interesting a shape was, if it wasn't in the photograph I couldn't use it.'[14]

He began to work in this way in 1967/8 and the development of his work since then has been centred around the changes of restrictions he set himself. At first, in paintings such as *Richard*, 1969, he worked exclusively from black and white photographs, always on the same gigantic scale, nine foot by seven foot (274 × 213cm), and with the further restriction of using only two tablespoonfuls of black pigment for each painting (although he has since admitted that he was not averse to bending this rule a little if it permitted him to finish a painting!) Having exhausted this procedure, he turned in 1971 to colour photography for his source. This time limiting himself to the three colours used by industrial printers, he built up his paintings colour-layer by colour-layer, in a manner comparable to that used in the dye-transfer printing process. Since 1972 he has investigated various ways of retaining evidence of process in the final work. In some paintings the grid is left showing, others retain a reference to the number of squares used in their title, such as *Linda no. 6646*, 1975–6, while some works expose the colour layer process: *Nat, Horizontal, Vertical, Diagonal*, 1973, is divided into four sections, one of which shows all three colours superimposed while each of the remaining areas is

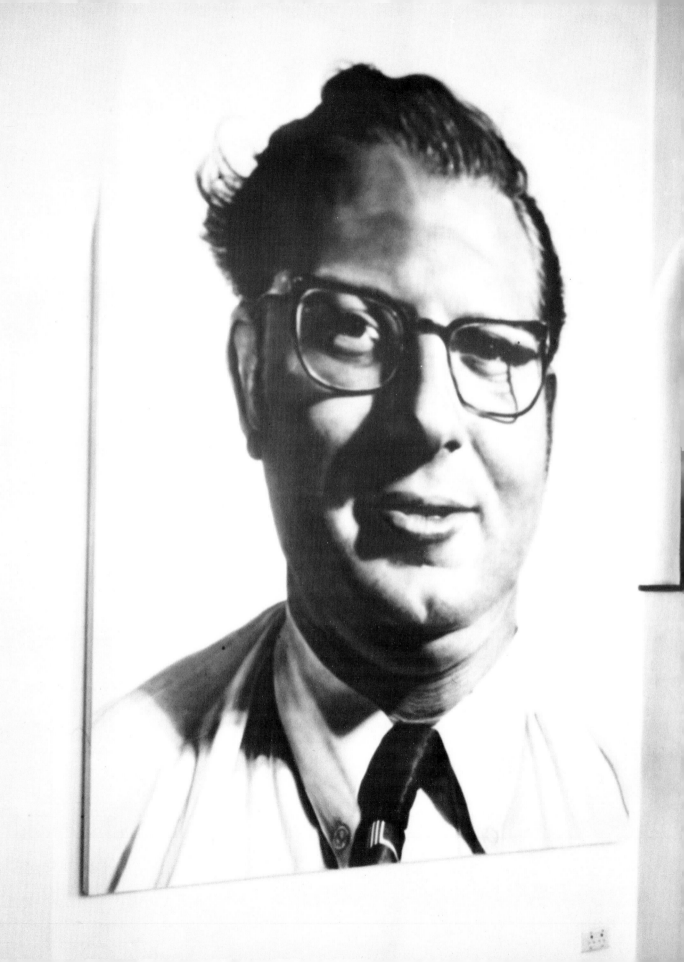

Chuck Close
(left) *Joe*, 1969,
acrylic on canvas,
108 × 84″ (274 × 213cm),
photographed *in situ*
in the Saatchi
collection, London.
(right) *Linda Pastel*,
1977, pastel on paper,
$29\frac{3}{4} \times 22\frac{1}{8}$″
(75·6 × 56·2cm)

Close continues to
use the same
photographs for some
of his later works. His
outlook is still
Conceptual but his
working process is
changing direction.

painted in only one of the three colours. Other experiments have consisted of exploring various ways of mark-making, as in his thumb-print drawings; using a standard size of paper but altering the size of the image rendered on it; and, using an 'unlimited' range of pastels with which to match the colours of a standard colour print.

The subjects of Close's works are invariably photographs of anonymous people, indeed, he refuses to undertake commissioned portraits or to paint the famous. Deliberately avoiding artful composition, flattering lighting effects or lively facial expression, he photographs his own friends in a deadpan, undramatic manner, aiming merely to record information about the visible appearance of the subject. He does not seek to use them as a basis for portrait paintings, perceptive psychological studies of his sitters' characters; his concern is with the problem of rendering precise visual information from photograph to canvas. His choice of subject is conditioned by this: 'If I were painting a tree, and if it were a little too green or too red, no one but a botanist would know or care. I wanted to paint something that people cared about – a face contains specific information that people can sense is either right or wrong. That keeps me on my toes . . .'[15]

Close aims to encourage a response based on the formal properties of the works rather than on the personalities of the people they portray. The large paintings such as *Richard* have a presence as paintings which no reproduction can hope to convey. Because of the scale of the work we rarely see its iconography as a whole, unless we stand very far back. At normal viewing distance our experience of the painting changes; our eyes reach only half-way up, we focus now on a nostril, now on the carefully rendered stubble on the chin. Panning over the painting like an insect crawling over it, we are aware above all of changing textures and of the

'colour' of black and white photography with its myriad of greys. In *Linda no. 6646* and other large colour paintings, layers of superimposed colour are experienced for their own sake: hair, for example, is made of eddies and swirls which ensnare the eye in abstract patterns. The surface of the paintings becomes all-important. Because the subjects are flat photographs there is no suggestion in them of traditional spatial illusion, while the artist's diligence in rendering the surface qualities of the source image reminds us that the illusionism of photography is nothing but a visual code of differing shapes, tones and colours. As Close points out: 'It's not even a painting of a person as much as it is the distribution of paint on a flat surface . . .'[16]

When in the presence of one of Close's works we do not find ourselves wondering about the artist's apparently impersonal attitude to his subjects or his tendency to portray people as if they were criminals on a police file. We are aware, above all, of the painting which, by its sheer scale and impassive content, simply exists as an object, defying reference to anything outside itself.

Chuck Close
(right) *John*, 1971–2,
acrylic on canvas,
100 × 90″ (254 × 229cm
(left) Photographs
showing the
successive stages of
work on *John*

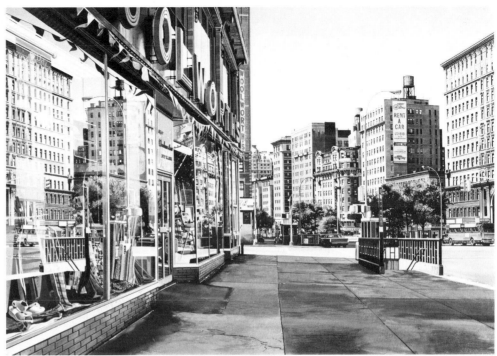

Richard Estes

Close's radical attitude to realism could not be further from that of Estes, the most traditional of the pioneers. Their artistic criteria are sharply opposed: Close's realist paintings derive their impact from Minimalist concepts, whereas Estes' works are dependent on traditional notions of pictorial order and balance. In common with the pre-twentieth-century realists whom he admires, Estes' main concern is to wrest harmonious beauty from the disorder of the real world he sees around him. For him, process, medium, scale and the use of photographs are all subservient to this overriding concern; they are a means to an end.

Alone of the pioneers, Estes has always been a realist. His training at the Art Institute of Chicago consisted of traditional life painting and drawing and he continued to work on figure paintings after leaving in 1956. He spent the following decade earning a living as a commercial artist by day and painting by

Richard Estes
(above) *Woolworths*,
1973, oil on canvas,
40 × 56″ (102 × 142cm)
(left) Detail of
Woolworths
(Reproduced actual
size)

Richard Estes
Food Shop, 1967,
oil on canvas,
65 × 48″ (165 × 122cm)

Richard Estes
Bus Reflections
(*Ansonia*), 1974,
oil on canvas,
36 × 48″ (91 × 122cm)

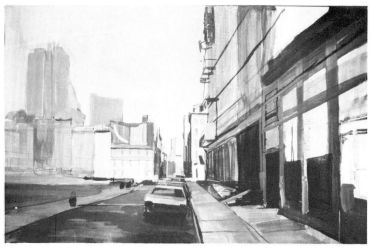
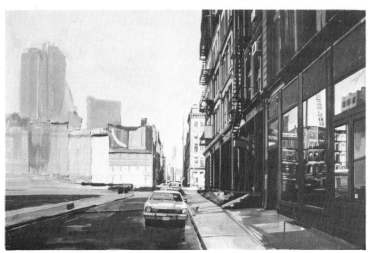
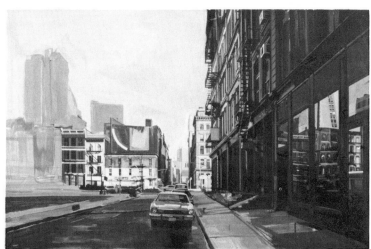
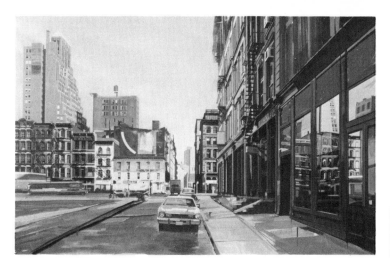
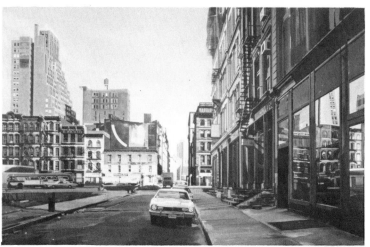

night. It was the practical difficulty of obtaining models, rather than preconceived theory, which led him to work from photographs towards the end of this period. Yet, as with Flack, his work developed through the use of photographs: using them as a source of information rather than as the subject of his paintings, they nevertheless increased his awareness of the way things truly look. The context in which people are seen became apparent; his subject matter moved away from studio-composed figure paintings towards more realistic views of people within their environment. His colours and forms became more specific, and by 1967 he was working in a fully photo-realist style.

Yet since then Estes has remained true to traditional pictorial criteria and techniques. He works with oil paint and brushes, only using acrylics for under-painting; he builds up his works gradually, working from loose underpainting towards ever-increasing precision; and although he remains faithful to the detailed information he finds in his source photographs, the finished painting is never a picture *of* a photograph. For Estes the transformation of his subject into a harmonious work is what matters: he combines information from several photographs in a single painting so that every aspect of the subject is kept in sharp focus, and he is not averse to changing the place or colour of certain elements if it serves the internal needs of the painting.

Richard Estes
Sequence of photgraphs showing the development of *Baby Doll Lounge*, 1978, oil on canvas, 36 × 60″ (91 × 152cm)

Taking the surroundings in which he lives as his subjects, such as the neighbourhood restaurant in *Food Shop*, 1967, he transforms humble backstreet sights, familiar to the inhabitants of New York, into carefully orchestrated harmonies. Without forfeiting accuracy of detail, but by choosing a viewpoint parallel to the picture plane, and by careful placing of the subject within the boundaries of the canvas, he uses the architectural articulation of a potentially mediocre façade as a basis for this painting in which the horizontals and verticals are as judiciously balanced as those in a Mondrian or a Vermeer.

Since evolving this mature style, Estes' artistic development has centred around its refinement. He has continued to take the urban landscape as his subject because he feels a painter's job is 'to look around and paint what you see', while he still focuses on unglamorous aspects of his environment because 'paintings of ugly things are more successful than paintings of beautiful things.'[17] This basic concern with transforming reality into an aesthetically satisfying painting led him to reduce the number of human figures in his work by 1970; glimpsed rather than seen, their presence does not distract the viewer from responding to the purely formal qualities of the paintings. At about the same time the loose painterly passages which were evident in the early works disappeared, and as his technical proficiency improved Estes turned to views such as *Bus Reflections (Ansonia)*, 1974, chosen for their spatial and compositional complexities. By featuring the reflective surfaces so characteristic of modern architecture, such works succeed in embodying the mood of modern cities while at the same time offering challenging spatial ambiguities. What at first glance appears to be a literal transcription of reality turns out to be a highly sophisticated manipulation of space and illusion. In this painting the

'real' street, by being reflected in the plate-glass window on the right-hand side of the painting, appears twice, so creating a rigorous symmetry and emphasizing the strong vertical accents which combine to give the painting its carefully balanced composition. The buildings in the far distance, also repeated in the reflection, act as a horizontal check to the dive into deep space of the street itself, so creating 'pockets' of spatial illusion which have a similar 'push and pull' as that of cubist paintings.

The emphasis which Estes places on the purely formal aspects of his works often results in paintings such as *Central Savings*, 1975, in which the subject matter acts merely as a point of departure for investigations into space and form. This painting, which is full of visual deceptions, illustrates just how far his works are removed from the way we perceive in reality. Faced with this scene our eye would either focus on the reflections in the plate glass which is depicted parallel to the picture plane, or on the view through it to the counters of the quick diner, yet in his painting Estes combines the two so that we look at what lies behind and in front of us simultaneously. The frontal viewpoint coupled with the geometric shapes inherent in his subject result in a painting in which the verticals and horizontals act as abstract shapes which are as vital a part of the painting's impact as the subject it represents.

On one level Estes belongs to the tradition of realists who humbly set out to portray the realities of contemporary life yet, like Seurat and Vermeer, he transforms his subjects into paintings which strike a strange balance between realism and artifice. Little concerned with the polemics of art-world aesthetics, distrustful of theories and without seeking to be an innovator, he has inadvertently become one of the best loved and most influential pioneers of Superrealism.

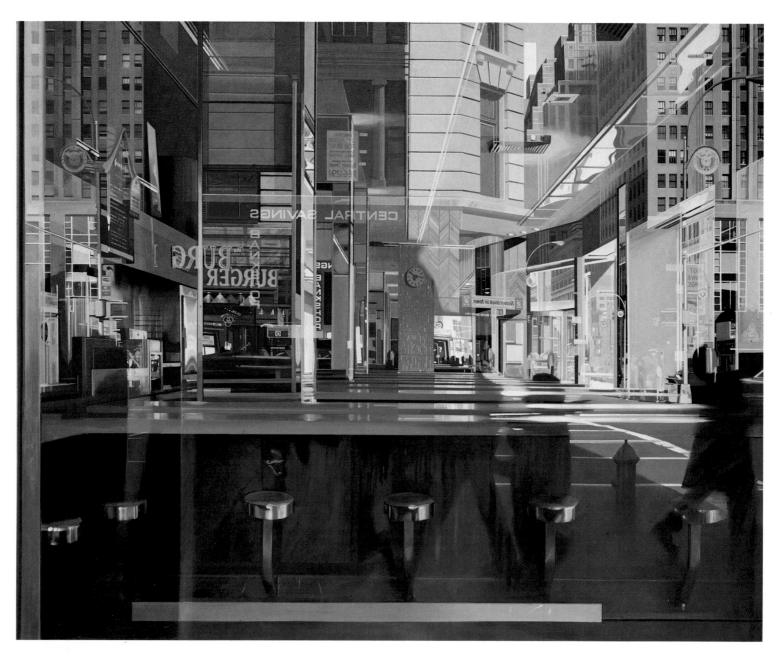

Richard Estes
Central Savings, 1975,
oil on canvas,
36 × 48″ (91 × 122cm)

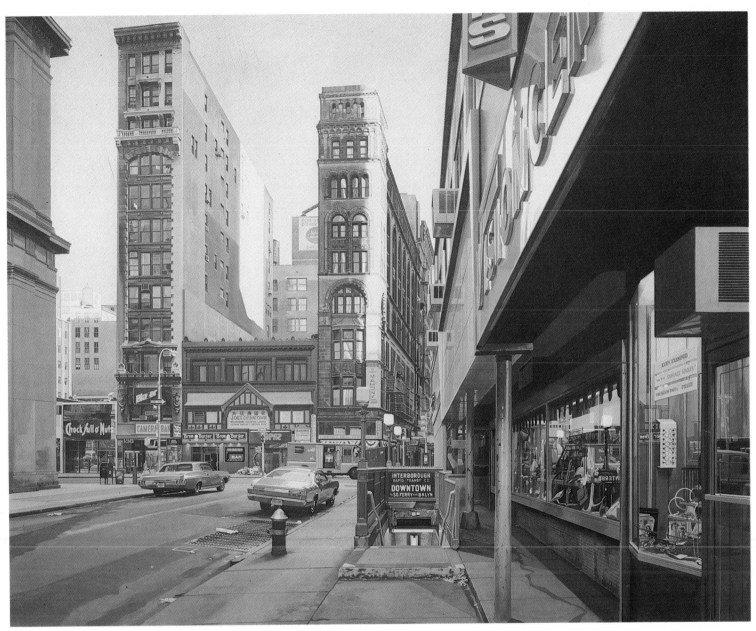

Richard Estes
Downtown, 1978,
oil on canvas,
48 × 60″ (122 × 152cm)

John Salt

If Estes is the most popular of the Superrealists with the general public, his counterpart among the painters themselves is John Salt. Like Estes, Salt has an aversion for conceptualism; his attitude to painting is closer to that of a master-craftsman than to a philosopher: for him its value lies in the pleasure to be found in producing a well-made object rather than in conveying abstract ideas. An exception among Superrealists, he does not depict a new and shiny world of man-made objects but finds visual subtlety in the muted tones and twisted shapes of wrecked cars and ancient trailers which he paints with sensitivity of vision and technical skill.

The clue to Salt's attitude lies partly in his artistic background. An Englishman, he studied at the Slade School of Art, London, where painting was regarded as the result of interaction between artist and subject. Emphasis was laid on working from live models and on the expressiveness and sensitivity with which this was interpreted. Salt reacted against so subjective an outlook; like Bechtle, he began to work from photographs as a way of achieving impartiality and of escaping the yoke of historical precedents, but he retained the visual acuteness developed during years of life drawing and painting. In 1967, soon after his arrival in America, he hit upon the solution to his artistic problem while flicking through car manufacturers' brochures. In images such as these he would find formal arrangements with no artistic antecedents. Initially working in monochrome, he produced paintings where the squared-up source image was carefully rendered onto the canvas, retaining its formal qualities to avoid the interpretation he found so distasteful.

Salt's desire to escape what he calls 'artiness' soon led him to project slides directly onto canvas, and to use airbrush and stencils to eliminate personal handwriting and draughtsmanship from his paintings. Saying that he found 'good photographers' photographs . . . a bit contrived. It was like copying art',[18] he began, at the same time, to work from photographs he took himself. Like Bechtle, his aim was to obtain source photographs which would act merely as visual information about the subject. Not consciously composing with the camera, but 'pointing it in the right direction'[19] he took pictures which led to informally composed paintings such as *Cars*, 1971. On first seeing such a painting one may be tempted to regard it as a comment on the dangers of the car-dominated American culture, yet Salt denies this, saying 'It just seemed natural to paint them.'[20] He sees his choice of the subject as an intuitive response to his new environment, depicting decaying and wrecked cars simply because they are an obvious characteristic of his newly-adopted country. For him the challenge lies in rendering the subtleties of tone, colour and form which he finds in his amateurish slides of these subjects. He remains uncommunicative when it comes to interpreting their social significance, feeling that this is best left to the viewer.

It is the extraordinary sensitivity with which Salt paints his imagery that isolates his works from those of the other Superrealists, and it is this which has earned him their admiration. Using numerous stencils to differentiate closely-aligned tones and colours with unusual finesse and juxtaposing the soft texture of weeds against rusting or shiny metal, in works such as *Green Chevy in Green Fields*, 1973, he transforms a documentary photograph into a poetic painting full of visual excitement. He is aware of the seeming senselessness of spending so much time producing images which could be approximated in a matter of seconds by mechanical means: a gentle, uncompetitive person, he does not claim that his manner of working should render other styles obsolete, but finds that for

John Salt
Bride, 1969, oil on canvas, 51 × 73″ (130 × 185cm)

John Salt (left) *Green Chevy in Green Fields*, 1973, oil on canvas, 49 × 72″ (125 × 184cm)

(top) *Chevrolet and Mobile Home*, 1975, oil on canvas, 45½ × 67½″ (115·6 × 171·5cm)

(above) *Three Toned Trailer*, 1975, oil on canvas, 27½ × 41½″ (70 × 108cm)

him the making of meticulous images has its own rewards. It is ironic that his style should have become so widely practised, since he originally developed it in isolation, partly as a means of finding a unique style which would prevent his work being compared to that of others.

Salt and his co-pioneers were not alone in exploring the use of photographs during the 1960s but the manner in which other painters did this was too far removed from mainstream Superrealism to be as influential in shaping the movement. George Deem's renderings of old masters, begun as early as 1963, were too close to the formal and painterly concerns of Pop. Gerhard Richter's fascinating paintings from blurred black and white photographs, which he commenced in 1962, were concerned with painting analogies of reality rather than imitating photographs, and they remained virtually unknown outside his native Germany until the end of the 1960s,

so did not exert influence on what remains an essentially American movement. Finally, Duane Hanson's startlingly life-like sculptures, begun in 1967, were certainly instrumental in bringing critical attention to the movement as a whole. (These are discussed in relation to the other verist sculptors in Chapter Six.)

The true pioneers of photo-realism – Morley, Flack, Bechtle, Close, Estes and Salt – acted as a powerful influence on its later practitioners. Their highly individual approaches indicated its rich potential and inspired the variety which exists in the works of later Superrealists. For Flack it is a means of making widely accessible statements about life, for Morley and Close an investigation of process; for Bechtle and Salt it is a means of escaping the influence of art itself, while Estes joins these two in seeing it as a way of painting realist canvases without expressionist or academic overtones.

John Salt
Cars, 1971, oil on canvas, 49 × 72"
(125 × 184cm)
Salt's paintings could be regarded as comments on the dangers of car-dominated American culture, but he refutes this, saying 'It just seemed natural to paint them'. (1978)

PHOTO-VISION AS SUBJECT

The pioneers of Superrealism did not remain alone for long. By the end of the 1960s a considerable number of artists from similar artistic backgrounds were tapping the hand-painted photograph for its artistic potential. Either stimulated by the innovators, or reaching similar conclusions independently, each added his or her personal contribution. Superrealism became an identifiable movement with a fully fledged style. Within the movement the diversity already apparent in the works and attitudes of the pioneers expanded. Indeed, part of the style's fascination stems from the variety of approaches which exist within its confines. As Ben Schonzeit points out 'If all the photorealists painted the *same* photograph you would get *totally* different paintings.'[1] The differences fall broadly into two categories: those who, in common with Close and Morley, treat the photograph as the subject of their work, and those who, like Estes and Flack, use it as a means to an end.

Consider Guy Johnson's *Emma Bell*, 1973, and Ralph Goings' *Hot Fudge Sundae*, 1972; both depict mundane reality, both are patently based on photographic

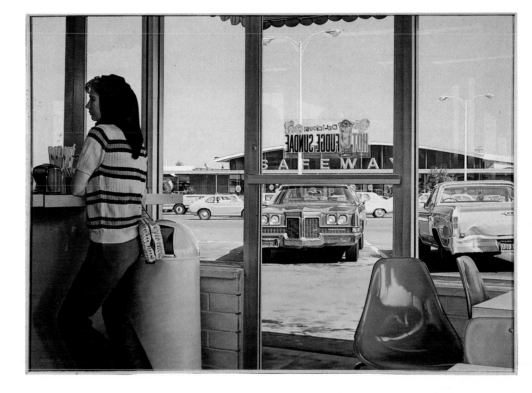

Guy Johnson (left)
Emma Bell, 1973,
oil on paper,
$23\frac{3}{4} \times 24\frac{1}{2}''$
(60·3 × 62·2cm)

Ralph Goings (right)
Hot Fudge Sundae,
1972, oil on canvas,
40 × 66''
(102 × 168cm)

information. Yet Goings' painting is not *about* photographic convention, whereas Johnson's is. Goings, intent on showing the 'thereness' of the fast-food diner, uses the camera for its ability to provide him with precise details so that his painting of the subject will possess an uncanny reality. Johnson's work leaves us in no doubt about its pictorial source: it is a painting of a family snapshot, not a painting of a woman in a car park. Its proportions and heightened colour are those of Kodachrome prints, and the artist deliberately includes the conventional

pose and camera blur so frequently found in such amateur snapshots. Whereas the Goings painting encourages an awareness of the things depicted in it – shiny surfaces or the view through the window – the Johnson painting invites a reconsideration of the formal properties of an imagery normally excluded from the Fine Arts.

One group is concerned with using the photograph as a means of obtaining information about its subject, while the other concentrates on the way in which photographs transform the way things look. Yet the two approaches are not

mutually exclusive; for example, Idelle Weber is as concerned with the close-up, a peculiarity of photo-vision, as she is with painting reality 'as it is' – and in some cases artists swing from one approach to the other. The two attitudes, already established in the work of the pioneers, act as the two polarities of Superrealism, rather than as sharply-zoned compartments.

Diversities also exist within each group. All the artists discussed in this chapter normally take photography as their subject, yet some focus on the cultural clichés it has produced (the snapshot, the stilted imagery to be found in horse magazines), while others look to the visual effects produced by film and lens (the close-up, dramatic changes of focus, camera blur or the stains on a ruined slide). Some work from photographs which they take themselves and see this as an important part of the creative process, while for others the fact that they are working from *existing* images is vital. McLean, Mahaffey, Chen, Raffael, Staiger and Bond have all produced works whose impact rests largely on the transposition of 'non-art' imagery onto canvas.

The pictorial conventions of photography

Richard McLean
Probably the best known of this group is Richard McLean who began painting his real-life cowboys and grinning jockeys from photographs found in horse magazines in 1968, while still unaware of Morley's work. He shares the latter's fascination for ready-made imagery and takes great pains to ensure that this is evident from his paintings. 'Say I've done a picture of a man fishing. I wanted it to read as a picture of a picture of a man fishing. So the painting is not about the activity; it's about the imagist activity that the subject serves to set up.'[2] To this end, his early

works often included borders around the central image.

Unlike Morley, McLean is unconcerned with conceptualism; choice of subject matter and formal concerns are important to him. Born in Hoquiam, Washington, he spent much of his boyhood in the rural Northwest before moving to California in the 1950s to study art. Both Pop art and Robert Bechtle's early Superrealist works influenced his move towards meticulous realism but his choice of subject came both from a desire to find a topic not heavily laboured in recent art as well as from an effort to come to terms with his childhood experiences. As with Bechtle, his painting has a significance which is personal, yet he gives it neutrality in order to leave its interpretation open-ended. He achieves this by painting from existing imagery. The source image thus functions on several levels: it acts as a distancing device but also provides him with formal possibilities which he finds exciting because of their non-art origins. By working from photographs of the horse world as depicted by itself (rodeos and racing subjects) his paintings, such as *Albuquerque*, 1972, confront us with pictorial conventions developed in a sub-culture largely unconscious of the contemporary art world and its visual vocabulary. Almost always the horse is seen in profile, its body parallel to the picture plane, the rider crouching on its back but with his head turned towards us so we may see his features. These are images without pretensions, intended to inform rather than seduce, yet they have a symmetry and simplicity of design which resemble their ancestor, the eighteenth-century racing print.

Projecting these photographs onto the canvas through an opaque projector, McLean transforms them into paintings. Often inventing his own colours (since the source image is frequently in black and white) he is not averse to adding in or

editing out certain elements if they interfere with the clarity of the painting. Yet he remains close enough to the source image for his painting to act as an exposition of a visual tradition which has flourished independently of Fine Art.

By using such imagery as his subject, McLean not only brings its formal conventions to our attention but also its iconography. Whether it be a racing picture or one based on modern-day rodeos, such as *Rustler Charger*, 1971, much of his work's impact rests on the fact that the world he portrays is far removed from that of the mostly urban art-gallery-going public. 'I'm pretty thoroughly an urbanized creature now making urban art. The horses don't fit that art context comfortably, from my experience, and that fascinates me. I'm interested in the way they act as paintings.'[3] What gives these pictures their unreal quality is the tension they set up by showing us extremely life-like representations of motifs which are close to modern myths. The rodeo paintings, in particular, remind us that the great outdoors, the freewheeling cowboy and Stetson-wearing cowgirl, belong not only to the television Western and the tobacco advert, but also exist in modern-day America.

Recently McLean has begun to work from photographs which he takes himself, so widening the scope of his imagery. Still remaining close to the source image, these paintings are centred around backstage scenes: the unharnessed horse in the stable (*Sheba*, 1978), or the stable lad leading it to the arena. McLean explores the unposed, day-to-day life of the same alien world which he had depicted in his paintings of triumphant jockeys and cowboys.

Hilo Chen and Noel Mahaffey
What McLean does for the horse photograph, Hilo Chen does for the pin-up, and Noel Mahaffey for the chambers of commerce and insurance company

Richard McLean
Albuquerque, 1972,
oil on canvas,
50 × 60″ (127 × 152cm)

Richard McLean
Rustler Charger,
1971, oil on canvas,
66 × 66" (168 × 168cm)

Noel Mahaffey
Louisiana Superdome,
1977, oil on canvas,
72 × 72" (184 × 184cm)

Noel Mahaffey (right)
Phoenix Federal,
1972, oil on canvas,
44 × 36″ (119 × 91cm)

Hilo Chen (left)
Bathroom 12,
1977, oil on canvas,
78 × 96″ (198 × 244cm)

84

brochure. Chen's *Bathroom 12*, 1977, reproduces all the conventions of the modern girlie-magazine image, although in fact he takes his own photographs: the model is placed in an expensive-looking bathroom, she arches her back provocatively, and the whole scene is depicted in dramatic studio lighting. Similarly, in Mahaffey's *Phoenix Federal*, 1972, the city headquarters of the company are depicted with all the brashness one expects to find in its own pamphlets. The aerial view is chosen to show the building from an angle destined to make it appear bigger (and therefore better) than its neighbour, the clear blue sky to inspire confidence in its products. Neither female nude nor modern city are subjects new to art, but these paintings do not seem to deal with the subjects as much as the trite manner in which they are portrayed in non-art imagery.

With airbrush and projector Chen transfers his photographs onto giant canvases in such a literal manner that one wonders whether his painting is an indictment, or a tacit approval, of soft pornography. Although his interest in the nude stems from a desire to depict the minutiae of detail he finds in skin tones, particularly as they are transformed by water, his choice of pose and setting is reminiscent of the modern pin-up. Born in Taiwan, but now resident in New York, Chen is a latecomer to Superrealism but typifies that approach which takes an ultra-cool look at the pictorial conventions of the popular image, and relies on scale and context to transform it into art.

Mahaffey moved from his early Pop-like paintings to deadpan Superrealism by 1970, though this is only one aspect of his work. One of the younger Superrealists, he began by working from publicity photographs obtained from various chambers of commerce throughout America, but he has also painted from photographs of nondescript urban views which are not reminiscent of hackneyed

mass imagery, and more recently he has been working in a manner which is closer to Estes than McLean. Still depicting city scenes, often of New York where he now lives, he works from his own photographs and takes a delight in portraying the appearance of things as they truly are. Frequently dwelling on the effects of brightly coloured neons in the city night, his paintings do not recall any particular pictorial clichés, but are close to the realist tradition which shows the beauties of contemporary life. *Louisiana Superdome*, 1977, captures the quality of air lit by artificial light sources – the blurring of edges, things indistinctly perceived, the sudden glares of conflicting lights in the darkness.

Joseph Raffael

Equally difficult to pigeon-hole are the works of Joseph Raffael; like McLean he

has worked from ready-made images, yet far from seeking neutrality or coolness his motivation comes from the sense of new-found personal 'wholeness' he has discovered in transcendental meditation. A New Yorker, now settled in California, he began his career with complex Pop-like paintings but his search for simplicity led him, as early as 1968, to paint from single iconic images such as the Egyptian bronze in *Tut*, 1968. Painted from *Paris Match*, it retains the colour distortions of magazine pictures, yet the loose brushwork and casual placing of the image on the canvas show that the potency of the subject, rather than the purely visual characteristics of the photograph, was important to the artist.

Choosing his subjects carefully, for their nobility of expression and inspiring presence, Raffael magnified the scale of the original photograph so that his

Joseph Raffael
Tut, 1968, oil on canvas, 77 × 59″ (196 × 150cm) Over six feet (1.8m) tall, this painting is derived from a *Paris Match* magazine, but magnifies its scale so that the subject takes on a mesmeric quality.

GRIFFITH PLANETARIUM PARKING LOT - WHERE JAMES DEAN HAD HIS TIRE SLASHED AND FOUGHT WITH THE TOUGHS

Paul Staiger
Griffith Planetarium Parking Lot – Where James Dean Had His Tire Slashed And Fought With The Toughs, 1971, acrylic, on canvas, $18\frac{1}{8} \times 22''$ (46 × 56cm)

About eighteen inches (46cm) high, this painting remains true to the heavily retouched 1950s picture postcard from which it was painted.

paintings took on a meseric, spiritual quality. His increasing awareness of the interrelatedness of all things soon led him to paint in a manner unlike specific realism, but his gigantic transpositions of magazine imagery onto canvas proved to be influential, particularly for their scale.

Douglas Bond and Paul Staiger

Raffael and McLean may have differed in their attitudes to audience response but both set out to transform ephemeral magazine images into art. For some Superrealists this has become a matter of confronting images from the past. Seizing on the photograph's ability to preserve the mood of an epoch, artists such as Douglas Bond and Paul Staiger have taken yesterday's mass-media imagery as their subject, to create works which jolt us into recognizing the ephemerality of taste and fashion. Both West Coast artists, they render their 'found' images onto canvas in a deadpan manner to create an awareness of the pictorial properties existing in imagery normally considered unworthy of serious aesthetic consideration.

Initially exploring the fashions and faded colours in old snapshots, Bond soon moved on to a preoccupation with the photographs of bathrooms and kitchens found in home furnishing magazines of the 1940s and 1950s. *Linoleum Kitchen*, 1973, is based on a picture from a linoleum catalogue so that the dominance of the floor results from the angle of vision taken by a photographer obviously keen to focus on the selling point. Yet by enlarging the image and rendering it on canvas, Bond transforms the picture into a painting in which the geometric patterns of the lino, seen against the oddly placed furniture, become interesting shapes in themselves. In *Bath Room*, 1973, the colour scheme favoured by the designer who was responsible for the 'moderne' interior – greys and blues set off by varying shades of pink – acts as a compositional device. In both cases the flattening effect of photo-vision and the faded technicolour of the source image become the true subjects of Bond's paintings.

Paul Staiger's paintings of Hollywood shrines have a similar quality. Rendered faithfully from picture postcards, their allusion to the 1950s is as dependent on the pictorial conventions of such images as it is on their subject matter. The text in *Griffith Planetarium Parking Lot . . .*, 1971, tells us that this is '*Where James Dean Had His Tire Slashed And Fought With The Toughs*', but equally active in recalling that era are the simplified shapes used by Staiger, reminiscent of the heavy retouching so popular at the time as a means of cleaning-up and glamorizing the subjects of postcards. By remaining true to the entire image, the painting draws our attention to the ways in which such artifacts use text and formalization to transform ordinary places into modern shrines. Staiger does not work exclusively from picture postcards: he has also worked from snapshots, but although he claims that 'the dependence on photo-subjects leads to a dismissal of formal considerations',[4] he favours frontal compositions made up of simple, flat areas of colour, and he avoids images rich in detailed representations of textures. Like Bond's, his paintings echo modernist formal concerns.

Guy Johnson and Gerard Gasiarowski

For every photograph of reality printed by the media there must exist a million taken

Douglas Bond
(far left) *Linoleum Kitchen*, 1972–3, acrylic on canvas, 40 × 108″ (102 × 274cm)

(left) *Bathroom*, 1973, acrylic on canvas, 45 × 66″ (114 × 168cm)

by non-professionals. Destined to go no further than the family album, they remain unseen witnesses to changing fashions and times, freezing for ever the appearance of people and places which have meaning only for the photographer and his or her immediate circle. Rescuing this truly popular art form from obscurity, some Superrealists have made the pictorial convention of the snapshot the subject of their paintings. Reminding us that the glamorized photographs found in the media are only a reflection of one aspect of reality, the American Guy Johnson and the Frenchman Gerard Gasiarowski, as well as Bond and Staiger, have transformed the humble family snap into art.

Johnson's work often deals with old snapshots, pre-war pictures of sleepy towns rendered on canvas in the 1970s. His working process differs from that of most Superrealists in that he re-photographs his sources, sometimes combining images from several into the new photo, and then paints *over* the re-photographed image in oils. As these paintings are of subjects whose appearance is now irrevocably changed, the fact that they are pictures of pictures is emphasized, a concern also apparent in his painting of *Emma Bell*. In both cases his work draws our attention to photography's ability to preserve the passing moment for ever.

For Gasiarowski the snapshot, whether recent or not, is merely one of many alternatives. During the later 1960s he was concerned with rendering on canvas the various *kinds* of reality which the camera captures. Like Morley,

David Kessler
(above) *Light Struck Cadillac*, from the 'Ruined Slide' series, 1976–7, airbrushed acrylic on canvas, 60 × 84″ (152 × 213cm)

(right) One of the 'Garden Pool Watercolour Series', 1977, airbrushed watercolour on paper, 29½ × 41½″ (75 × 105cm)

Gasiarowski is concerned with the limitless possibilities open to the modern painter, and his more recent works show a strong expressionist bias, which appears to reject the careful restraint of his photo-realist paintings.

David Kessler and John Clem Clarke

Paintings from family snaps emphasize the simple fact that not all photographs are sharply focused, well composed and correctly exposed successes. For the young Californian, David Kessler, the visual aberrations of unsuccessful photographs become exciting in themselves. In contrast to other Superrealists, he is not concerned with the associations which photographs conjure up, nor with using them to attain distance or dislocation of context, but deals with the distortions of reality created by photographic mistakes. In *Light Struck Cadillac*, 1976, he takes a classic Superrealist theme and shows just how fragile is the link between photographic illusionism and total disaster. One of a series of paintings on the 'ruined slide' theme, the shiny new car is airbrushed onto the canvas complete with reflections, in an immaculate photo-realist manner, but the artist has taken equal pains to reproduce the appearance of the amorphous-shaped light streak which marred the illusionism of the source transparency. The abstraction of the yellow veil of colour can be enjoyed for itself; and the inclusion of this 'mistake' reminds us of the insubstantiality of photographic illusionism, while the white border which surrounds the whole painting emphasizes that the painting is a picture of a picture. The work acts on several levels: it points to the abstractions which are all too easily caused by processing errors and draws our attention to the fact that the 'reality' of photographs is, after all, nothing more than the reaction between film, light and chemicals.

John Clem Clarke paints from photographs of his friends dressed and posed to suggest the subject matter of the old masters. He shares Kessler's preoccupation with the visual appearance of 'unsuccessful' photographs, but his attitude to subject matter places him slightly outside the boundaries of mainstream Superrealism. Awkward young hippies stand in for the perfectly proportioned gods of Renaissance art, while leggy 1960s beauties replace their dimpled Venuses. The exaggerated tonal contrasts and harsh colour distortions in the paintings emphasize the joke (a painting from a photograph taken to look like a painting which we probably know only from photographic reproductions anyway).

Of these two painters, only Kessler is concerned with remaining close to the ultra-real look of Superrealism, while Clem Clarke's work is centred around art about art – indeed, he pioneered the use of stencils and spray-gun in works which exposed photo-mechanical reproduction rather than photo-illusionism. Kessler's recent work is of slides of non-specific subjects such as water surfaces, because he feels, their 'very structure, although totally real, implies total abstraction.'[5] Close-up shots enable him to continue exploring abstract effects in photographs without losing contact with illusionism.

Photographic ways of seeing

All the works discussed so far deal with the pictorial conventions evolved by photography. Whether their source is the sophisticated professional photograph or the amateur snapshot, they point to the paradox which underlies photographic 'truth': that it transforms reality in order to create life-like illusions. Nowhere is this more evident than in close-up views. In the days before the invention of photography, painters occasionally represented small segments of reality, but the pictorial convention of the close-up – seeing tiny portions of reality in isolation – was developed only through photography. Using this as a starting point, a host of Superrealists have explored its varied possibilities: the opportunity to analyse the minutiae of photographic form (Schonzeit), visually exciting distortions of scale and viewpoint (Robert Cottingham and Ron Kleemann), or the transformation of meaning which results from isolating part of an object (Charles Bell and David Parrish). They are not concerned simply with painting deadpan pictures of pictures but nevertheless base their works on a pictorial convention borrowed from photography.

Ben Schonzeit

New Yorker Ben Schonzeit frequently uses the close-up in order to discover just how photographic illusionism occurs. A painter intensely pre-occupied with *seeing*, his works investigate structures and colours as captured by film and lens. His close-up *Nude*, 1974, neither refers to the pin-up nor to the old masters, as did those of Chen and Clem Clarke; it explores the way in which the slide records the shapes of pores and film of greasiness on the skin. It is a painting which deals with the contrast between out-of-focus and sharp focus, and the hot Kodachrome colours of the studio-lit transparency.

Schonzeit's main concern is with the visual appearance of the slide and, like

John Clem Clarke
Judgement of Paris IV, 1969, oil on canvas, 79 × 108″ (201 × 274cm)
An art joke, this is a painting from a photograph which was taken to look like an old master painting – which itself would be best known in reproduction.

Ben Schonzeit
(left) *Nude*, 1974, acrylic on canvas, 96 × 84" (244 × 213cm)
(right) *Cabbage*, 1973, acrylic on canvas, 80 × 108" (204 × 274cm)
'I enjoyed ... dealing with the translation of photographs into paint, and what could be said with paint that you didn't get out of photographs ...'
(Ben Schonzeit, 1978)

Ben Schonzeit
The Music Room,
1977–8, oil on canvas,
right panel of a
diptych which measures
96 × 192″
(244 × 488cm)
In Schonzeit's later
work his love of
sensual forms and
textures is expressed
in loose
interpretations from
photographs.

Much of the impact of Schonzeit's works rest on their gigantic scale; *Cabbages*, 1973, for instance, is a nine foot wide (274cm) painting of a much smaller subject. It retains the compact solidity of layered cabbage leaves which characterizes the subject, but its scale serves to transform the representation of these mundane objects into a visual adventure: 'The painting becomes the place you are in . . . the smaller the painting, the more it exists as a window, and the larger it is the more it becomes a place; it's a much more physical experience.'[7] His works retain the glow of a colour slide projection and show his love of tangible things, their hardness and softness, the way light falls on them and is picked up by the lens. Their subject matter ranges far and wide: from raw meat to plastic sandals, from a simple glass of water to an atomic explosion, and although he admits that for him, they often contain symbolic meaning, he shares the mainstream Superrealist view that this should not be imposed on the viewer. 'There's a lot of raw material, lots of suggestion . . . *specifically*, I like to leave that open because every person will come to it with their own thing, which is what it's about.'[8]

Photo-realism spans only a few years in Schonzeit's output. He turned to working from slides at the end of the 1960s after spending an uneasy period trying to be an abstract painter, and as well as the close-up, his work explored the elasticity of scale and juxtaposition of disparate objects which photographic images provide. More recently he has become dissatisfied with the restrictions of meticulous rendering: his love of sensual forms and textures is now expressed in loose interpretations from photographs, such as the *Music Room* series, 1977–8, which fully exploit paint as paint in a manner which the airbrushed photo-realism of his earlier work could not allow.

Flack, he takes them himself. Favouring the indoor lighting of the studio, he makes use of sophisticated equipment such as strobe lights and reflectors to dramatize the subject and pick out its textural qualities. Using projector and spray-gun he concentrates on the visual problems encountered while transferring the slide image onto canvas. 'I enjoyed . . . dealing with the translation of photographs into paint, and what could be said with paint that you didn't get out of photographs.'[6] By working from close-ups he can emphasize this investigation of the way things look when reduced to flat photographic shape and colour.

Charles Bell and David Parrish

Equally fascinated by the close-up, Charles Bell and David Parrish concentrate on the strangeness which it can confer on the mundane. The click, click of the camera shutter, the arbitrary cropping of the viewfinder, lead to transformations which give us a novel view. Seen this way, parts of a pinball machine (Bell) or a motorbike engine (Parrish), turn into sinuous, self-willed objects, while their enlargement onto flat canvas serves to emphasize their abstract properties. In Bell's recent work, we never see the pinball machine in its entirety: small portions are stranded on the canvas where they lie, blown up and transformed into an odd balance between illusion and abstraction. *The Wizard*, 1977, for instance, is highly realistic; it retains the quality of artificial light emanating from the machine and the blurred out-of-focus areas of the photograph, yet the viewpoint from which the pinball machine is depicted and the enormous distortion of scale demand an appraisal of the work's formal qualities.

Prior to pinball machines, Bell painted from photographs of toys and bubble gum machines, such as *Gumball no. 10, "Sugar Daddy"*, 1975, which appears to record the subject in a straightforward deadpan manner but, when seen close-to, abounds with painterly passages. Though lacking the dynamic brashness of his more recent work, this painting shows a similar awareness of the close-up's abstract possibilities. Born and trained in Oklahoma, Bell's move to realism was inspired by Pop and he still shares that movement's love for the artifacts of popular culture. He says that his attitude to subject is partly a matter of 'dispassionately putting things together' but that he is also 'concerned with the feelings we share about familiar objects . . . I'm saying, "Hey look, these everyday things really are terrific".'[9] By the same token he uses the conventions of photo-

vision partly because 'the camera . . . allows a complexity in subject matter' and 'the lens-eye view gives a special "today" quality to visual experience, thanks to our daily media bombardment.'[11]

Also fascinated by his subject matter, David Parrish's paintings of motorbikes show a similar preoccupation with the camera's ability to distort by isolating segments of a larger whole. In more recent works, this Alabama artist continues to point out that photographic fact can be stranger than fiction, for instance in *Kayo II*, 1977, where an inflatable toy and brightly coloured carpets appear larger than a petrol-filling station. Instead of using the camera's ability to turn the mundane into the fantastic, he picks a subject with inherent eccentricity but which is rendered all the more incongruous by photographic 'distortion' of scale.

Charles Bell
The Wizard, 1977,
oil on canvas,
54 × 66" (137 × 166cm)

David Parrish (left)
Kayo II, 1977,
oil on canvas,
50 × 70″ (127 × 178cm)

Charles Bell
(far left) *Gumball
no. 10, 'Sugardaddy'*,
1975, oil on canvas,
66 × 66″ (168 × 168cm)
(left) *Fire Ball 500 no. 1*,
1977, oil on canvas,
54 × 66″ (137 × 168cm)

Ron Kleeman
Buggy, 1977,
acrylic on paper,
17 × 21″ (43 × 53cm)

Ron Kleemann

In his pinball paintings, Bell transforms his subjects so that they appear to become other things: brilliantly coloured zig-zags leap into waves; a little figure becomes a giant demonic wizard leering at us from the wall. Ron Kleemann uses cropped, dramatic close-ups too, but without seeking to explore the strangeness of associations which this gives his subjects. (Robert Cottingham also uses the close-up but in his case the source image is merely a starting point for a degree of formalization which takes his work beyond the category of the photograph as subject.)

Shiny red fire-engines, powerful trucks and gleaming racing-cars are Kleemann's subjects; redolent of speed and adventure, they are invariably new and unharmed, the very stuff of little boys' dreams. Yet his work goes beyond the technical virtuosity with which he makes these subjects credible. His brushwork is loose and painterly so that close-to, the illusions of transparent glass or of hard metallic surfaces dissolve into fluid shapes and colours, sensuous and lively in themselves. In many of his paintings the close-up acts as a means of showing just how abstract 'photographic reality' can be; in *Buggy*, 1977, for instance, the equal emphasis with which almost the entire image is painted serves to squash the subject onto the two-dimensional flatness of the canvas so that spatial recession is distorted: engine parts become decorative patterns and we are made aware of the abstract shapes made by the coils of machinery. This desire to combine abstraction and realism runs throughout the work of this Michigan-born artist, from his early Pop-like paintings in which highly illusionist machine imagery was juxtaposed onto abstract shapes, to the subtleties of his recent work.

Despite their interest in the formal aspects of painting, the artists discussed in this chapter all use the photograph as a means of finding pictorial conventions which have no prior tradition in painting. Dispensing with the conceptual overtones of Morley and Close, they take the photograph as subject either as a means of dealing with the conventions of non-art imagery or in order to explore the various ways of seeing which the camera has opened up. A Schonzeit salad or a Kleemann truck reveals the dramatization of everyday items when seen through the lens and viewfinder. McLean and Mahaffey remind us that photography has developed its own conventions parallel to, but independent of, contemporary events in Fine Art. That these conventions change with time is revealed by the images from the past which Bond, Staiger and Johnson have painted, while the exploration of photographic 'errors' by Kessler and Clem Clarke show the ultimate impalpability of photographic illusionism.

Tom Blakewell
(above) *Takashimaya*,
1974, oil on canvas,
68 × 96" (173 × 244cm)

(right) *Little Roy's*
Goldwing, 1974,
oil on canvas,
$67\frac{5}{8} × 83\frac{1}{2}$" (172 × 212cm)

THE CAMERA AS TOOL

For many Superrealists, what matters most is not so much what the photograph stands for, as what it can do. Less interested in its power to transform reality, they use it as a tool, a convenient way of obtaining precise information, of achieving coolness and distance or of converting the solid three-dimensional subject into a flat surface. Rather than setting up a dialogue between painting and the pictorial conventions of photography, their work speaks of the relationship between the world out there and its representation on canvas.

Taking a long cool look at the world around them, painters such as Ralph Goings, Arne Besser and Franz Gertsch set out to paint unblinking records of it. The camera provides an impartial account of the way things look. It gives them the required visual information in a useful form, capturing an instant, immobilizing the subject and sheltering it from the constant flux of real time. The light won't alter, children won't fidget, the car won't be driven away just as the artist is about to depict the reflections on its hub caps. These artists use the pictorial conventions of photography as elements within their work rather than as sources of visual excitement in themselves.

For others, the photograph is merely a starting point. Placing loyalty to the demands of the painting above truth to photographic fact, Robert Cottingham, Don Eddy and Michael Leonard are willing to depart far from the source image if the painting seems to require it.

'The idea of being photographic or true to life doesn't really interest me' (Don Eddy).[1] Despite the Superreal look of their paintings they solve problems of composition, colour and form according to criteria derived from Fine Art traditions as much as from those to be discovered in photography. Cottingham, for example, finds exciting compositions in close-ups of far-off objects yet is little concerned with other aspects of photographic vision.

The camera as impartial eye
Tom Blackwell

The division between photography as tool and as the actual subject of the work is not always clear cut: some painters combine elements of both attitudes in single paintings, while others, like McLean and Mahaffey, have moved from one to the other. Such is the case with Tom Blackwell. One of the most interesting of the second generation Superrealists, his work encompasses most of its major

Tom Blackwell
34 Ford Tudor
Sedan (Customized
Chrysler Engine), 1971
oil on canvas,
54 × 56″ (137 × 142cm)

carefully composed photographs in the dramatically-lit interiors of automobile shows, where he gloried in the effects of coloured light reflected on the polished chrome of brand new machines. Working from cropped close-ups of car and motor-cycle engines he produced paintings in which the coils and twists of metallic tubes and the gleam on shiny bolts, turn into sinuous, almost abstract, patterns. Like the close-ups of Bell and Parrish, these were paintings which milked the pictorial potential of photo-vision.

As interested in the significance of subject matter as he is in formal matters, Blackwell has also painted works in which he records, as he puts it, 'the look and ambience of the modern world, synthetic junk and all.'[2] From 1973 onwards the motor-cycles are shown out of doors in natural light and settings, and usually the whole machine is depicted, for example *Little Roy's Goldwing*, 1974. Still dependent on photography, the artist no longer emphasizes its properties in these paintings, but *uses* it, as a means of recording the unorganized nature of the real world. These outdoor subjects in turn led him to widen the scope of his subject matter to include street scenes, where his early interest in reflections is coupled with the desire to capture the mood of reality, unabridged.

Like the motor-cycle, the urban street, with its expanses of plate glass creating reflections and counter-reflections, affords fine opportunities for lyrical brushwork while at the same time capturing 'the kind of thing that everyone sees but nobody looks at'.[3] *Takashimaya*, 1974, with its balanced horizontals and verticals, its busy areas set off against clear, unfussy ones, is typical of Blackwell's ability to create paintings which have the apparent casualness of reality as captured by the lens but which, on closer examination, turn out to be tightly organized compositions where as much loyalty is accorded to the

concerns. Born in Chicago, home of General Motors, he is fascinated by twisting entrails of machinery, by the reflections on polished surfaces, by the manner in which we accept media imagery as equating reality. Above all, Blackwell is known for his paintings of the motor-cycle, the contemporary icon, canonized by the film *Easy Rider*: it is the archetypal Superrealist subject – modern, man-made, and bristling with reflective surfaces.

Having moved from Abstract Expressionism to Pop, Blackwell began to work from single images in the early 1970s. The lack of precision in magazine pictures soon led him to take his own

traditional demands of painting as to the 'truths' offered by the camera.

Ralph Goings

The paintings of Californian Ralph Goings epitomize Superrealism's most salient characteristics. Along with his friend Bechtle he is, perhaps, the classic photo-realist. Taking a supercool, unblinking stare at middle America, his works are concerned purely with the act of *seeing*, unconditioned by preconceived notions about the social or emotional connotations of the subject matter. He achieves neutrality by deliberately suppressing evidence of brushwork, but most of all by working from intentionally artless photographs. Like Estes, he is not averse to using several source photographs for one painting: the camera is merely a useful tool which provides accurate and impartial information about textures, about the exact colour of vinyl or sky, about the shapes created by spaces between objects on a two-dimensional surface. 'One of the delightful things I find about working from photographs,' he says, is that 'you really get a chance to see reality in all its awkwardness and all of its randomness.'[4] With this in mind, like Salt and Bechtle, he consciously avoids composing with the camera, but merely points it towards the trucks and fast-food diners which are his main subject matter.

Concentrating on mundane aspects of contemporary life, Goings' paintings reveal their unexpected beauty; *Dick's Union General*, 1971, depicts a building and vehicle neither of which would rate highly in contemporary canons of taste, yet the loving attention with which Goings paints their forms and surfaces implies a re-evaluation of aesthetic judgment. As the artist says: 'Depiction becomes an extension of seeing. Looking leads to discovery of the specific and particular. Whether or not the specific and particular are in and of themselves artful is a modernist question that is only

Ralph Goings
Dick's Union General, 1971, oil on canvas, 40 × 56″ (102 × 142cm)

valid as a question if we accept the modernist hierarchy of form.'[5] According to Linda Chase,[6] his dispassionate approach was partly prompted by reading Robbe-Grillet's 'New Novel' *Le Voyeur*, especially the passage where the protagonist recalls drawing a seagull as a child; he can remember vividly how the scene *looked*, but cannot bring to mind how he *felt* at the time. Already encouraged by Pop art to abandon abstraction in the early 1960s, Goings was painting pick-up trucks in a classic Superrealist manner by 1969, hamburger joints by 1970, and their interiors by 1972.

Goings is often at his best when using a narrow range of closely aligned colours as in *Airstream Trailer*, 1970, and his work has benefited enormously from his recent move to a remote township in New York State, where the harsh Californian light is replaced by the softer diffused light of the East Coast. His works have become more subtle and muted, colours tend to bleed into each other, edges to be less sharply

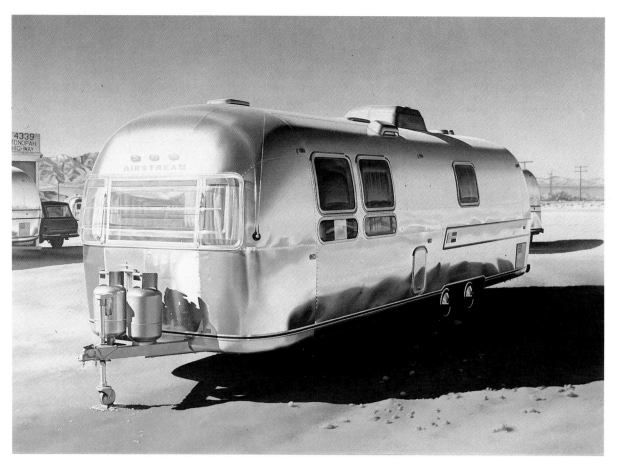

Ralph Goings
(above) *Airstream Trailer*, 1970, oil on canvas, 60 × 84" (152 × 213cm) (right) *One-Eleven Diner*, 1977, oil on canvas, 38 × 52" (97 × 132cm)

'One of the delightful things I find about working from photographs . . . you really get a chance to see reality in all its awkwardness and all its randomness'. (Ralph Goings, 1972)

defined, so that objects do not appear in such isolation from each other. Retaining his sensitivity to surface, he now seems to be investigating forms in greater depth. Quieter in mood, the interiors of his diners, for example *One-Eleven Diner*, 1977, feature fewer synthetic materials – wood vies with Formica, the waitress wears cotton not nylon. Responding to his new environment in a characteristically realist manner, Goings' entire Superrealist output testifies to his concern with the outward appearance of things rather than with their symbolic significance.

Idelle Weber, Jean Olivier Hucleux, Arne Besser

Much the same can be said of the work of Idelle Weber, Jean Olivier Hucleux and Arne Besser, but whereas Goings deliberately picks banal subjects, these three painters often focus on topics reeking with emotive associations – only to paint them with a total lack of passion. Like the sulky shouting of 'I don't care', Hucleux's graveyards, Weber's street litter and Besser's prostitutes seem to defy emotional response. To give their works a deadpan neutrality, they all avoid the dramatization of artificial light or sweeping camera angles, working from day-lit, frontal shots of their subjects which act primarily as information. Although Weber frequently relies on the photographic convention of close-up vision, she does so for its ability to pick out one particular segment of reality rather than for its distorting potential.

Besser and Hucleux also retain some of the pictorial conventions of photography in their paintings, but their works seem to be primarily concerned with rendering the 'thereness' of subject in a matter-of-fact fashion rather than with the look of the photograph. One of the few French Superrealists, Jean Olivier Hucleux's giant representations of human and car cemeteries (*Le Cimetière*, 1974), as well as portraits (one of which shows Jean-Pierre

Arne Besser (left)
Reba, 1976, oil on
canvas, 60 × 48″
(152 × 122cm)

**Jean Olivier
Hucleux** (right)
Le Cimetière, 1974,
oil on wood,
78½ × 118″
(200 × 300cm)

Raynaud in his white tiled house complete with crypt and tombstones), show him to be pre-occupied with death, yet in classic Superrealist fashion the act of rendering his subject from the projected slide is the main concern and the artist's own views on his subject remain inscrutable.

Like Goings, both Hucleux and Weber delight in the visual characteristics of their subjects: the smooth marble of a grave, the velvety bloom of a peach. For Weber the surface quality of a piece of fruit has as much significance as the gleam on a discarded wrapper: the subject is chosen for its formal elements. Her change of subject from fruit and vegetable displays to litter, made in 1974, was prompted by the visual excitement of the latter. Finding the containers more formally stimulating than their contents, she set about photographing empty crates and cartons on the pavement. She insists that the paintings are not intended as social comment, but that she is 'attracted by the sprawling quality of groups of discarded objects. The image is so different from the formality and order in which such objects appear, when new or unused, on shelves or in closets. However . . . I am attracted to formal pictorial elements in discarded trash.'[7] Resident in New York though Chicago-born, Weber began as a realist in the 1950s and was associated with Pop during the following decade. Her work even then stressed draughtsmanship, a quality still retained in her Superrealist paintings. In *Nugget Brand*, 1976, for example, geometric forms are emphasized, and great care is taken in

relating these to the edges of the painting. Her delight in the rich calligraphic designs which appear on the discarded packaging is obvious. Although she composes in the viewfinder, from subjects found in New York's less salubrious districts, she sometimes alters the arrangement of her subject before she photographs it, if she feels this will help the composition. By the same token, although she works from the projected slide, she sometimes brings back an item of rubbish to the studio as additional information to work from. Both the photograph and subject matter are subservient to the contrasts of texture, shape and colour upon which she bases her work.

The amoral stand towards socially relevant issues taken by Weber and Hucleux becomes more shocking when applied to subjects which have traditionally been chosen for their 'expressionist' connotations: circus performers and prostitutes, the subjects of Arne Besser's work, have a pedigree in modern art from Manet to Picasso, where

they have usually acted as symbols for the social outcasts and victims of an imperfect society. Yet in Besser's paintings prostitutes are treated with the same passionless gaze as a Goings pick-up truck. Street-signs, window displays and passers-by are accorded equal attention, while the informal composition found in many of his works stresses the visual chaos of things as they are. As in a film still, pictorially important elements such as a street corner or a prominent figure, are often placed off-centre, giving Besser's work the casualness of an arrested moment in time. Resident in New York but with his artistic origins in New Mexico and Los Angeles, he had an academic training, and though his Superrealist paintings retain traces of photo-vision, his painterly brushwork and masterful depiction of the human body speak of years spent in the life-class (for example *Reba*, 1976). That his loyalties ultimately lie with traditional realism has been borne out by his recent water-colours of natural landscapes.

Franz Gertsch, Jack Mendenhall, John Baeder

The work of Besser, Hucleux and Weber seems almost perverse in its literal, objective treatment of emotive subjects. In contrast, Gertsch, Mendenhall and Baeder's paintings, also based on the documentary power of photography, draw our attention to the oddities to be found in 'reality'. Their paintings seem to indicate that fact truly is stranger than fiction; Baeder's idiosyncratic diners or the sheer bad taste of Mendenhall's interiors appear hardly credible, as do the drama and intensity which Gertsch discovers in the most mundane of human activities.

The current nostalgia boom has relegated 1930s design to the antique shop and the period movie, yet John Baeder's art deco diners, obviously painted from recent photographs, tell us that these highly individualized buildings still exist in the here and now. For example, the sheer exhibitionism of *Empire Diner*, 1976, designed to emphasize the effects of

Idelle Weber (left)
Nugget Brand, 1976,
oil on canvas,
47 × 72″ (119 × 184cm)

John Baeder (above)
Mickey's Diner, 1978,
oil on canvas,
48 × 72″ (122 × 184cm)

111

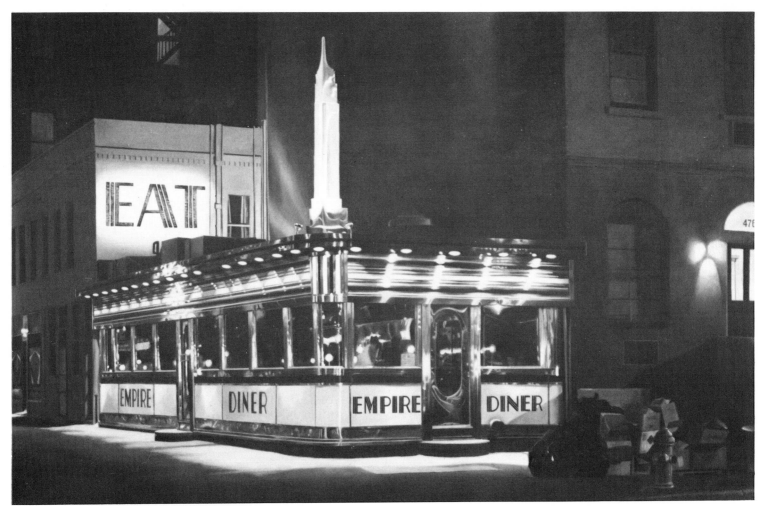

electric light on streamlined chrome, seems to belong firmly to the past, yet the polythene litter bags piled outside tell us that it still stands now. Without its Superrealist technique, the painting would not win the suspension of disbelief upon which much of its impact rests. Born in Indiana but living in New York, Baeder shares a fascination for the recent past with Staiger and Bond, and like Staiger has painted from old picture postcards, but most of his work centres round his strangely wonderful diners, factually recorded by the camera. The detailed accuracy of photography enables him to convey unlikely subjects with conviction, but beyond this his work does not explore

photographic vision. Often working on a small scale and frequently in watercolour, with a muted palette and subtle painterly brushwork, he gives his paintings a presence which differs markedly from the source photographs. The camera is used merely to *record* the unexpected – and very often unnoticed – aspects of the real world to which his paintings draw our attention.

The subjects of Franz Gertsch's paintings are not unusual in themselves but seem to point to the non-ordinary undertones to be found in the mundane. Experiencing this Swiss artist's work is rather like watching a film without the sound; we can see what goes on but do not

know the implications. Gertsch isolates incidents in the lives of his immediate circle – his friends helping each other with their make-up, a picnic, children playing on a beach – but treats them in an objective, photo-realist manner which seems to contradict the subjectivity with which such personal, human relations are usually grasped. Working on a gigantic scale (one of his works is almost twenty feet (600 cm) wide), heightening the tonal contrasts and already lurid colour of the projected transparency, he retains the 'truth' of reality as documented by the camera yet emphasizes its dramatic aspects.

No doubt the colourful and now

John Baeder (left)
Empire Diner, 1976,
oil on canvas,
32 × 50″ (81 × 127cm)

Jack Mendenhall
(above) *Two Figures
in Setting*, 1972,

acrylic on canvas,
82 × 78″
(209 × 198cm)
(right) *Mirrored
Dressing Room*, 1977,
oil on canvas,
59½ × 70½″
(151 × 179cm)

extinct hippies which Gertsch frequently depicts also contribute to the exotic nature of his work; like specimens, they appear to be pinned down for posterity. Yet for the artist the subject and technique are subservient to his avowed aim to 'render a sense of life'.[8] He paints the young because they best embody life's energy and vitality, he works from slides because he believes that 'reality, today, cannot be seized other than by the camera since man has become used to considering photographed reality as the ultimate rendering of the real.'[9] Before adopting this style in 1968, Gertsch had formalized from reality or had used it in a surrealist manner, and his present work still shows his commitment to humanist values. By dealing with the interaction between people in an objective manner his works seem to hint at the schism which exists between a purely visual

understanding of situations and the complex interplay of sense and intellect with which we actually perceive real-life encounters.

The sense of life captured by Gertsch is notable only for its absence in the unnaturally silent, ultra-clean interiors depicted by Jack Mendenhall. The people who occasionally invade them (for example *Two Figures in Setting*, 1972), immaculately groomed and politely smiling, appear as wooden as the furniture, while both furnishings and people seem to belong to the television soap opera rather than to real life. Since 1971 this Californian painter has portrayed the trite world of the contemporary nouveau-riche, and although he works from pre-existing photographs found in interior design magazines, like Baeder he uses photo-realism as a means of establishing the

credibility of unlikely subject matter. We realize with a shock that such interiors, so unrelated to contemporary design trends, actually do exist.

Where formal concerns overshadow photographic vision

Recently Mendenhall's interest has shifted away from deadpan representations towards the near-abstraction of reflections and counter-reflections to be found in photographs of mirror-clad interiors. *Mirrored Dressing Room*, 1977, typical of these works, deals with the visual complexities of reality and reflected reflections of reality, so that it is these rather than the room itself which are the subjects of his work. This fascination with the visual ambiguities of reflective surfaces shows an attitude to

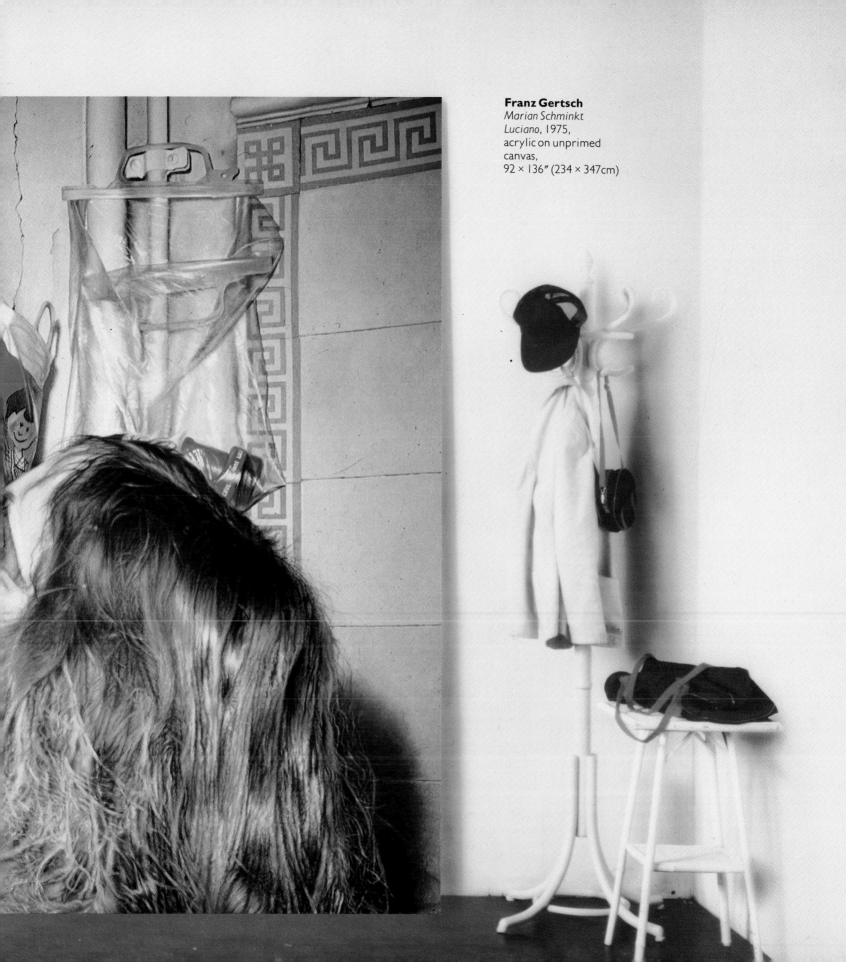

Franz Gertsch
Marian Schminkt Luciano, 1975,
acrylic on unprimed
canvas,
92 × 136" (234 × 347cm)

and the main aspect is to make the painting work in its own terms; the photograph then becomes a formal and colour reference.'[10] By working from views of anonymous buildings devoid of reference to the particular, he achieves two aims: the *general idea* of modern urbanity is conveyed, and the paintings are freed from the danger of being merely illustrative. The cool interplay of harsh verticals and horizontals against the fluid shapes of reflected light on glass have a

Brendan Neiland (left) *Division*, 1978, acrylic on canvas, 82 × 54½″ (209 × 138cm)

Plane, 1976, acrylic on canvas, 60 × 72″ (152 × 184cm)

Robert Cottingham (far right) *Art*, 1971, oil on canvas, 78 × 78″ (198 × 198cm)

Sylvia Plimack Mangold (below) *Two Exact Rules on a Diminishing Floor*

the camera which differs radically from its use as impassive recorder typified in the works of Goings.

Brendan Neiland and Sylvia Plimack Mangold

In the case of some photo-realists, the camera is used simply as a means of documentation. Sylvia Plimack Mangold's floors, Brendan Neiland's glass and steel façades, and Robert Cottingham's shop signs all show a concern for the abstract attributes of their subjects which overshadow the demands of illusionism as such, while the works of Michael Leonard and Don Eddy retain the accuracy of detail found in the photograph but are not dependent on it for their pictorial organization.

This approach can take an artist's work almost beyond the boundaries of photo-realism. The English painter Brendan Neiland works from his own photographs of skyscrapers in order to evoke the contemporary urban environment, yet 'the painting becomes an interpretation,

visual excitement of their own, independent of their representational function. Rather than giving an impassive account of reality, these are paintings which raise interesting questions about the polarities of realist and non-objective art.

As early as 1968, Sylvia Plimack Mangold's floor pieces were already pointing to the possible diffusion of these supposed opposites. They could either be seen as abstract explorations of pictorial space or as highly realistic representation of parquet floors. Painted from polaroid snapshots but without retaining the visual peculiarities of such images, these works were about the artificiality of illusion: the wood grain was rendered with loving detail yet the floor lacked familiar reference points, so that the paintings appear to indicate that we can only trust the 'reality' of the painting itself.

Since 1975, the artist's pre-occupation with precision has led to paintings such as *Two Exact Rules on a Diminishing Floor Plane*, 1976, where some elements are mathematically measurable, yet they only serve to show that a betrayal of such accuracy is necessary if a convincing illusion is to be created; thus the floor tiles in the background must be smaller in width than those depicted on the picture plane. The conceptual nature of her work has led her away from photo-realism towards the use of traditional one-viewpoint perspective and *trompe l'oeil* treatment of surfaces, yet her entire output is unified by a concern with the 'abstract' character of certain aspects of reality.

Robert Cottingham

Whereas Plimack Mangold paints highly illusionist renderings of abstract-looking subjects, Robert Cottingham seeks out abstraction in the individualized neon signs he paints. 'I don't care about being realistic. In other words I don't put in a little rust spot or bolts that show . . . I'm

just using the subjects as the stepping-off points to compose the painting.'[11] Composing with the camera, he extracts the maximum formal excitement from his subject by manipulating the photographic image. The telephoto lens finds views of reality not easily accessible to the naked eye, a shallow depth of field flattens space, while abstract patterns are formed by the strong shadows cast by the neons, by cropping, and by the use of dramatic camera angles.

This attitude to photography is close to that of Kleemann and Bell but, unlike them, Cottingham does not hesitate to

transform his sources. By putting formal considerations above all others, the true subjects of his work are the abstract patterns he discovers in the contrasting diagonals, flat shapes, colours and linear flow of the neon tubes seen against their background. (For example *Art*, 1971.) Even in his recent work, where a different lens is used to show more general views, Cottingham's tendency to dramatize and formalize are evident. Using his training in the field of advertising art to good effect he turns a mundane subject, such as the façade in *Frankfurters and Hamburgers*, 1977, into a dynamic image. Cottingham's

Robert Cottingham
Roxy, 1971, oil on
canvas, $76\frac{1}{2} \times 76\frac{1}{2}$"
(194 × 194cm)

Robert Cottingham
Frankfurters and Hamburgers, 1977,
oil on canvas,
78 × 78″ (198 × 198cm)

creation of stunning visual effects forms a marked contrast to the subdued calm produced by Neiland or to the cerebral appeal of Plimack Mangold's work, yet all three painters challenge the supposed incompatibility of abstraction and realism.

Don Eddy and Michael Leonard

More concerned with the realist's traditional problems of reconciling the demands of subject and those of pictorial organization, the Californian Don Eddy and the Englishman Michael Leonard epitomize the use of the camera as tool. Both prefer the freedom of working from black and white photographs rather than from slide projections, and both use several source photographs for a single painting, thereby asserting their right to make their own compositional and colour choices. Their loyalty is to the needs of the painting; the photograph acts merely as a convenient source of information.

The high illusionism with which Eddy so skilfully portrays his subjects could lead us to see his paintings as deadpan depictions of the world 'as it is', yet further consideration soon reveals the artificiality which underlies his work. All the vessels in *Glassware I*, 1978, are depicted in sharp focus, a visual discipline which neither human nor photographic vision could attain; we see convincing illusions of three-dimensional objects, yet the painting as a whole reads as a flat surface; the colours appear to be those of glass, yet they have a uniformity which does not ring true to life. The result is a tightly structured painting which deals with spatial ambiguity rather than with photography or reality as such. 'The central problem in the paintings to me is a painting problem and not a subject matter problem. It has to do with the relationship between the outside world, the surface of the canvas, and the kind of tension that is set up between illusionary space and the integrity of the surface of the canvas . . .

things refer not only to reality but back to the painting.'[12] Despite his use of classic Superrealist iconography – cars, shop windows and reflective surfaces – Eddy's work has always been concerned primarily with formal issues. The grid-like composition of *Glassware I* is a natural progression from the formalizations already apparent in earlier works such as the 1972 *Pots and Pans*, where the information from the source photographs was tidied up in the interest of geometric clarity. Similarly, the colours in early paintings such as *Untitled*, 1971, were his own, chosen for pictorial reasons, and he now restricts his palette to four colours to give his work even greater unity.

That Eddy is essentially concerned with solving pictorial problems is borne out by the fact that he sets himself increasingly difficult tasks. As if wrestling with the problem of real space, photographic space and pictorial space were not enough, he now imposes colour restrictions on himself and also chooses particularly difficult subjects such as silver on glass or even, more recently, glassware on glass shelves. Sometimes using as many as forty source photographs in order to keep the whole subject in sharp focus, his paintings manage to combine the straightforward delight of realistic representation with the severe discipline of geometric formalization. Appearing deceptively simple, these elegant works are, paradoxically, among the most visually complex of all Superrealist paintings.

Michael Leonard's reasons for deviating from photographic 'truth' differ from Eddy's but he shares the latter's willingness to manipulate his photographic sources in the interests of compositional clarity. Less concerned with exploring visual ambiguities, Leonard seeks rather to strike a balance between the formal demands of the painting and the need for precision in depicting the subject. In his recent painting *Scaffolders*, 1978, for example,

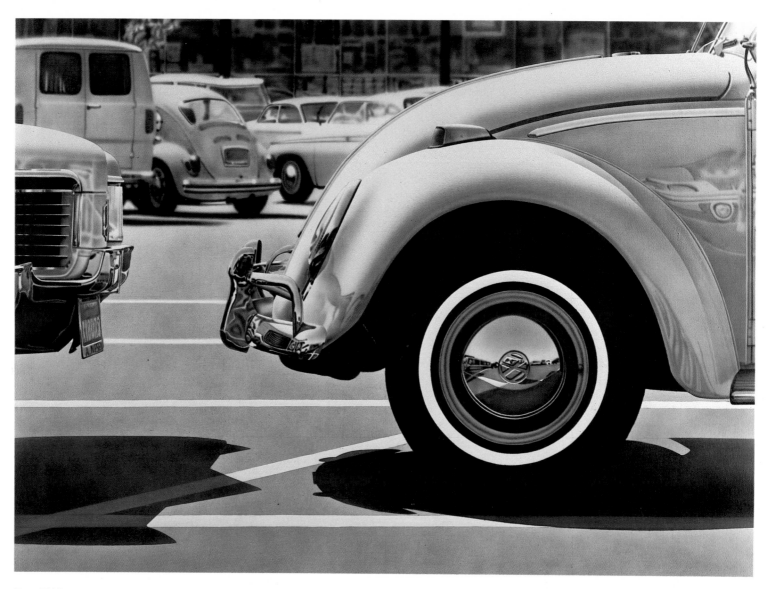

Don Eddy
Untitled, 1971,
oil on canvas,
48 × 65″ (122 × 165cm)

Don Eddy
Glassware I, 1978,
acrylic on canvas,
$52\frac{1}{4} \times 40''$
(133×102cm)
Sometimes using as
many as forty source
photographs in order
to keep the whole
subject in sharp focus,
Eddy combines the
straightforward
delight of realistic
representation with
the severe discipline
of geometric
formalization.

124

the verticals and horizontals of the scaffolding tubes are placed to echo the shape of the canvas; the figures, clouds and scaffolding board intentionally create the contrary diagonal pulls which complete the painting's composition, while the border which surrounds the image insulates his colour harmonies against the possible conflicting shades of gallery or living-room wall. Typical of his work, it is composed according to his own criteria, not those of the camera.

Leonard is a realist so that, like Flack, his art will be accessible to all; he uses photographs because they provide precise information, but beyond this he does not share the classic Superrealist concerns typified by Goings or Close. His rather enigmatic paintings depict people and places which have personal meaning for him, and the grey tonalities with which he unifies his colours are sometimes reminiscent of Corot rather than Kodachrome. Trained as a graphic designer, he was an illustrator until he made his recent decision to devote himself to painting, yet his works are remarkably free of illustrative properties; they are characterized, rather, by a gently insistent presence which show his sensitivity to traditional aesthetic concerns.

Leonard's approach to composition has roots which stretch back as far as the Renaissance, while Eddy's links are with post-World War II aesthetics. Although Leonard uses photographs instead of sketches he still juggles his information around until it forms a coherent centralized image whereas Eddy organizes his subject into an 'all over', non-focalized composition. Yet both produce carefully contrived paintings which in turn form a sharp contrast to the representations of unabridged reality by artists such as Goings or Besser.

The variety of approaches discussed in this chapter is enormously diverse, both in terms of aims and means. Some artists abhor the use of traditional brushwork – for example Neiland and Eddy – using the spray-gun to suppress personalized mark-making; others savour the tactility of surface quality which the brush permits – for example Blackwell and Baeder; while others use it, but suppress its evidence – for example Goings and Leonard. For some the slide projector is taboo; for others it is crucial. An interest in formalization leads Cottingham and Neiland to generalize while Eddy, Plimack Mangold and Weber seek to combine it with meticulous precision.

However, the crucial differences lie in their attitude to reality. They comprise two main groups, one setting out to capture the haphazard informality of the surrounding world (Goings, Hucleux, Besser, Weber, Gertsch and Baeder), the other seeking to organize it into an ordered, pictorial entity (Eddy, Neiland, Cottingham, late Mendenhall, Plimack Mangold and Leonard). Yet despite this fundamental divergence, these artists are all united in their attitude to the photograph. Unlike the painters in the previous chapter, they are not concerned with the look of the photograph as such; they all use it as a means to an end rather than as an end in itself. Consider the works of Baeder and Douglas Bond, for example: both are fascinated by the 1930s, but whereas Bond explores the photographs of the period which feature art-deco design, Baeder deals directly with the eccentricities of period architecture. Baeder uses the photograph as accurate documentation, while Bond deals with the visual peculiarities of period photography.

Michael Leonard
Scaffolders, 1978,
acrylic on canvas,
41 × 40″ (104 × 102cm)

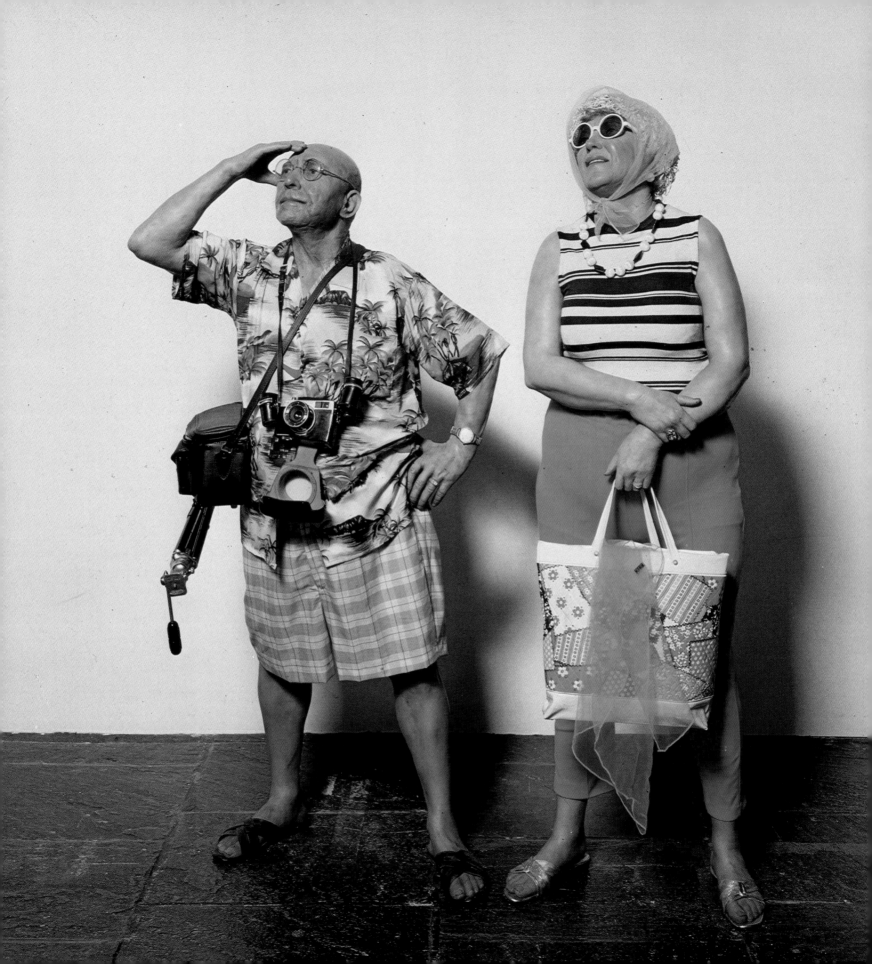

THE SCULPTORS

It could be argued that there is no real place for verist sculpture within Superrealism; that it is a movement centred around the artist's use of the photograph and that none of the sculptors deal with photographic realism. There are a few sculptors, however, who share the photo-realist painters' concern with objective truth and seek a similar degree of illusionism in their works, so that while their method of achieving it differs, their motivation is the same. Photo-realist painters reject the inaccuracies of subjective response and find maximum information in the dispassionate records provided by the camera; likewise, the verist sculptors avoid subjectivity by working directly from life-casts. Indeed, one could say that the sculptors produce the only truly Superreal works – solid, life-size replicas of reality – as opposed to the ultimate unreality of flat paintings.

Rumour has it that a Duane Hanson sculpture was shot in a recent art theft; on being surprised by one of his figures the thieves panicked and 'killed' the interloper. Whether this story is true or false is of little importance; the point is, it certainly *could* be true, and the same could not have happened with a painting. The degree of illusionism with which Hanson and other verist sculptors render their subjects is such that they frequently hoodwink people into taking them for the real thing. Indeed, the impact of their works rests largely on just this ability to deceive. At no point in the history of sculpture have people and objects been

rendered so realistically – and the shock is all the greater because we have been schooled to expect non-illusionism in sculpture.

The desire to create a figure so life-like that it almost breathes is as ancient as the attempt to paint a picture which fools the eye. It is often forgotten that the Greeks

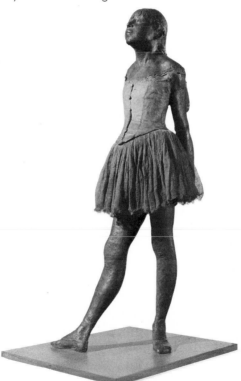

Duane Hanson (left)
Tourists, 1970,
polyester resin and
fibreglass,
polychromed in oils,
life-size

Edgar Degas (above)
*The Little Dancer
Aged Fourteen*, 1800–81,
bronze and other
media,
$38\frac{3}{4} \times 16\frac{1}{2} \times 14\frac{3}{8}$"
(98·5 × 42 × 36·5cm)

polychromed their sculptures with this in mind – the Pygmalion legend is based on this wish – and it is a theme which recurs throughout Western culture, from dolls which wet their nappies and cry real tears to religious idols which have 'real' hair and eyes. Its culmination can be found at Madame Tussaud's Waxworks, yet it is generally felt that such verisimilitude stands for cheap sensationalism or that it is 'popular art', far removed from the proper business of the serious artist, whose task is to transgress appearances in order to attain a 'higher truth'.

Naturalism itself is hardly new to sculpture. The scandal caused by Rodin's *Age of Bronze*, 1877, when he was wrongly accused of cheating by taking casts from life, was prompted by the fact that some unscrupulous academicians did, indeed, secretly indulge in this practice. Although naturalism dominated nineteenth-century attitudes, care was always taken to differentiate between Art and mere mimicry by the use of traditional monochrome materials such as bronze or marble, and above all by choice of subject matter. The human figure was used as a vehicle to glorify the famous, to embody narrative or to symbolize abstract ideas (such as Hope or Charity); whether it was idealized or not, nature was a means of conveying a message rather than as an end in itself.

The only sculpture of the period which eschewed such an approach was Degas' *The Little Dancer Aged Fourteen*, 1881, now cast in bronze but originally made of

polychromed wax and fully clothed with real garments, from shoes to hair ribbon. Yet despite its lively surface texture, which ensures that it cannot be mistaken for a real person, the sculpture was seen as the high-water-mark of naturalism for almost a century. As recently as 1965, the renowned art historian Alan Bowness wrote that it 'came about as close to the waxwork as art can get and represents the extreme of naturalism in sculpture. Nobody could or did go further in this direction.'[1] Two years later, Duane Hanson made the first Superrealist sculpture, cast from life, and polychromed to look far more life-like than even Degas' dancer. But his work, and that of the other verist sculptors, must be seen within the context of the above quotation, since it arose partly as a conscious reaction against the prevailing view as expressed by Alan Bowness. Until Superrealism emerged, the degree of naturalism reached by Degas was seen as an impasse, and twentieth-century figurative sculpture was largely

concerned with breaking out of naturalist confines. Nature became a spring-board, either for searches into pure form – as in the works of Brancusi, or for expressive purposes – such as those by Matisse. In both cases the sculptor transformed his subject by distortion or simplification so that aesthetic criteria continued to be based mainly on the manner in which the artists transgressed their sources. Consequently, verist sculpture is disorientating, not only because it refuses to respect the borderline which has traditionally existed between art and nature, but because it claims serious consideration as Art while being based on criteria which have hitherto been used to point to the differences between art and charlatanism.

Expectations are further confused because verist sculpture also stands apart from twentieth-century attempts to fuse art and life, as originated by Marcel Duchamp. Ever since he declared an ordinary bottle rack to be a work of art in 1914, artistic boundaries have been stretched to encompass actual reality. Creativity was redefined as being situated in the act of *choice* rather than in the act of physical fashioning and the path was opened for the ultra-real art of 1930s Surrealist 'found objects', 1950s 'happenings' and the Performance and Environmental art of the present day. Verist sculpture thus commits a double crime: it mimics reality rather than

encompassing it, but refuses to transform it for formal or expressive reasons.

Yet, like photo-realist painting, much of the impact of verist sculpture is founded on this deliberate refusal to conform with accepted aesthetic criteria, and again the attitude was derived, most of all, from Pop art. Like Pop, it depends on dislocation of context for effect: de Andrea's famous sculpture of two lovers, for example, shocks because one does not expect to come across naked people copulating on the floor of an art gallery. Both he and Duane Hanson cite George Segal's life-size figures as important influences, and when Jasper Johns, with Duchampian humour, used the traditional methods and materials of sculpture to make bronze replicas of expendable, mass-produced beer cans, he was unconsciously paving the way for Marilyn Levine and Fumio Yoshimuro's simulations of real objects. But the consummate craftsmanship which underlies their works differentiates it from Pop; verist sculpture shares Pop art's

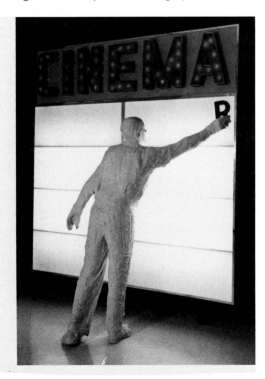

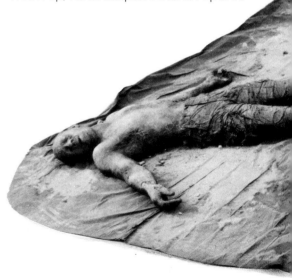

George Segal (left)
Cinema, 1963,
plaster, illuminated
plexiglass, metal,
118 × 96 × 39″
(300 × 244 × 99cm)

Jasper Johns (top)
Painted Bronze (Ale Cans), 1960,
painted bronze,
$5\frac{1}{2} \times 8 \times 4\frac{3}{4}″$
(14 × 20·3 × 12cm)

opposition to Greenberg's aesthetics but eschews its deliberately sloppy formalism. The central difference between the two lies in the Superrealist sculptor's earnest commitment to verisimilitude and this, too, is the unifying link between the sculptors: they all produce works which bear an extraordinary and uncanny resemblance to their subjects.

Duane Hanson

By far the most immediately startling, and certainly the most well known, are Duane Hanson's clothed figures; his 1978 retrospective exhibition broke all attendance records when it was shown at the Whitney Museum, New York, and his work has received wide coverage, not only in the art press but also in the mass media. It is particularly appropriate that he should be one of the most popular of all Superrealists, since his use of high illusionism is not founded on sophisticated, circular jokes about art and reality, but stems from a sincere desire to create works which comment on social problems whilst being accessible to the general public. Despite its precise realism his work is closer in spirit to the expressionism of Bacon and Keinholz, who evoke social and psychological misery, than to Pop's cool irony.

Hanson reached artistic maturity relatively late. Born into a small rural community in Minnesota, which he says knew nothing of art, he spent a great deal of his early career attempting to find a visual language which would be understood by such people, without regressing into outdated narrative figuration. He wanted to reconcile his populist aims with the ideas on contemporary art learned at art school. 'I did some formalist pieces, making pretty aesthetic statements in wood, stone and clay . . . It always ended up as decoration, and I felt unhappy about it. I wanted something that could really communicate with people.'[2] Two factors helped to resolve his dilemma: his acquaintance with the technique of casting from life-moulds in polyester resin, and the discovery of Pop. The latter showed him that realism could have contemporary validity, while the use of plastics cancelled out any overtones of academicism.

In 1965, aged forty, Hanson made his first realist sculpture. Entitled *Abortion*, it depicted a pregnant woman lying under a

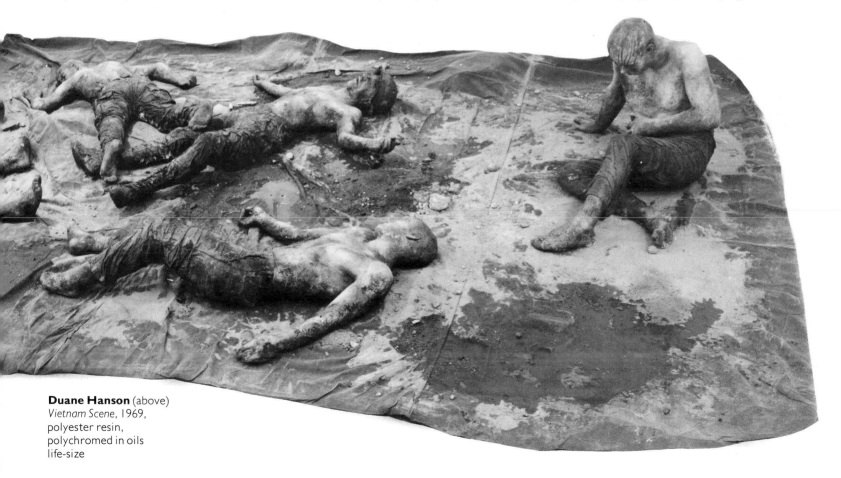

Duane Hanson (above)
Vietnam Scene, 1969,
polyester resin,
polychromed in oils
life-size

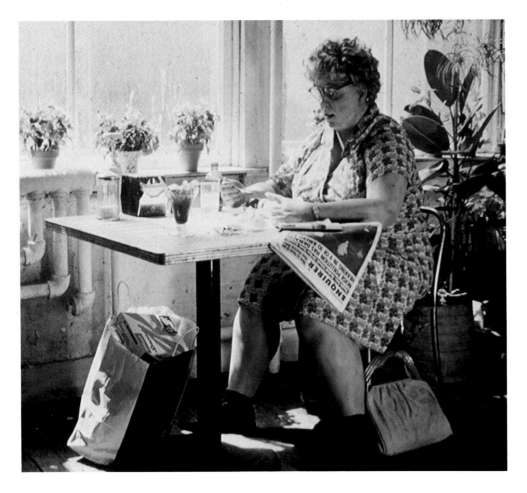

Duane Hanson
Woman Eating, 1971,
polyester resin and
fibreglass with
talcum, polychromed
in oils, life-size

'The subject matter
that I like best deals
with the familiar
lower and middle-
class American types
of today. To me, the
resignation,
emptiness and
loneliness of their
existence captures
the true reality of life
for these people . . . I
want to achieve a
certain tough realism
which speaks of the
fascinating
idiosyncrasies of our
times'. (Duane
Hanson, 1977)

shroud, and although it was small and
made in plaster it typified the concerns
which were to occupy him for the next
five years. Made in direct response to
news coverage of deaths caused by illegal
abortions, it was realist, hard-hitting and
topical. Other works followed in the same
vein, using subjects culled from
contemporary press reports to pinpoint
the violent and tragic aspects of modern
life – topics intended to affect the general
populace, regardless of their knowledge
of art. From 1967 onwards the figures
became life-size, polychromed and
clothed. The themes remained the same
but the reassuring barriers between 'art'
and reality were completely removed.
Continuing to focus on contemporary
disasters such as race riots, road accidents
and social outcasts, Hanson dealt with
them directly, by-passing aesthetic
niceties and reconstructing the scenes
with maximum realism in the interests of
maximum impact. *Vietnam Scene*, 1969,
intentionally renders the five dying
soldiers with such authenticity that one's
immediate reaction is to the subject itself,
rather than to its formal properties. A
subject close to the hearts of all
Americans at the time, it derives its
intensity partly from its context (soldiers
don't die in art galleries or museums), and
partly because it recreates, in tangible
form, the atrocities usually experienced
more artificially on the two-dimensional
television screen or the grainy news
photograph.

The technique which Hanson evolved
for early works such as *Vietnam Scene* is
one he has used ever since, although
originally the poses were often based on
news photographs. More recently, the
naked live model is asked to take up the
required position and then covered with
petroleum jelly so that the mould will not
stick. A separate mould is successively
made for the head, torso, and each arm
and leg, by wrapping layers of bandages
dipped into wet dental plaster around the

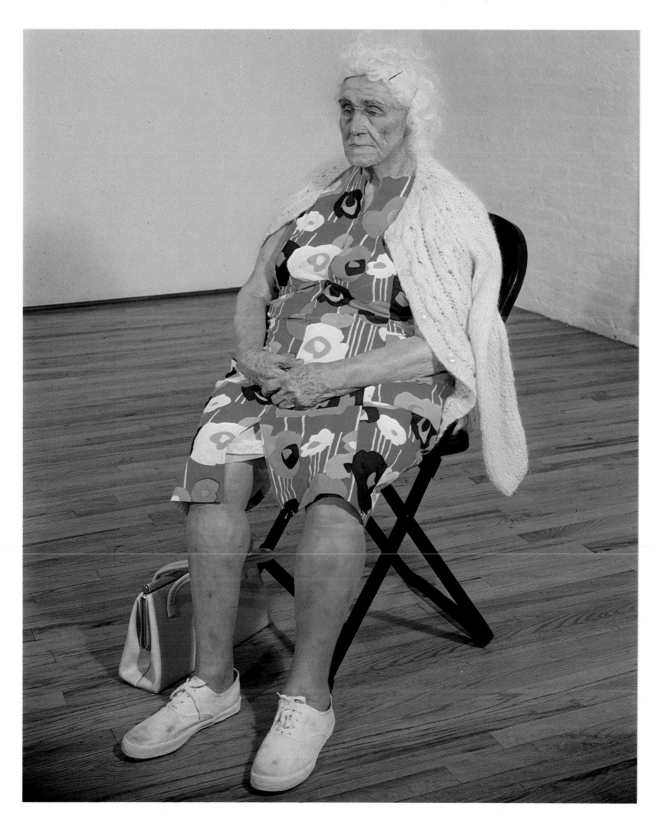

Duane Hanson
Woman with White hair,
1976, cast vinyl,
polychromed in oils,
life-size

limb. Once it has dried (after about thirty to forty-five minutes) each plaster mould is cut away from the body, repaired and cleaned. At this stage certain changes in its shape can be made: any awkwardness in, for example, the curve of a back or an arm can be rectified since the moulds have a certain degree of flexibility. They are then filled with successive layers of flesh-coloured polyester resin, reinforced with fibreglass, the mould is cut away, and the separate pieces of the body are joined together, any further adjustments being made at this stage, including remodelling the facial expression. The figure is then

ready to be painted, and given the wig, clothes and jewellery which complete the illusion.

With this realist technique Hanson was hoping to provoke a direct response to the subject so that people would forget they were looking at 'art'. This clearly worked for the curator of the Bicardi Museum, Florida, who refused to show Hanson's *Gangland Victim*, 1967, and *Motorcycle Accident*, 1969, because 'people come here to relax and see some beauty, not throw up',[3] but although it is easy to deride his reaction he did identify the pivot upon which these expressionist works rest. It is

precisely *because* they are presented as art that Hanson's tableaux are effective. Similar themes have been treated by contemporary artists – for example, Edward Keinholz's treatment of racial hatred – with varying degrees of obliqueness but none with the directness of Hanson. But art which is almost completely dependent on shock tactics is in danger of seeming trite once the initial impact has worn off. As Hanson puts it, 'You can't always scream and holler. You have to whisper once in a while, and sometimes a whisper is more powerful.'[4] From 1970 he turned his attention to

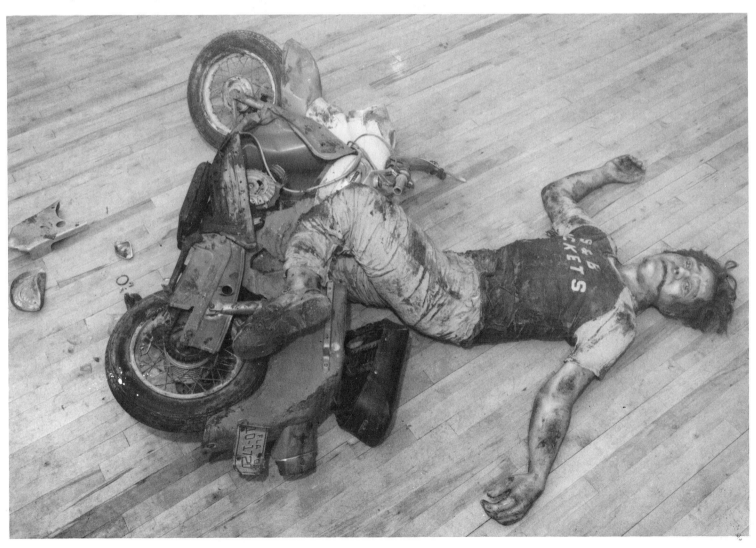

topics that were less sensational, depicting psychological and spiritual malaise rather than the extremes of human suffering; an exhausted businessman or a dejected janitor replace the maimed and hopeless victims of his earlier work. His means altered accordingly: no longer re-enacting a situation suggestive of narrative, the figures are caught unawares; they are single (or at most, in couples), and usually without elaborate props. Moreover, their poses are chosen by the artist, often in co-operation with the model, rather than from news images, and the sculptures often depict the models as themselves. But in his shift away from the theatrical, Hanson did not sacrifice expressiveness or social comment.

'The subject matter that I like best deals with the familiar lower and middle-class American types of today. To me, the resignation, emptiness and loneliness of their existence captures the true reality of life for these people ... I want to achieve a certain tough realism which speaks of the fascinating idiosyncrasies of our time.'[5] Veering between the polarities of satire and sympathy, Hanson's figures typify the values of middle America. Decently clothed and more than adequately fed, they nevertheless appear unfulfilled; they are downcast and disillusioned or else coarse and insensitive. Some sculptures are clearly satirical: the elderly couple in *Tourists*, 1970, for example, appear to have been stolen from a comedy film and immortalized in polyester. Hanson admits that he has little patience for the attitude to life some of his figures embody, but he does not always take such a negative view of the people he creates. Often his most successful works are those which suggest a more ambivalent approach: a slovenly woman feeding on unattainable dreams marketed by romantic magazines may look ridiculous, yet sadness underlies the satire. We realize that she is as much a victim of circumstance as of her own

Duane Hanson
(left) *Motorcycle Accident*, 1969, fibreglass, polychromed in oils, life-size

(below) *Florida Shopper*, 1973, polyester and fibreglass, polychromed in oils, life-size

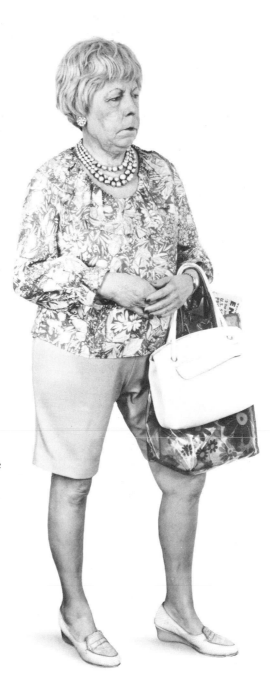

limitations. And particularly in his recent works, one often detects a central core of dignity beneath the hopelessness of the subjects, such as the self-pride of a very old lady (*Woman with White Hair*, 1976); again, when he shows people engaged in unfulfilling tasks such as dishwashing, laundering or janitoring, the works emanate sympathy rather than satire.

Hanson's ability to convey meaning without resorting to narrative or distortion stems from his acuteness of observation. We laugh at the tourist who has a rain-hood over her straw hat, we are touched by the old woman who wears tennis shoes for comfort yet keeps them as neat as her best leather ones doubtless are, and we know that the janitor will move awkwardly – because we feel we have seen them all before. With an eye for the telling detail, for choosing precisely the right facial expression and stance, Hanson suggests the universal by portraying the particular. This, too, is what distinguishes his works from those in waxwork museums; his figures are typifications of social trends rather than portraits.

Hanson's technical proficiency, too, has improved consistently so that the recent works, in particular, simulate skin textures and facial expressions with such uncanny realism that they are guaranteed to trick even the most practised eye, yet, as Joseph Masheck has pointed out, ultimately it is their artificiality rather than their realism which gives the works their impact.[6] They are unnaturally motionless, we can stare at them with impunity in a manner forbidden by social taboos where real people are concerned, and we may be led to reflect that the lifelessness of the figures echoes the life-styles which they evoke. With a deliberate stylelessness (and, some would argue, with naïvety), Hanson uses a realist technique in order to achieve expressionist aims.

John de Andrea

In complete contrast, John de Andrea, the only other verist sculptor who is concerned with the human figure, has no desire to comment on society's shortcomings. Though he uses the same basic technique as Hanson, he produces works which differ profoundly both in intent and effect. His is a classical art, concerned with ideals of beauty rather than with expression; his subject is the nude, not the clothed figure, and his models are invariably young and attractive. Yet his work is equally unsettling, albeit for different reasons. By making accurate facsimiles of models who conform to contemporary standards of beauty he causes confusion in our acquired sense of the division between the ideal and the realist; while his choice of the nude as subject is provoking in itself, given its somewhat dubious status in art since World War II.

De Andrea's path to realism was less tortured than Hanson's. Born in Denver, Colorado, in 1941, he studied art during the early 1960s, so benefiting from the liberating influence of Pop while still a young man. He began casting from life moulds in the late 1960s and was only twenty-nine years old when he showed the results at his first solo exhibition in 1970. In common with most Superrealists, he cites an aversion to Abstract Expressionism and a strong debt to Pop as his reasons for becoming a realist, and after a hesitant period of attempting to combine sculpture and painting he set out to 'make one good figure. I'd never seen or heard of one, and I thought that was

good.'[7] Since those early beginnings he has worked in two main categories: single or paired nudes, but in both cases his avowed aim is to make figures so life-like that they appear to breathe. The single figures rarely imply action or narrative: they pose seated, standing, or reclining, as if for an art class. Yet their ultra-realism produces an effect quite different from the usual product of the life-class. As with Hanson's works, the figure is too life-like for us to respond to it as art yet it confuses us further because of its concern with beauty and the nude, the twin bastions of art since the Renaissance. Like the *Mona Lisa*, they stood for all that was considered sacred in art until their vicious demise in the twentieth century – so that de Andrea makes two unpardonable gaffes: he uses discredited artistic criteria and he mixes two opposed means of expression.

The *Seated Woman*, 1978, for example, could be the answer to a modelling agency's dream – she is slim, fresh faced, and well proportioned – but she also has unevenly-coloured skin, hands which speak of work rather than glamour, and, horror of horrors, uncomfortably virile pubic hair. She is too real to be ideal, yet too ideal to be realist and as with Hanson's figures, the illusion soon wears off; the woman we thought we saw, so unselfconsciously naked in an art gallery, turns out to be nothing but a dummy. She does not return our look, but gazes on regardless. As the realization dawns, her pensive calm comes closer to unnatural rigidity, and any sexual fantasies she may have provoked soon vanish.

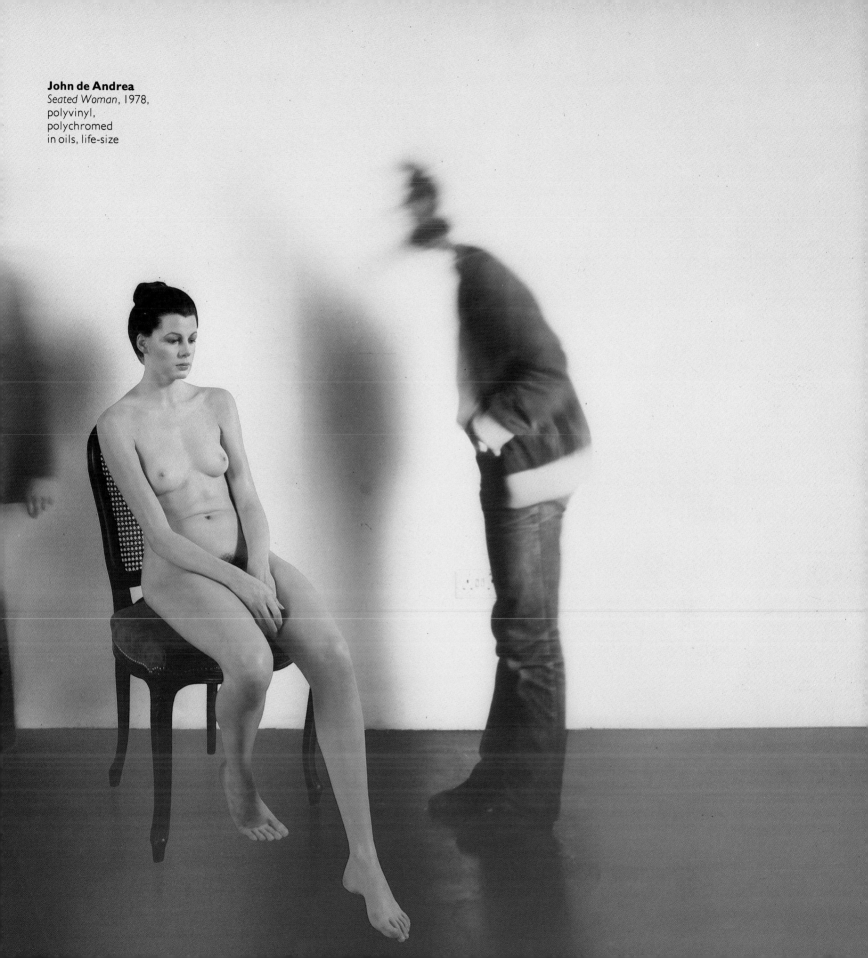

John de Andrea
Seated Woman, 1978,
polyvinyl,
polychromed
in oils, life-size

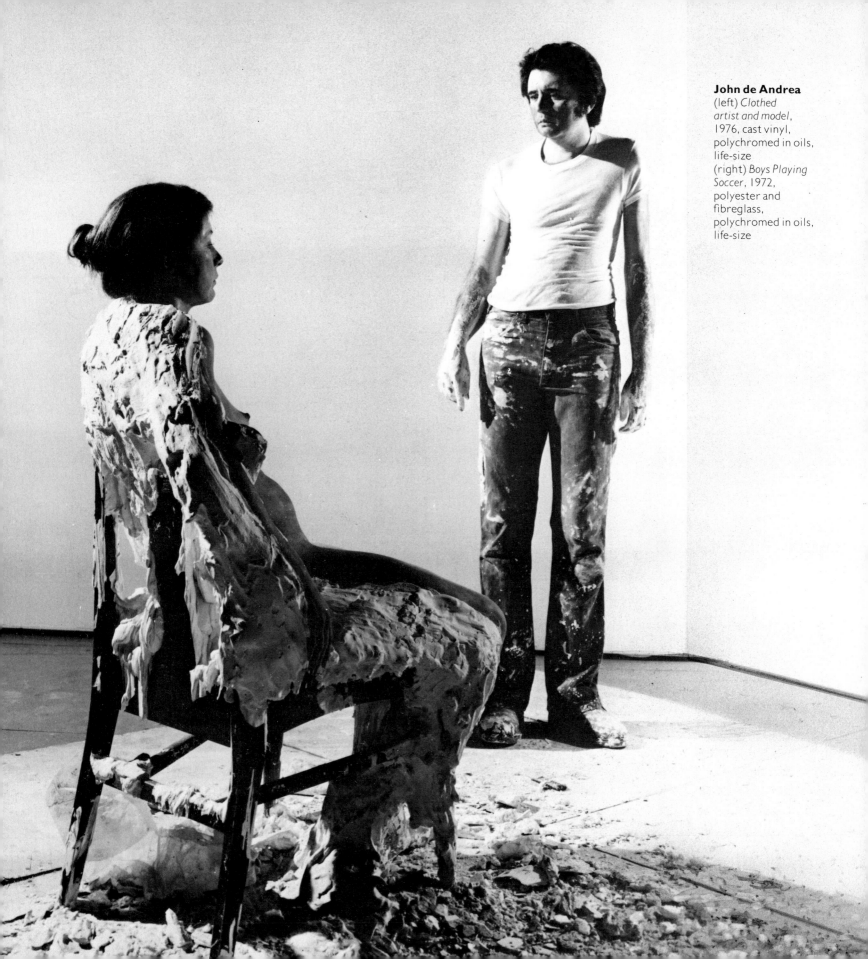

John de Andrea
(left) *Clothed artist and model*, 1976, cast vinyl, polychromed in oils, life-size
(right) *Boys Playing Soccer*, 1972, polyester and fibreglass, polychromed in oils, life-size

The mood of eroticism which, however briefly, touches the single figures, is even more evident in the paired nudes. As in a Surreal dream, we witness familiar scenes such as boys playing soccer or young lovers gazing into each other's eyes, but, inexplicably, they appear in the nude. These works seem even more bizarre than the single figures because they are 'subject sculptures' as opposed to life studies. Mostly they depict people engaged in particular activities, communicating with each other in some way, and there is often a suggestion of unspoken narrative. Like eighteenth-century conversation pieces or nineteenth-century anecdotal paintings, they lead us to wonder exactly what is happening. They seem incongruous partly because the protagonists are naked, but also because they are shown in arrested action; like a real-life version of the game of 'statues', these figures are halted in their tracks; but *they* are doomed to sustain their positions (and emotions) for ever.

The problem of relating separate figures, or volumes, to each other is one which has fascinated sculptors as diverse as Michelangelo, Rodin and Hepworth. It concerns, as de Andrea has pointed out, the creation of a psychological relationship between the two, but it is also a formal challenge. De Andrea approaches it from various angles; in some cases the figures are paired, one feels, mostly because they form a pleasing composition. In *Boys Playing Soccer*, 1972, for example, the figures create three-

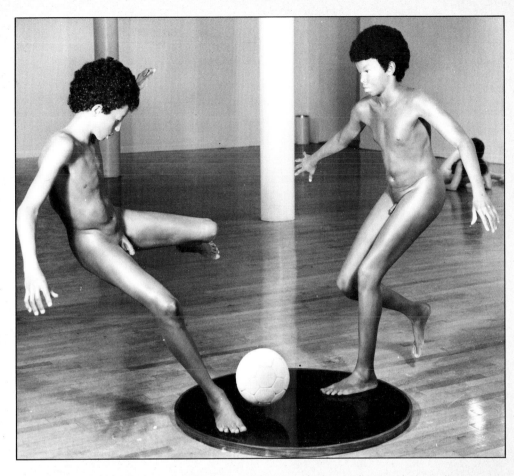

dimensional arabesques in a manner not far removed from the classical tradition. But where the emphasis is placed on emotional relationships, such as a lover's quarrel, we sense that the sculptor is primarily concerned with freezing a moment in time, with showing the event as it really happened. We see scenes we have experienced or observed countless times, either in life or on film, or else themes traditional to Western art. But in both cases they are treated with the same explicit realism as the single figures. Naked lovers, or the artist's model, for example, have a long artistic pedigree and, as with his use of the nude itself, one feels that de Andrea is challenging art at its own game, by re-enacting its themes in terms of 'real' life.

This is particularly true of *Clothed artist and model*, 1976, by de Andrea, a work where we are shown the artist in the process of creating 'art', yet the work is so lifelike that it exists uneasily between art and 'reality'. It sums up the layers of meaning which can exist in de Andrea's work: the theme is traditional and particularly apt, since its antecedent is the Pygmalion story concerning the sculptor who created a live and perfect woman from clay; and de Andrea's version makes full play on the various levels of reality and

illusion. The story is reversed since we witness a 'live' woman being transformed into Art, yet the art creates an illusion of reality, and this illusion is itself exposed since we see how it is done. De Andrea's works deal with paradox. They are highly realist, while mostly being untypical of real life, they show ideal types without idealization, they deal with Art while looking too lifelike to be art. His work is disconcerting because it disturbs our response mechanism: it lies suspended uneasily between art and life, and confuses our expectations by seeming to be neither.

If making figures which fool the eye seems strange, then the simulation of inanimate objects is even stranger, since these are man-made in the first place. Yet this is the concern of Marilyn Levine and Fumio Yoshimura. Their works consist of imitating useful objects with an alien material and process which leaves them devoid of practical use but transforms them into art. She transmutes clay into 'leather' goods and he makes wooden copies of metal machines. The simulation of everyday items is hardly new; many societies have used token objects in religious ceremonies, and still do, while in the secular industrialized world they are used in shop displays and advertising signs – indeed, whole buildings have been made to look like the product they sell. But these objects are made within the context of a corporate belief (religion, or capitalism) whereas the works of Levine and Yoshimura exist as Fine Art, and as such their affinities are with the humour and conceptualism of Duchamp and Pop.

Marilyn Levine

Levine's life-size ceramic shoes and leather jackets depend on a similar dislocation of expectations as the marble 'sugar' cubes in Duchamp's *Why not sneeze, Rose Selavy?* 1921. Permanent hard materials are used to simulate soft transmutable ones and the illusion is so complete that we are impelled to touch them to find out if they are not, in fact, the real thing. But unlike Duchamp's, her works seek total illusionism and show a strong commitment to craftsmanship. She does not work from casts, but has developed a technique for strengthening clay which permits her to build up the objects from thin slabs in a manner close to the original, and she not only simulates stitching, creasing and staining but even makes zips and buckles from clay. The eeriness of the illusion is further reinforced in exhibitions where she shows the works in specific contexts, such as hanging a ceramic 'leather jacket' from a real coat-rack.

Born in 1935, Levine turned to sculpture relatively late, having studied chemistry in her native Alberta before switching to art in the late 1960s, and she was preoccupied with abstraction until about 1970 when she began to make realist objects. Although she is aware that 'the conflict between visual and tactile clues disturbs one's sense of reality',[8] she is not solely concerned with such concepts and places great emphasis on the significance of subject matter. She chooses leather (and occasionally canvas) objects, because they best reveal traces of their users. The passage of time, she feels, is expressed by the wrinkles and abrasions which such things develop, and they also reflect the personalities of their owners.

John de Andrea (left)
Couple on Floor, 1973,
polyester resin,
polychromed in oils,
life-size

Marilyn Levine (above)
Trent's Jacket, 1976,
ceramic, 36 × 18 × 8½″
(91 × 46 × 21·5cm)

Marcel Duchamp
(above right)
*Why not sneeze, Rose
Selavy?* 1921
assisted readymade,
4 × 6⅛ × 8½″
(10·2 × 15·4 × 21·5cm),
bird cage, marble,
cuttlebone, wood, mirror
and thermometer
(Reproduced here in black
and white)

For similar reasons she avoids 'new pieces or those too involved with a particular style. An over-awareness of the era would dilute the impact of humaneness. My boots could be either fifty weeks old or fifty years old. Their time in history is totally indeterminate.'[9] Yet whether intentional or not, such use of 'timeless' subjects is essentially romantic.

In an age of mass-produced, synthetic goods, leather objects such as Gladstone bags and stout lace-up boots symbolize a yearning for the past, when objects were well made in 'natural' materials, and by hand. Levine's chosen objects also often suggest travel and adventure, the city-dweller's dream of being alone in the wild, close to nature. The leather jacket is not a slick, fashion garment, but one made to withstand the great outdoors, the leather mug is reminiscent of the itinerant cowboy; the mud-caked boots conjure up hardy pioneers or lumberjacks. No doubt these objects are still in common use but when viewed within the context of the predominantly city-based art world, they evoke distant and exotic myths.

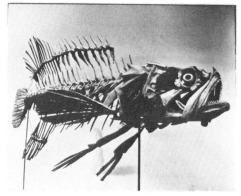

Fumio Yoshimura

Levine's works use illusionism to point to the human associations of her subjects, but since the resulting sculptures are as tangibly real as their models they also disturb our expectations of 'reality'. Fumio Yoshimura adds a further twist, by making highly accurate replicas but then withholding the satisfaction of completing the illusion. 'We never had realism as an idea in Japan . . . I'm not really reproducing the things, I'm producing ghosts';[10] he goes on to point out that eighty per cent of the characters in classic Noh plays are ghosts. There are clear parallels with his own work; a wooden motorbike bears the same relationship to its prototype as a real actor impersonating an unreal character: in both cases the tangible masquerades as an unreal version of the real.

Yoshimura was born in Kamakura, Japan, in 1926, so he belongs to the same generation as Hanson, having come of age at the time of the world's first nuclear bomb. He studied painting in Tokyo, graduated from its university in 1948, and now lives and shows his work in America. Whereas Hanson's works protest overtly about the world, Yoshimura's retain an oriental calm. Yet a knot of tension is concealed within their restrained and pristine appearance. There is an element of manic perversity in setting out to fashion unmalleable material such as hard

Fumio Yoshimura
(far left) *Motorcycle*,
1973, wood,
40 × 86″(102 × 218cm)
(near left) *Grouper*,
1976, linden wood,
27 × 59 × 20″
(67 × 150 × 51cm)
(right) *Typewriter*,
1975, spruce, pine
and linden wood,
12 × 15 × 16″
(30·5 × 38 × 40·5cm)

wood into the detailed and fluid forms of plants, animals or machine-formed, metal objects.

The copying of things may be seen as a means of understanding them more fully and of encouraging an appreciation of their beauty. Seen with this in mind, Yoshimura's choice of subjects is particularly fascinating since it falls into two distinct categories: natural phenomena and the man-made. For centuries, artists in both East and West have investigated their surroundings in the shape of animals and plants, yet the machine-made object is now an equally important part of man's environment. By taking both as his subject, Yoshimura seems to suggest that we should come to accept them equally.

Unlike the majority of twentieth-century artists, Yoshimura does not present machines as symbols of the threats (or joys) of an advanced and alien technological age. His subjects are not anonymous, dehumanized monsters but familiar, homely objects such as typewriters and bicycles which have been used by private individuals for generations. Indeed, many of them are ancient models, dating back to the last century, so that seen as a whole his work suggests technology's place within our cultural heritage and within the normal nature of things. And his use of raw, grainy wood as a material underlines this point, since it links a natural and timeless material with modern industrial products. Yet, paradoxically, this juxtaposition of wood and machine, by producing 'ghost machines', also jars our sensibilities.

Like Levine's transpositions of leather into clay, Yoshimura's use of wood introduces an element of absurdity into his work. Both sculptors create objects which look remarkably like everyday, utilitarian ones, which imitate every detail of surface or of structure, but whose wheels don't turn and whose zips won't unfasten. Yoshimura's are ghosts and Levine's are 'fakes': but whereas her working process echoes the craftsmanship with which her subjects are themselves made, his hand-cut objects stubbornly oppose the precision and ease with which nature and industry alike fashion the models on which they are based. Yoshimura's realism, which disdains even to deceive, has a distancing effect, while Levine uses it to bring home the human associations of her subjects; like the photo-realist painters, these sculptors use similar means to achieve dissimilar ends.

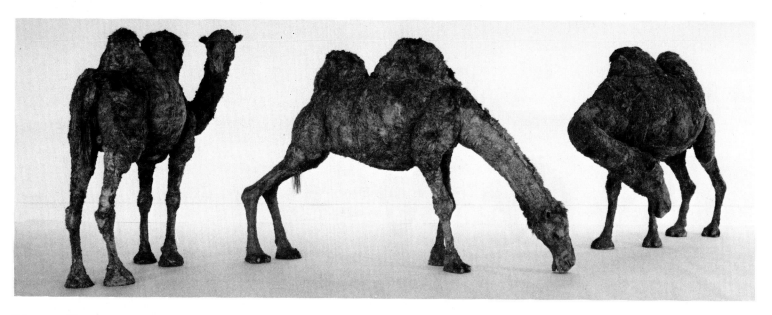

Nancy Graves

In the case of Nancy Graves we have an artist who has produced a few works which *look* Superreal yet whose total output and artistic credo differs profoundly from everything the style usually stands for. She does not consider herself to be a Superrealist, yet her work has often been shown and discussed within its context. One could argue that Yoshimura's works also belong outside the movement since he does not simulate surfaces, but his concern with every other aspect of objective realism gives his work greater affinity to that of the Superrealists than Nancy Graves' sculptures of various breeds of camel.

Born in Pittsville, Massachusetts, in 1940, Graves' primary concern is neither with realism *per se*, nor with objectivity and illusionism. She is involved with nature and the universe, with coming to a fuller understanding of their workings, and with exposing man's tendency to patronize every form of life by seeing himself as the centre of all things. She conveys these ideas by making systematic explorations of selected topics. Her life-like camels, far from being 'funky' objects, were part of this serious and

comprehensive approach, and the subject was chosen because, she feels, 'Camel was a metaphor, a prototype, an allusion'.[11] First made in 1965, they were not stuffed or moulded, but painstakingly constructed – a lengthy process undertaken by Graves as a means of coming to a thorough understanding of the physical structure and proportions of the creatures. She 'next considered this sculptural entity in terms of its structural properties: as armature',[12] and later works on this theme consisted of simulations of their bones (and even of entire skeletons) made of wax, marble dust, acrylic and paint over a steel armature, while she explored their evolution, history and biological mechanics with film, photographs, charts and maps.

The accuracy with which Graves transformed her materials to create the outward appearance of the camels has commanded respect from professional zoologists, and this meticulousness is a characteristic of all her work. She remains close to primary sources of information, such as scientific data, in order to deal with her subjects in a manner which goes beyond intuitive response. In the case of a

Nancy Graves
(above) *Camels VII, VI, VIII*, 1968–9, wood, steel, burlap, polyurethane, animal skin, wax, oil paint
VI = $7\frac{1}{2}$ × 12 × 4'
(229 × 366 × 122cm)

VII = 8 × 9 × 4'
(244 × 274 × 122cm)
VIII = $7\frac{1}{2}$ × 10 × 4'
(229 × 305 × 122cm)
(right) Photograph of Nancy Graves's studio, March 1970

few of the camels it led to three-dimensional 'replicas', but a similar conscientiousness of approach gave rise to her recent apparently abstract paintings which are in fact accurately based on images of the earth's surface as recorded by satellite photographs.

Objectivity is intrinsic to Graves' artistic credo, since she aims to see nature as it is, rather than as seen through the eyes of mankind. *Izi Boukir*, one of her films on camels, quotes the naturalist Henry Beston as saying that man patronizes animals, 'and therein we err and greatly err, for the animal shall not be measured by man'.[13] Most cultures have a history of animal sculpture but have used creatures to embody human characteristics or aspirations, while in our own culture they are normally relegated to the status of commercial

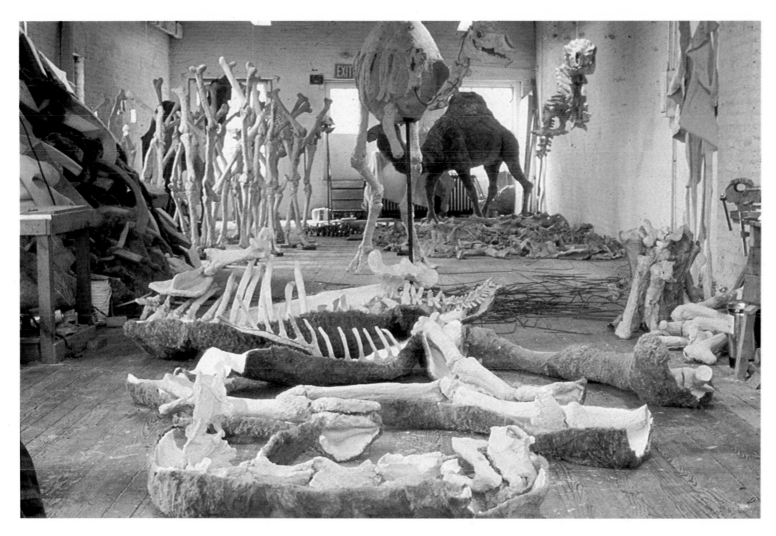

trade-marks, but Graves' camels are notable for their lack of human characteristics. The fact that they appear to have strayed out of a zoological museum was not intended as a device to shock the art world but sprang from a sincere desire to explore their structural form as well as to make us reconsider our attitudes to creatures other than ourselves.

Many other artists create highly realistic sculptures without sharing Superrealist aims. The Berliner Ludmila Seefreid Matéjková, and the Canadian Colette Whiten both cast figures from life, while the Englishman Malcolm Poynter polychromes his figures to simulate skin textures; even Alan Jones' mannequins and Jan Haworth's stuffed dolls have been discussed within the context of verist sculpture. But they all differ from those included here because they all qualify visible appearances in some way in order to give their works expressive or Surreal content. The unifying factor in the works of Levine, Yoshimura, de Andrea and Hanson – and in some of Graves' – is their objective realism, and it is this which links them with Superrealism. Like the photo-realist painters, their use of verisimilitude stems from highly varied aims. Only de Andrea sees it as a major aim in itself. For Hanson it is a means of conveying social comment, for Graves a by-product of attempts to understand her subject. Levine feels it best sums up human values while Yoshimura uses it to question reality itself. So that their work differs enormously, not only in subject and materials, but in the response it provokes.

This in itself demonstrates that verist sculpture goes beyond mere virtuosity. Unlike the art of the waxwork maker, the taxidermist, or the wax-effigist, it aspires to more than the creation of a breathtaking likeness. The works of Hanson, de Andrea and Levine may trick

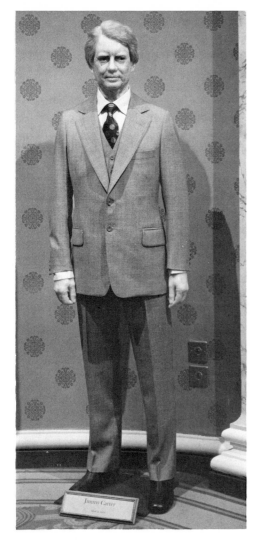

us into taking them for the real thing, but ultimately their effect depends, as it does with Yoshimura and Graves, on the fact that they are unreal. Partly because, as Kim Levin points out, 'the degree of life-likeness corresponds perversely to the awareness of its deceit',[14] and partly because the illusion soon wears off and we are left to reconsider our ideas and feelings about the subjects themselves.

Yet the initial illusion *is* dazzling, and perhaps because their effect is so much more total than that of any painting, the works of the sculptors have been influential in popularizing the Superrealist movement as a whole to a degree which far outweighs the small number of artists involved. Hanson's figures and Graves' camels, appearing in the early days of Superrealism when the art world was dominated by Conceptual and Minimal works, had a shock value which served to focus the issues raised by the movement as a whole. Here were artists using a discredited visual language as a means of conveying ideas about reality without seeking to distort form or subject in the interest of self-expression. It may have uncomfortably retrogressive overtones, but to dismiss it as anachronistic is to ignore its undeniably contemporary qualities. The ethos of Superrealism is essentially that of our own times.

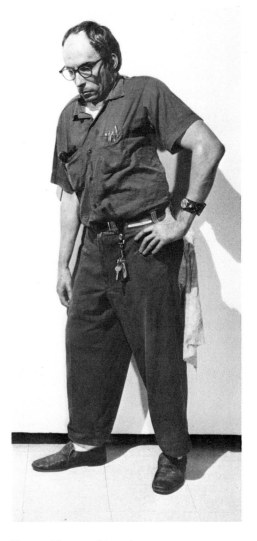

Madame Tussaud's Waxworks (above)
President Carter, 1976, wax portrait with human hair, polychromed in watercolour, fibreglass body, life-size

It is generally felt that the verisimilitude of waxworks stands for cheap sensationalism far removed from the proper business of the serious artist. Superrealist sculpture challenges such aesthetic judgments.

Duane Hanson (above)
Janitor, 1973, polyester and fibreglass, life-size

NOTES

Introduction

1 Linda Chase and Ted McBurnett, 'The photo-realists: twelve interviews', *Art in America*, New York, November-December 1972

2 Linda Chase, 'Photo-realism: post-modern illusionism', *Art International*, Lugano, Spring 1976

3 Chase and McBurnett, *op. cit.*

4 Brian O'Doherty, 'The photo-realists : twelve interviews', *Art in America*, New York, November-December 1972

5 Chase and McBurnett, *op. cit.*

Roots

1 Edward Lucie-Smith, 'The neutral style', *Art and Artists*, London 1975

2 Lucy Lippard (Ed), 'Questions to Stella and Judd', *Art News*, New York, September 1966

3 Walter Midgette, reviewing Udo Kultermann's *New Realism, Art in America*, New York, November–December 1972

4 Herbert Raymond, 'The real Estes', *Art and Artists*, London, August 1974

Pioneers

1 John Russell and Suzi Gablick, *Pop Art Redefined*, Thames and Hudson, London 1969

2 *ibid.*

3 Kim Levin, 'Malcolm Morley: post-style illusionism', *Arts Magazine*, New York, February 1973

4 Audrey Flack to the author, June 1978

5 *ibid.*

6 *ibid.*

7 *ibid.*

8 John Perrault, 'Audrey Flack: odds against the house', *The SoHo Weekly News*, New York, March 1978

9 O'Doherty, *op. cit.*

10 O'Doherty, *op. cit.*

11 Gerritt Henry, 'The real thing', *Art International*, Lugano, Summer 1972

12 Kim Levin, 'Chuck Close: decoding the image', *Arts Magazine*, New York, June 1978

13 Lucy Lippard (Ed), *op. cit.*

14 Chase and McBurnett, *op. cit.*

15 Colin Naylor and Genesis P. Orridge, *Contemporary Artists*, St James' Press, London 1977

16 Barbara Harshman, 'An interview with Chuck Close', *Arts Magazine*, New York, June 1978

17 John Arthur, 'A conversation with Richard Estes', in catalogue *Richard Estes: the urban landscape*, Museum of Fine Arts, Boston 1978

18 Chase and McBurnett, *op. cit.*

19 John Salt to the author, June 1978

20 *ibid.*

Photo-vision as subject

1 Ben Schonzeit to the author, June 1978

2 O'Doherty, *op. cit.*

3 Dan Tooker, 'Richard McLean interviewed', *Art International*, Lugano, Autumn 1974

4 Paul Staiger, *Documenta 5* catalogue, Bertelsmann, Kassell 1972

5 David Kessler, statement sent to the author, August 1978.

6 Ben Schonzeit to the author, June 1978

7 *ibid.*

8 *ibid.*

9 Louis K. Meisel, catalogue *Charles Bell*, Louis K. Meisel Gallery, New York 1977

10 *ibid.*

11 *ibid.*

The Camera as tool

1 Nancy Foote, 'The photo-realists: twelve interviews', *Art in America*, New York, November–December 1972

2 Tom Blackwell, catalogue for solo show, Louis K. Meisel Gallery, New York, October 1977

3 *ibid.*

4 O'Doherty, *op. cit.*

5 Naylor and Orridge, *op. cit.*

6 Linda Chase, 'Existential vs. humanist realism', in Gregory Battcock, *Superrealism: a critical anthology*, E. P. Dutton, New York 1975

7 Ellen Lubell, 'Idelle Weber', *Arts Magazine*, New York, September 1977

8 Michael S. Cullen, 'Hyperréalistes américains – réalistes européens' *CNAC/ Archives* 11/12, Paris 1974 (author's translation)

9 *ibid.*

10 Brendan Neiland, *Working Process*, catalogue for Sunderland Arts Centre Touring Exhibition, 1978

11 Chase and McBurnett, *op. cit.*

12 Foote, *op. cit.*

The Sculptors

1 Alan Bowness, *Modern Sculpture*, Studio Vista, London 1965.

2 Martin H. Bush, 'Duane Hanson', Edwin Ulrich Museum of Art, Wichita State University, Kansas 1976

3 *ibid.*

4 *ibid.*

5 Naylor and Orridge, *op. cit.*

6 Joseph H. Masheck, 'Verist sculpture: Hanson and de Andrea', *Art in America*, New York, November–December 1972

7 Duncan Pollock, 'The photo-realists: twelve interviews', *Art in America*, New York, November–December 1972

8 Foote, *op. cit.*

9 Foote, *op. cit.*

10 Kim Levin, 'The ersatz object', *Arts Magazine*, New York, February 1974

11 Nancy Graves, statement sent to the author, September 1978

12 *ibid.*

13 Lucy Lippard, 'The films of Nancy Graves', *Art in America*, New York, November-December 1972

14 Kim Levin, 'The ersatz object', *Arts Magazine*, New York, February 1964

ARTISTS' BIOGRAPHIES

John Baeder born 1938, South Bend, Indiana, graduated from Auburn University, Auburn, Alabama, 1960; first solo show: Hundred Acres Gallery, Oew York, 1972; represented by O.K. Harris Gallery, New York

Robert Bechtle born 1932, San Francisco; California College of Arts and Crafts and University of California, Berkeley, 1955–8; first solo show: San Francisco Museum of Art, San Francisco, 1959; represented by O.K. Harris Gallery, New York

Charles Bell born 1935, Tulsa, Oklahoma; graduated from University of Oklahoma, 1957; first solo show: Setay Gallery, Beverly Hills, California, 1958; represented by Louis K. Meisel Gallery, New York

Arne Besser born 1935, Downers Grove, Illinois; University of New Mexico, 1953–4 and 1956; Art Center School, Los Angeles, California, 1958–60; first solo show: B.N.R. Gallery, New York, 1965; represented by ACA Galleries, New York

Tom Blackwell born 1938, Chicago; self-taught; first solo show: Roy Parsons Gallery, Los Angeles, 1961; represented by Louis K. Meisel Gallery, New York

Douglas T. Bond born 1937, Atlanta, Georgia; graduated from California State College at Los Angeles, 1966; first solo show: Bottega Gallery, Pasadena, California, 1966; represented by O.K. Harris Gallery, New York

Hilo Chen born 1942, Taipei, Taiwan; graduated from Chung Yien College, Taiwan, 1956; first solo show: Louis K. Meisel Gallery, New York; represented by Louis K. Meisel Gallery

John Clem Clarke born 1937, Bend, Oregon; Oregon State University, Corvallis, and Mexico College, Mexico (dates not known); graduated from University of Oregon, Eugene, 1960; first solo show: Kornblee Gallery, New York, 1968; represented by O. K. Harris Gallery, New York

Chuck Close born 1940, Washington, USA; University of Washington, Seattle, 1958–62; Yale University, New Haven, 1962–4; Akademie der bildenden Künste, Vienna, 1964–5; first solo show: University of Massachusetts, Amhurst, 1967; represented by Pace Gallery, New York

Robert Cottingham born 1935, Brooklyn, New York, USA; Pratt Institute, Brooklyn, New York, 1959–63; first solo show: Molly Barnes Gallery, Los Angeles, California, 1968; represented by O.K. Harris Gallery, New York

John de Andrea born 1941, Denver, Colorado; graduated from University of Colorado, 1965; first solo show: O.K. Harris Gallery, New York, 1970; represented by O.K. Harris Gallery, New York

Don Eddy born 1944, Long Beach, California; graduated from University of Hawaii, 1969; University of California, Santa Barbara, California, 1969–70; first solo show: Ewing Krainin Gallery, Honolulu, Hawaii, 1968; represented by Nancy Hoffman Gallery, New York

Richard Estes born 1936, Evanstown, Illinois; Chicago Art Institute, Chicago, 1952–6; first solo show: Allan Stone Gallery, New York, 1968; represented by Allan Stone Gallery, New York

Audrey Flack born 1931, New York City; graduated from Cooper Union, New York, 1951; scholarship to Yale University, New Haven, 1952; first solo show: Roko Gallery, New York, 1959; represented by Louis K. Meisel Gallery, New York

Gerard Gasiorowski born 1930, Paris, France; Ecole des Arts Appliqués à l'Industrie, Paris (dates not known); first solo show: Galerie Thelen, Essen, Germany, 1970; represented by Galerie Thelen and by Galerie Laplace 3, Paris

Franz Gertsch born 1930, Moeringen, Switzerland; first solo show: Martin Krebs Gallery, Bern, 1968; represented by Veith Turske, Cologne

Ralph Goings born 1928, Corning, California; graduated from California College of Arts and Crafts, Oakland, 1953; first solo show: Artists Cooperative Gallery, Sacramento, California, 1960; represented by O.K. Harris Gallery, New York

Nancy Graves born 1940, Pittsfield, Massachusetts; Vassar College, 1958–61; Yale University, School of Art and Architecture, 1964; first solo show: Graham Gallery, New York, 1968; represented by Janie C. Lee Gallery, Houston, Texas

Duane Hanson born 1925, Alexandria, Minnesota; Luther College, Decorah, Iowa, 1943; University of Washington, 1944; Malacaster College, Minnesota, 1944; University of Minnesota, 1947; graduated from Cranbrook Academy of Art, Michigan, 1951; first solo show: Museum of Art, Cranbrook Academy of Art, Michigan, 1951; represented by O.K. Harris Gallery, New York

Jean Olivier Hucleux born 1923, Channy, France; no further information available

Guy Johnson born 1927, Fort Wayne, Indiana; graduated from Florida State University, 1952; first solo show: Hundred Acres Gallery, New York, 1971; represented by Louis K. Meisel Gallery, New York

David Kessler born 1950, Teaneck, New Jersey; graduated from Arizona State University, 1972, and San Francisco Art Institute, 1975; first solo show: Arizona State University, Tempe, Arizona, 1973; represented by ADI Gallery, San Francisco

Ron Kleemann born 1937, Bay City, Michigan; graduated from University of Michigan, College of Architecture and Design, 1961; first solo show: French and Co, New York, 1971; represented by Louis K. Meisel Gallery, New York

Michael Leonard born 1933, Bangalore, India; St Martin's School of Art, London, England, 1954–7; first solo show: Fischer Fine Art, London, 1974; represented by Fischer Fine Art, London

Marilyn Levine born 1935, Medicine Hat, Alberta; graduated from University of Alberta, Edmonton, 1959; School of Art, University of Regina, 1961–9; University of California, Berkeley, 1969–71; first solo show: University Art Museum, Berkeley, California, 1971; represented by O.K. Harris Gallery, New York

Noel Mahaffey born 1944, St Augustine, Florida; Dallas Museum of Fine Arts, 1962; Atelier Kelley, Dallas, 1959–62; Pennsylvania Academy of the Fine Arts, 1962–6; first solo show: Hundred Acres Gallery, New York, 1971; represented by Barbara Toll, New York

Richard McLean born 1934, Hoquiam, Washington; graduated from California College of Arts and Crafts, 1958, and Mills College, Oakland, California, 1962; first solo show: Lucien Labaudt Gallery, San Francisco, California, 1957; represented by O.K. Harris Gallery, New York

Jack Mendenhall born 1937, Ventura, California; graduated from California College of Arts and Crafts, 1970; first solo show: O.K. Harris Gallery, New York, 1974; represented by O.K. Harris Gallery, New York

Malcolm Morley born 1931, London, England; Camberwell School of Arts and Crafts, London, 1952–3; Royal College of Art, London, 1954–6; first solo show: Kornblee Gallery, New York, 1957; represented by Nancy Hoffman Gallery, New York

Brendan Neiland born 1941, Lichfield, England; Birmingham College of Art, Birmingham, 1962–6; Royal College of Art, London, 1966–9; first solo show: Angela Flowers Gallery, London, 1971; represented by Fischer Fine Art, London

David Parrish born 1939, Birmingham, Alabama; University of Alabama, Tuscaloosa (dates not known); first solo show: Brooks Memorial Art Gallery, Memphis, 1971; represented by Nancy Hoffman Gallery, New York

Sylvia Plimack Mangold born 1938, New York City; Cooper Union, New York, 1956–9; Yale University, New Haven 1961; first solo show: Fischbach Gallery, New York, 1974; represented by Droll/Kolbert, New York

Joseph Raffael born 1933, Brooklyn, New York; Cooper Union, 1951–4; graduated from Yale School of Fine Arts, 1956; first solo show: Kanegis Gallery, Boston 1958; represented by Nancy Hoffman Gallery, New York, Roy Boyd, Chicago and John Berggruen, San Francisco

John Salt born 1937, Birmingham, England; Birmingham College of Art, Birmingham, 1954–7; Slade School of Fine Art, London, 1958–60; first solo show: Ikon Gallery, Birmingham, England, 1965; represented by O.K. Harris Gallery, New York

Ben Schonzeit born 1942, Brooklyn, New York; graduated from Cooper Union, New York, 1964; first solo show: French & Co, New York, 1970; represented by Nancy Hoffman Gallery, New York

Paul Staiger born 1941, Portland, Oregon; Northwestern University, University of Chicago and California College of Arts and Crafts (dates not known); first solo show: Michael Walls Gallery, San Francisco, California, 1969; represented by Susan Caldwell Galleries, New York

Idelle Weber born 1932, Chicago, Illinois; graduated from the University of California, Los Angeles, 1955; first solo show: Bertha Schaefer Gallery, New York, 1963; represented by O.K. Harris Gallery, New York

Fumio Yoshimura born 1926, Kamakura, Japan; graduated from University of Art, Tokyo, 1948; first solo show: Pennsylvania Academy of Fine Arts, Philadelphia, 1970; represented by Nancy Hoffman Gallery, New York

BIBLIOGRAPHY

Books

Abadie, Daniel, *L'Hyperréalisme américain*, Petite Encylopédie de l'Art, Vol. 113, Gernand Hazan, Paris 1975

Battcock, Gregory, (Ed) *Super Realism: A Critical Anthology*, E. P. Dutton, New York 1975

Brachot, Isy, (Ed) *Hyperréalisme: Maîtres américains et européens*, Brachot, Brussels 1973

Chase, Linda, *Hyperrealism*, Crown Publishers, New York and Academy Editions, London 1975

Chase, Linda, *Photo Realism*, Eminent Publications, New York 1975

Coke, Van Deren, *The Painter and the Photograph*, University of New Mexico Press, Albuquerque 1972

Kultermann, Udo, *New Realism*, Matthews Miller Dunbar, London 1972

Lucie-Smith, Edward, *Super Realism*, Phaidon, Oxord and E. P. Dutton, New York 1979

Naylor, Colin and Orridge, Genesis P., (Eds) *Contemporary Artists*, St James Press, London 1977

Sager, Peter, *Neue Formen des Realismus*, Verlag DuMont Schauberg, Cologne 1973

Magazine articles in date order

1964

Kramer, Hilton, 'Realists and Others', *Arts Magazine*, New York, January

Ventura, Anita, 'Pop, Photo and Paint', *Arts Magazine*, New York, April

1966

Swenson, Gene R., 'Paint, Flesh, Vesuvius', *Arts Magazine*, New York, November

1967

Alloway, Lawrence, 'Art as Likeness', *Arts Magazine*, New York, May

Laderman, Gabriel, 'Unconventional Realists', *Artforum*, New York, November

1968

Alloway, Lawrence, 'Morley Paints a Picture', *Art News*, New York, Summer

Constable, Rosalind, 'Style of the Year: The Inhumanists', *New York Magazine*, New York, 16 December

1969

Pomeroy, Ralph, 'New York: Super-Real is back in town', *Art and Artists*, London, May

Tillim, Sidney, 'A Variety of Realisms', *Artforum*, New York, Summer

Nemser, Cindy, 'Paintings from the Photograph', *Arts Magazine*, New York, December – January 1970

1970

Nemser, Cindy, 'An Interview with Chuck Close', *Artforum*, New York, January

Nemser, Cindy, 'Presenting Chuck Close', *Art in America*, New York, January–February

Atkinson, Tracy and Taylor, John, 'Likenesses', *Art and Artists*, London, February

Hugh, Robert, 'An Omnivorous and Literal Dependence', *Arts Magazine*, New York, March

Nemser, Cindy, 'Sculpture and the New Realism', *Arts Magazine*, New York, April

Ratcliff, Carter, 'New York: 22 Realists Exhibit at the Whitney', *Art International*, Lugano, April

Stevens, Carol, 'Message into Medium; Photography as an Artist's Tool', *Print*, New Haven, May–June

Lord, Barry, 'The Eleven O'clock News in Colour', *Artscanada*, Toronto, June

Lord, Barry, 'Whitney Museum's 22 Realists Exhibition', *Artscanada*, Toronto, June

Hanson, Duane, 'Presenting Duane Hanson', *Art in America*, New York, September–October

Wasserman, Emily, 'A Conversation with Nancy Graves', *Artforum*, New York, October

1971

Nochlin, Linda, 'Realism Now', *Art News*, New York, January

Kilier, Peter, 'Interview with Franz Gertsch', *AZ*, Zurich, 24 February

Marandel, Patrice J., 'The Deductive Image: Notes on some Figurative Painters', *Art International*, Lugano, September

Sager, Peter, 'Neue Formen des Realismus', *Magazine Kunst*, Mainz, 4th quarter

Battcock, Gregory, 'Celluloid Sculptors', *Art and Artists*, London, October

Lévêque, Jean Jacques, 'L'Hyperréalisme', *Opus International*, Paris, November

Karp, Ivan, 'Rent is the Only Reality or the Hotel instead of the Hymns', *Arts Magazine*, New York, December 1971–January 1972

1972

Rosenberg, Harold, 'Reality Again', *The New Yorker Magazine*, New York, 5 February

Wolmer, Denise, 'In the Galleries: Sharp Focus Realism', *Arts Magazine*, New York, March

O'Doherty, Brian, 'Inside the White Cube', *Artforum*, New York, April

Richardson, Brenda, 'Conversation with Nancy Graves', *Arts Magazine*, New York, April

Nemser, Cindy, 'The Close-up Vision: Representational Art', *Arts Magazine*, May

Sterckx, Pierre, 'John de Andrea: et maintenant parle', *Clé pour les Arts*, Brussels, May

Rein, Ingrid, 'Dokumenta 5', *Kunst*, Munich, June

Nakov, Andrei B., 'Sharp focus realism: Le retour de l'image', *XXᵉ Siècle*, Paris, June

Henry, Gerrit, 'The Real Thing', *Art International*, Lugano, Summer

Olbricht, K. H., 'Die fröhliche Wissenschaft der Kunst ein Beitrag Zu Dokumenta 5', *Kunst*, Munich, September

Thwaites, John Anthony, 'Kassel – in the air?', *Art and Artists*, London, September

Alloway, Lawrence, 'Reality', *Artforum*, New York, October

Chase, Linda, O'Doherty, Brian, Foote, Nancy and McBurnett, Ted, 'The Photo-realists: 12 Interviews', *Art in America*, New York, November–December

Masheck, Joseph, 'Verist Sculpture: Hanson and de Andrea', *Art in America*, New York, November–December

Pollock, Duncan, Chase, Linda and McBurnett, Ted, 'The Verist Sculptors: 2 Interviews: de Andrea and Hanson', *Art in America*, New York, November–December

Seitz, William, 'The Real and the Artificial: Painting of the New Environment', *Art in America*, New York, November–December

1973

Schon, Wolf, 'Amerikanischer Fotorealismus', *Das Kunstwerk*, Stuttgart, January

Levin, Kim, 'Malcolm Morley:Post-style Illusionism', *Arts Magazine*, New York, February

Graf, Urs, 'Entretien entre Franz Gertsch et Urs Graf', *L'Art Vivant*, Paris, March

Baldwin, Carl, 'Le penchant des peintres américains pour le réalisme', *Connaissance des Arts*, Paris, April

Melville, Robert, 'The Photograph as Subject', *Architectural Review*, London, May

Gassiot-Talabot, Gerald, 'Réalisme et Tautologie', *Opus International*, Paris, June

Levin, Kim, 'The Newest Realism or a synthetic slice of life', *Opus International*, Paris, June

Troche, Michel, 'Réalisme et hyperréalisme', *Opus International*, Paris, June

Vallée, Desmone, 'Une neutralité agressive', *Opus International*, Paris, June

Restany, Pierre, 'Sharp-Focus: La continuité d'une vision américaine', *Domus*, Milan, August

Nochlin, Linda, 'The Realist Criminal and the Abstract Law – Part I', *Art in America*, September–November

Beardsail, Judy, 'Stuart M. Speiser Photorealist Collection', *The Art Gallery Magazine*, Ivoryton, October

Chase, Linda, 'Recycling Reality', *The Art Gallery Magazine*, Ivoryton, October

Baldwin, Carl, 'Realism: The American Mainstream', *Réalités*, Paris, November

Midgette, Willard F., 'Review of Art Books: New Realism by Udo Kultermann', *Art in America*, New York, November–December

Nochlin, Linda, 'The Realist Criminal and the Abstract Law – Part II', *Art in America*, November–December

1974

Chase, Linda, 'The Connotation of Denotation', *Arts Magazine*, New York. February

Dyckes, William, 'The Photo as Subject: the Paintings and Drawings of Chuck Close', *Arts Magazine*, New York, February

Levin, Kim, 'The Ersatz Object', *Arts Magazine*, New York, February

Nemser, Cindy, 'Conversation with Audrey Flack', *Arts Magazine*, New York, February

Nochlin, Linda, 'Some Women Realists', *Arts Magazine*, New York, February

Raymond, H. D., 'Beyond Freedom, Dignity and Ridicule', *Arts Magazine*, New York, February

Wilson, William S., 'The Paintings of Joseph Raffael', *Studio International*, London, May

Arn, Robert, 'The Moving Eye Nancy Graves Sculpture, Film and Painting', *Artscanada*, Toronto, Spring

Gassiot-Talabot, Gerald, 'Le choc des "réalismes"', *XXᵉ Siècle*, Paris, June

Henry, Gerrit, 'The Silk Purse of High Style Interior Decoration or the Bathroom Painting of Douglas Bond', *Arts Magazine*, New York, June

Ries, Martin, 'Ron Kleeman', *Arts Magazine*, New York, June

Alliata, Vicky, 'American Essays on Super-Realism', *Domus*, Milan, July

Tooker, Dan, 'Richard McLean interviewed by Dan Tooker', *Art International*, Lugano, September

1975

Varnedoe, Kirk, 'Duane Hanson Retrospective and Recent Work', *Arts Magazine*, New York, January

Del Renzio, Tony, 'Robert Cottingham – The Capers of the Signscape', *Art and Artists*, London, February

Lucie-Smith, Edward, 'The Neutral Style', *Art and Artists*, London, August

Nemser, Cindy, 'Audrey Flack Photorealist Rebel', *The Feminist Art Journal*, New York, Fall

Lippard, Lucy L., 'Distancing, the Films of Nancy Graves', *Art in America*, New York, November–December

1976

Schonzeit, Ben, 'Schonzeit on Schonzeit', *Art and Artists*, London, January

Rosenblum, Robert, 'Painting America First', *Art in America*, New York, January–February

Chase, Linda, 'Photo-Realism: Post-Modernist Illusionism', *Art International*, Lugano, March-April

Lucie-Smith, Edward, 'Realism Rules: O.K.?', *Art and Artists*, London, September

Butterfield, Jan, 'I have Always Copied': an Interview with Joseph Raffael', *Arts Magazine*, New York, October

Kuspit, Donald B., 'Duane Hanson's American Inferno', *Art in America*, New York, November–December

Lamagna, Carlo, 'Tom Blackwell's New Paintings', *Art International*, Lugano, December

Greenwood, Michael, 'Current Representational Art: Five Other Visions', *Artscanada*, Toronto, December – January 1977

Greenwood, Michael, 'Towards a definition of Realism: Reflections on the Rothmans Show', *Artscanada*, Toronto, December – January 1977

1977

Peterson, Susan, 'Ceramics of Marilyn Levine', *Craft Horizons*, New York, February

Lubell, Ellen, 'Idelle Weber', *Arts Magazine*, New York, September

1978

Perreault, John, 'False Objects, Duplicates, Replicas and Types', *Artforum*, New York, February

Perreault, John, 'Audrey Flack: Odds Against the House', *The SoHo Weekly News*, New York, March 23

Battcock, Gregory, 'Thinking Decently: two Audacious Artists in New York', (re: Audrey Flack), *New York Arts Journal*, New York, April–May

Harshman, Barbara, 'An Interview with Chuck Close', *Arts Magazine*, New York, June

Levin, Kim, 'Chuck Close: Decoding the Image', *Arts Magazine*, New York, June

1979

Ness, Hallmark John, 'Painting and Perception . . . Don Eddy', *Arts Magazine*, New York, December

Exhibition catalogues in date order

1966

USA New York, (New York State), Solomon R. Guggenheim Museum *The Photographic Image*

1968

USA Poughkeepsie, (New York State), Vassar College of Art *Realism Now*

1969

USA Milwaukee, (Wisconsin), Milwaukee Art Center *Directions: 2 Aspects of a New Realism*

USA New York, (New York State), The Riverside Museum *Paintings from the Photo*

1970

USA Balboa, (California), Newport Harbor Art Museum *Directly Seen: New Realism in California*

USA New York, (New York State), Whitney Museum of American Art *22 Realists*

USA Stockton, (California), Pioneer Museum and Haggin Gallery *Contemporary Californian Realist Painting*

West Germany Aachen; Neue Gallery *Klischee und Anti-Klischee*

1971

USA Chicago, (Illinois), Museum of Contemporary Art *Radical Realism*

USA Los Angeles, (California), Los Angeles County Art Museum *Chuck Close: Recent Work*

USA Potsdam, (New York State), State University College *New Realism*

USA San Francisco, (California), San Francisco Museum of Art *Through the Photograph to Painting*

West Germany Aachen, Neue Gallery *Nancy Graves; Sculpture/Drawings, Films*

1972

France Paris, Galerie des 4 Mouvements *Hyperréalistes américains*

Netherlands Eindhoven, Stedelijk van Abbemuseum *Relativerend Realisme*

USA Chicago, (Illinois), Museum of Contemporary Art *Chuck Close*

USA Coral Gables, (Florida), Lowe Art Museum, University of Miami *Phases of New Realism*

USA New York, (New York State), New York Cultural Center *Realism Now*

USA New York, (New York State), New York Cultural Center *The Realist Revival*

USA New York, (New York State), Sidney Janis Gallery *Sharpfocus Realism by 28 Painters and Sculptors*

West Germany Aachen, Neue Galerie *Ben Schonzeit*

West Germany Cologne, Onnasch Galerie
Duane Hanson

West Germany Kassel, Kunsthalle
Dokumenta 5

West Germany Stuttgart,
Württembergischer Kunstverein,
Amerikanischer Fotorealismus

1973

Denmark Humlebaek, Louisiana Museum of
Modern Art, (Louisiana Revy, February 1973)
*Ekstrem Realisme: Vaerker fra Neue Galerie der
Stadt Aachen, Samnlung Ludwig*

England London, Serpentine Gallery *Photo-
Realism: Paintings, sculpture and prints from the
Ludwig Collection and others*

France Paris, Galerie des 4 Mouvements
Grands maitres hyperréalistes américains

Sweden Stockholm, Galerie Löwenadler
American Sharp Focus Realism

USA Lincoln, (Massachusetts), De Cordova
Museum *The Super-Realist Vision*

USA Los Angeles, (California), Los Angeles
Municipal Art Gallery *Separate Realities*

USA New York, (New York State), Louis K.
Meisel Gallery *Stuart M. Speiser Collection of
Photo-Realism*

USA Portland, (Oregon), Portland Center for
the Visual Arts *Radical Realists*

USA Sacramento, (California), Crocker Art
Gallery *Robert Bechtle*

USA San Jose, (California), San Jose State
University Art Gallery *East Coast/ West
Coast/New Realism*

USA San Francisco, (California), San Francisco
Museum of Art *The Richard Brown Baker
Collection*

West Germany Hannover, Kunstverein *Kunst
nach Wirklichkeit: Ein Neuer Realismus in
Amerika und Europa*

West Germany Recklinghausen, Städtliche
Kunsthalle *Mit Kamera, Pinsel und Spritzpistole*

1974

France Paris, Centre National d'Art
Contemporain *Hyperréalistes américains –
réalistes européens*

Italy Milan, Rotunda di via Besana *Iperrealisti
americani – realisti europi*

Netherlands Rotterdam, Museum Boymans-
van Beuningen *Kijken Naar de Werklijkheid*

USA Chicago, (Illinois), Museum of
Contemporary Art *The Real and the Ideal in
Figurative Sculpture: Duane Hanson and John de
Andrea*

USA Hartford, (Connecticut), Wadsworth
Atheneum *New/Photo Realism: Paintings and
Sculptures of the 1970s*

USA Potsdam, (New York State), State
University College *New Realism Revisited*

USA Worcester, (Massachusetts), Worcester
Art Museum *3 Realists: Close, Estes, Raffael*

West Germany Aachen, Neue Galerie *Duane
Hanson*

1975

Denmark Humlebaek, Louisiana Museum
Duane Hanson

USA Austin, (Texas), Laguana Gloria Museum
Chuck Close: Dot Drawings 1973–5

USA Baltimore, (Maryland), Baltimore
Museum *Super Realism: An Exhibition*

USA New Haven, (Connecticut), Yale
University Art Gallery *Richard Brown Baker
Collects*

USA New York, (New York State), Louis K.
Meisel Gallery *Watercolours and drawings –
American Realists*

West Germany Darmstadt, Kunsthalle
Realismus und Realitat

1976

Canada Stratford, (Ontario), The Gallery
Aspects of Realism

USA New York, (New York State), Louis K.
Meisel Gallery *Audrey Flack: the Gray Border
Series*

USA Washington D.C., National Collection of
Fine Arts, Smithsonian Institute *America as Art*

USA Wichita, (Kansas), Edwin Ulrich Museum
of Art, Wichita State University *Duane Hanson*

1977

Australia Canberra, Australian National
Gallery *Illusion and Reality*

USA Chico, (California), The University Art Gallery, California State University *A Comparative Study of Nineteenth Century Californian Paintings and Contemporary Californian Realism*

USA Jacksonville, (Florida), The Jacksonville Art Museum *New Realism*

USA New York, (New York State), Louis K. Meisel Gallery *Tom Blackwell*

USA New York, (New York State), Louis K. Meisel Gallery *Charles Bell*

USA New York, (New York State), The Pace Gallery *Chuck Close: Recent Work*

USA Philadelphia, (Pennsylvania), Pennsylvania Academy of the Fine Arts *8 Contemporary American Realists*

1978

England Sunderland, Sunderland Arts Centre *Working Process, (including Brendan Neiland)*

USA Boston, (Massachusetts), Museum of Fine Arts *Richard Estes: the Urban Landscape*

USA New York, (New York State), Louis K. Meisel Gallery *Audrey Flack 'Vanitas'*

USA Philadelphia, (Pennsylvania), Philadelphia Museum of Art *8 Americans*

USA San Francisco, (California), San Francisco Museum of Modern Art *Joseph Raffael: the California Years, 1969–78*

PICTURE ACKNOWLEDGMENTS

The author and publisher would like to thank all the artists, collectors, galleries and museums for their help in supplying the photographs listed on the pages below; in particular they are grateful for the generous assistance of Nancy Hoffman, Ivan Karp, Louis Meisel and Charles Saatchi. The publishers would also like to thank Paul Williams and Roy Flooks for the special photographic effects.

2 Gertsch – courtesy Galerie Veith Turske, Cologne

3, 6 Hanson – courtesy O.K. Harris Gallery, New York

8 Dagnan-Bouveret – Musée des Beaux-Arts, Lyon; © by S.P.A.D.E.M., Paris, 1980

10 Colville – Ludwig Collection, Wallraf-Richartz-Museum, Cologne

11 Kleeman – courtesy Louis K. Meisel Gallery, New York

12 McLean – courtesy O.K. Harris Gallery, New York

14 Parrish – courtesy Nancy Hoffman Gallery Inc, New York

15 Schonzeit – courtesy Nancy Hoffman Gallery Inc, New York

16 Harnett – Wadsworth Atheneum, Hartford, The Ella Gallup Sumner and Mary Catlin Sumner Collection

17 Weber – courtesy O.K. Harris Gallery, New York

18 Magritte – The Art Institute of Chicago; © by S.P.A.D.E.M., Paris, 1980

19 Posen – courtesy Robert Miller Gallery, New York; collection of Sydney and Frances Lewis

20 Goings – collection of Doris and Charles Saatchi, London

22 Goings – courtesy O.K. Harris Gallery, New York

24/25 Pollock – The Tate Gallery, London

26 Warhol – courtesy Leo Castelli Gallery, New York; collection of Mr and Mrs Burton Tremaine, Meriden, Connecticut

27 Close – Ludwig Collection, Neue Galerie, Aachen

28/29 Rosenquist – courtesy Leo Castelli Gallery, New York; collection of the National Centre of Contemporary Art, Paris

30 (left) Lichtenstein – courtesy Leo Castelli Gallery, New York

30 (right) – courtesy Roy Lichtenstein

31 Bechtle – courtesy the artist

32 Kessler – courtesy the artist

34 Morley and Martin – collection of Doris and Charles Saatchi, London

35 (left) Judd – courtesy Leo Castelli Gallery, New York; collection of Mr and Mrs Joseph Helman

35 (right) Salt – courtesy O.K. Harris Gallery, New York

36 Artschwager – courtesy Leo Castelli Gallery, New York; Ludwig Collection, Neue Galerie, Aachen

37 (top) Bechtle – courtesy O.K. Harris Gallery, New York; collection of Mr and Mrs R. Zimmerman, Nashville

37 (bottom) Pearlstein – courtesy Allan Frumkin Gallery, New York

38 Kanovitz – Ludwig Collection, Neue Galerie, Aachen

39 Nesbitt – courtesy Andrew Crispo Gallery, New York

40 (top) Christo – courtesy Annely Juda Fine Art, London; photo Wolfgang Volz

40 (bottom) Burgin – courtesy the artist

41 Kosuth – The Museum of Modern Art, New York, Larry Aldrich Foundation Fund

42 Morley – Ludwig Collection, Neue Galerie, Aachen

43 Morley – courtesy Nancy Hoffman Gallery Inc, New York

44, 45, 46 Morley – collection of Doris and Charles Saatchi, London

47 Morley – Ludwig Collection, Neue Galerie, Aachen

48 Flack – courtesy the artist

49 courtesy Audrey Flack; photo Jeanne Hamilton

50 (top left) courtesy Audrey Flack

50 (top right and bottom) courtesy Louis K. Meisel Gallery, New York

51 Flack – courtesy Louis K. Meisel Gallery, New York

52 Flack – courtesy Louis K. Meisel Gallery, New York; collection of The Museum of Modern Art, New York

53 (left) Bechtle – courtesy O.K. Harris Gallery, New York

53 (right) – courtesy Robert Bechtle

54 courtesy Robert Bechtle

55 Bechtle – collection of Doris and Charles Saatchi, London

56 Bechtle – courtesy The High Museum of Art, Atlanta, Georgia; Gift of the National Endowment of the Arts and The Ray M. and Mary Elizabeth Lee Foundation, 1978

57 Bechtle – courtesy O.K. Harris Gallery, New York

58 Close – Private Collection

122 Eddy – Ludwig Collection, Neue Galerie, Aachen

123 Eddy – courtesy Nancy Hoffman Gallery Inc, New York

124 Leonard – courtesy the artist

126 Hanson – courtesy O.K. Harris Gallery New York

127 Degas – The Tate Gallery, London; © by A.D.A.G.P., Paris, 1980

128 (top) Johns – courtesy Leo Castelli Gallery, New York

128 (bottom left) Segal – Albright-Knox Art Gallery, Buffalo, New York

129, 130, 131, 132 Hanson – courtesy O.K. Harris Gallery, New York

133 Hanson – collection of Doris and Charles Saatchi, London

135, 136, 137, 138 De Andrea – courtesy O.K. Harris Gallery, New York

139 (left) Levine – courtesy O.K. Harris Gallery, New York

139 (right) Duchamp – Philadelphia Museum of Art, The Louise and Walter Arensberg Collection; © by A.D.A.G.P., Paris, 1980

140, 141 Yoshimura – courtesy Nancy Hoffman Gallery, New York

142 Graves – The National Gallery of Canada, Ottawa, gift of Mr Allan Bronfman, Montreal

143 Graves – courtesy the artist

144 (left) courtesy Madame Tussaud's, London

144 (right) Hanson – courtesy O.K. Harris Gallery, New York; collection of The Milwaukee Art Center

INDEX